re(

THE REAL THING

contemporary art from china

First published 2007 by order of the Tate Trustees
by Tate Liverpool, Albert Dock, Liverpool L3 4BB

in association with Tate Publishing, a division of
Tate Enterprises Ltd, Millbank, London SW1P 4RG
www.tate.org.uk/publishing
on the occasion of the exhibition

The Real Thing: Contemporary Art from China
Tate Liverpool
30 March - 10 June 2007

Supported by the Liverpool Culture Company
as part of the city's preparations for European
Capital of Culture 2008, with additional support
from The Henry Moore Foundation and
The Red Mansion Foundation

British Library Cataloguing in Publication Data
A catalogue record for this book is available
from the British Library

ISBN 978-1-85437-713-5

Distributed in the United States and Canada by
Harry N. Abrams, Inc., New York

Library of Congress Cataloging in Publication Data
Library of Congress Control Number: 2006938011

Designed by He Hao
Printed by Artron Colour Printing Co. Ltd

Front cover design: Piccia Neri

CONTENTS

Foreword and Acknowledgements

Christoph Grunenberg
Director
Tate Liverpool

Since its foundation in 1988, Tate Liverpool has established a reputation for its innovative exhibition programme that is as committed to exhibitions of international art as it is to British art. *The Real Thing: Contemporary Art from China* once again confirms Tate Liverpool's outward-looking vision, and its commitment to bringing the best of the world's art and culture to Britain. The exhibition in Liverpool is appropriate and timely; twinned with Shanghai, and home to the oldest Chinese community in the UK, Liverpool has always maintained an active dialogue with China. This historical legacy is reflected in this exhibition, which brings to Liverpool art from one of the world's most dynamic and culturally sophisticated countries at a time when interest in the country is running high. Despite the proliferation of exhibitions internationally of contemporary Chinese art, this is the first major exhibition in the UK, and distinguishes itself from the other exhibitions, not only in the depth and range of work shown in presenting some of the most interesting and important art to be made since 2000, but in the unusual degree of collaboration established between the co-curators and the artists. *The Real Thing* comprises a majority of works that are either shown for the first time outside of China, or were specially commissioned for the exhibition.

The title, 'The Real Thing', can be taken straight, as an indication that the exhibition is a true reflection of contemporary art in China today. Many artists show a sincerity in their work that is noticeably lacking in the Cynical Realism style of previous generations. These predominantly young contemporary artists, largely based around Beijing and Shanghai, have chosen to remain in China, unlike many of the generation before them, and are moving towards a self-confidence and maturity that stems from an understanding of the contemporary world, China's place within it, as well as the contemplation of their own individual positions within a society at a time of rapid, and profound cultural change. 'The Real Thing' can also be taken ironically — humour and irony continue to characterise much of the art currently made in China. The sheer scale, range and ambition of many of the works, including some spectacular installations in the public realm, demonstrate the vivacity, energy, skill, and imagination

of these artists, with whom we hope this is the start of a longer professional relationship.

We would like to thank all the artists involved in the exhibition for their energy, ideas and commitment. We would also like to thank the Liverpool Culture Company, The Henry Moore Foundation, The Red Mansion Foundation, and Paul and Margrit Hahnloser-Ingold for their generous support of the exhibition. In supporting the realisation of many of the works especially for the exhibition, we would like to thank Urs Meile, Urs Meile Galerie, Lucerne and Beijing, and the Northwest Regional Development Agency for Ai Weiwei's spectacular *Working Progress* (*Fountain of Light*), with additional thanks to United Utilities, Liverpool Vision and British Waterways; Marian Goodman and Lorenz Helbling, from the Marian Goodman Gallery, New York, and ShangHart Gallery, Shanghai, respectively, for *East of Que Village* by Yang Fudong; Caspar Schuebbe for *2007, 3, 30* by Gu Dexin; Frank Cohen and Nicolai Frahm for *If I knew the danger ahead, I'd have stayed well clear* by the Yangjiang Group. We would also like to thank the Long March Foundation, Beijing; Alexander Ochs Gallery, Berlin and Beijing and White Space, Beijing. We are also indebted to all those, too numerous to name, who have contributed to shaping the show through the many and various conversations and discussions that have taken place across the continents.

I would like especially to thank the team of curators who have worked so hard over the last few years to bring this special exhibition together: Simon Groom, Head of Exhibitions and Displays at Tate Liverpool, the Beijing-based writer and curator Karen Smith, and the Shanghai-based artist and curator Xu Zhen. They have been well assisted by Kyla McDonald, and thanks are due to Jean Tormey for the public programme, and to Ken Simons and his team for the installation. Thanks are also due to Mao Weidong and Benjamin Liu for their translating skills; Gao Yuan and Lao Ma at Fake Studio; Amelie von Wedel and Qu Kejie for assisting with *2007/03/30*; Wang Bo and Skin3, Shao Yide, Dacong, and Intelligent Alternative for providing additional audio-visual materials; Li Xinmin for organising the shipping in China, and He Hao for his design of the catalogue.

The Real Thing

Simon Groom
Head of Exhibitions
Tate Liverpool

The Real Thing, though the first comprehensive exhibition of contemporary art by Chinese artists in the UK, is one of many exhibitions internationally that attests to the extraordinary interest shown in the art of the country today. Coupled with the astonishing rise in prices for works at the auction houses, signalled most dramatically at the New York Sotheby's sale in March 2006, it would seem to be a very good time to be a Chinese artist. But this interest has also not been without its problems — already the feeling of China fatigue is palpable, and when works by young Chinese artists barely out of the academies are selling for more than well-established names from the rest of the world, questions are inevitably asked about whether what we are witnessing is the emergence of a speculative market, rather than the reappraisal and discovery of genuinely good work by genuinely interesting artists, finally able to achieve visibility through their insertion into the international circuit. Certainly, the frequency with which the same names appear at the auction houses, and the same artists constitute the core of most exhibitions, can make it appear as though there is little more to discover, and threaten to reduce the experience of one's exposure to Chinese contemporary art to little more than that of brand recognition. Yet only a few years ago, there was still the perception that China was a vast treasure house of artists, working away in the obscurity of such a large country, waiting only to be discovered by those curators and dealers intrepid enough to navigate the complexities of such a foreign country, to reveal 'the real thing' to the rest of the world, and so satisfy the rapacious global demand for artistic consumption that it simultaneously serves to stimulate.

The Real Thing recognises the complexity of the dilemmas facing the reception of contemporary art from China in such a cultural context. In its invocation of the Coca-Cola marketing slogan, the title of the exhibition acknowledges that for many, Chinese art operates on the level of a brand, its complexities reduced to familiar codes legible only for what they purport to reveal about that greatest of all contemporary brands, China. Despite the inclusion of Chinese artists in international shows around the world as artists, rather than *Chinese* artists, perhaps precisely because

most people still tend to equate contemporary Chinese art with the Political Pop and Cynical Realism of the auction sales, so popular because the iconography of the paintings reference such overtly Chinese signature themes, made the more appealingly consumable by simultaneously referencing such iconic and saleable western styles as Pop, there is still great ignorance about the range, variety and ambition of much of what is actually being made, seen and shown in China. To conflate contemporary art from China with specifically Chinese imagery, in which the political slogans of the Mao era have been updated to little more than the style of commercial imagery familiar to the postmodern and consumerist appetite of a western audience, is as reductive as the attempts to try to distinguish and define a unique 'Chinese' sensibility, that for so long characterised many of the debates around showing non-western art in the West, approaches, both of which, threaten to paralyse, and marginalise, Chinese contemporary art.

Perhaps unsurprisingly, the struggle to define a 'unique Chinese sensibility' is now largely being conducted by a wave of returnee Chinese — those whose families, usually of great wealth, were forced to leave the country when Mao took power in 1949, for Hong Kong or Taiwan — and centred predominantly around Shanghai, confident in the belief that, as exiles returned, they continue to carry the 'true' Chinese spirit, so brashly compromised first by Mao's bankrupt cultural policies, and then by the country's rapid modernisation that looks too suspiciously western. However, not once did I hear from any of the artists, or Chinese curators, any discussion about a distinctively Chinese art being a problem, or even an issue. It is a measure of just how far and fast the world has changed for Chinese artists, that in 2005, Uli Sigg, the great Swiss collector of Chinese contemporary art since 1995, should have put to each artist in his collection, the question: 'Chineseness — is there such a thing?' In his customarily direct and acerbic manner, Xu Zhen's *reductum ad absurbio* response was to ask how the condition of being 'Swiss' affected Sigg's own collecting practices.

Rather than seeking to impose yet another external view on what Chinese contemporary art is, *The Real Thing* evolved out of an extended series of conversations and discussions with a wide range of artists, curators and critics based in China. Given the relatively short time in which contemporary art has evolved, and the often adverse conditions it has had to endure, the art world is relatively small, if extended globally, so that

everybody seems to know everyone else. More surprising, however, was the diversity of view on almost every issue held by so few, views expressed with a passion and commitment that was indicative of just how energetic and vital the contemporary art scene is in China. Discussions ranged, inevitably, from the impossibility of a show that was truly reflective of contemporary practice, to the desirability of such a show, to those who thought that there should be a moratorium on international shows of Chinese art, either because there were already too many, or since its acceptance by the international community and the market had undermined the very notion of an avant-garde.

Whilst recognising the dilemmas any major exhibition of contemporary art would have, the co-curators of *The Real Thing*, critic and writer Karen Smith, based in Beijing since 1992, and the young Shanghai-based artist Xu Zhen, nonetheless believed it was possible, and more importantly, still relevant, to put together an exhibition that reflected the variety and strength of contemporary practice, without compromising the nature of the selection or works for an international audience. The exhibition would not seek to be exhaustive, but would instead focus either on those works made since 2000 that we regarded as being of especial interest, or those artists that we felt to be at the forefront of the contemporary scene, either through their continuing relevance and influence, if older, or the power and interest of their ideas and work, if younger.

The year 2000 was chosen as the cut-off point for various reasons: the turn of the millennium was a watershed economically and socially. China was admitted to the World Trade Organisation in 2001, and won the right to stage the 2008 Olympic Games in 2003. Although restrictions on internal movement within China were lifted in the mid-1980s, it is only relatively recently that restrictions on residence permits have eased, allowing for greater mobility. International travel was obviously far more restricted, and out of the question for the vast majority of people, where cost and acquiring a passport and foreign visa were, and for many still continue to be, major obstacles, but the freedom of international travel and the frequency of contacts internationally is now taken for granted by many. Along with freedom of movement came freedom of information. Although China had had access to the internet since early 1997 (although access was restricted and monitored), it was only after 2000 that it really began to establish itself as a tool for mass communication and information, as computers began to get cheaper, and the first internet cafes were

permitted to open in 2003. Although the Government still continues to monitor the internet, and exert influence over some of the major service providers, it is, to all intents and purposes, open and free. One site that has proved particularly popular amongst a general as well as specialist audience, is the blog run by Ai Weiwei, on which he publishes not only a full account of his daily activities, but comments on cultural issues, many of which are sharply critical of government policy.

2000 also marked the moment when the State recognised the importance, politically, of contemporary art, and the power that contemporary culture could exercise on the international stage, signalled perhaps by the strong representation of Chinese artists at the Venice Biennale in 1999, but enacted most tellingly in the Chinese Government's decision in 2001 to send an exhibition of contemporary, rather than classical, art to Berlin at the request of the German Government, *Living in Time*. The 2000 Shanghai Biennale was the first major exhibition of contemporary international art to be organised by a state institution at the Shanghai Museum of Art, which showed what had hitherto been regarded as underground or subversive art as mainstream. The satellite exhibition curated by Ai Weiwei, with its deliberately provocative title, *Fuck Off*, which sought to gather together all the most interesting tendencies of the avant-garde in China at the time, also passed unchallenged by the authorities. These early years of the Millennium, then, were important, in signalling a radical shift in both the status of the artist, and the possibilities open to them: no longer as an outsider working in opposition to an official cultural position, no matter how ill-defined, the artist began to emerge as a superstar with mass-media appeal, art itself regarded as simply another sub culture, like 'youth', which rapidly emerged, supported and sustained by the appearance of the first major Chinese collectors of contemporary art actually based in China.

The energy of the Chinese arts world is not contained, codified, and confined like a lot of work abroad; there is a plurality of practice and style, none of which can be said to represent Chinese art. Any idea of a unitary or coherent identity, for the country as much as for the art, has collapsed into an open space of infinite possibility, and parallel worlds. One need only walk for five minutes in any major city in China to realise quite how many worlds coexist, and at what unequal speeds they move: despite the constant noise of the streets, and the seemingly ever-present sound of welding from the construction sites, the present has never felt such a narrow shelf of time

compared to the idea of a future, so tangible even if still impossible to delineate. Most striking, perhaps, are the huge, beautifully designed shopping malls full of designer shops and impossibly expensive goods, eerily empty, for now, but standing confidently ready for a time when future economic prosperity means everybody will be able to afford to shop there.

How much the diversity of style and approach has to do with the lack of a gallery infrastructure is difficult to tell. Apart from the name, there is no Chinese equivalent of a National Art Gallery, which becomes *de facto* of its power, prestige, and collecting policies, a national arbiter of taste. The major state museums are still galleries available for hire, or serve as repositories of major international travelling exhibitions, often organised as part of a governmental cultural exchange for political ends. The last few years has seen a massive growth of state funded galleries either built or proposed, with estimates of over a hundred new major galleries by 2008, but whose primary interest seems to be economic rather than cultural. Typically, the local authority will fund the capital cost, after which the gallery will have to be self-funding or else risk being converted to another use. Only relatively recently has there begun to develop a structure of private galleries, and those that there were prior, such as ShangHart in Shanghai and The Courtyard Gallery in Beijing, were mainly run by foreigners. It is only in the last few years, and based predominantly around Morganshan Road in Shanghai and 798 in Beijing, that both foreign and Chinese owned galleries have begun to proliferate, and only since 2005 that international galleries have begun to establish their presence in China with the opening of several major gallery spaces.

With the increasing commercialisation of the art market, and the rapid rise in prices which has made certain artists suddenly incredibly wealthy, there has been the attendant temptation by many of those artists to continue to make art that is predominantly saleable rather than creatively interesting, and which often ends up representing the face of contemporary Chinese art in international survey shows. In wanting to show the best of contemporary art from China, we took a creative risk in inviting proposals from those artists we thought most interesting, which provided an opportunity for artists to create a work in relative freedom from market considerations — freeing them from the tyranny of being caught in a style with which they may have become associated — and also to avoid any accusation that the show was simply another western view of Chinese art that would conform to what a western audience would expect to see. It

also corresponds closely to the way that many of the artists work, making use of the speed, price and technical efficiency of Chinese labour and industry, to produce works on a scale and ambition unaffordable to most of their western counterparts — although increasingly western artists are turning to China for the production of their work — and simply because the opportunity is there, given the enormous interest on the part of dealers and collectors willing to fund large works unimaginable in any other part of the world. It also corresponds closest to the way that the most interesting exhibitions are put together in China, where artists will make new work, often of a very different kind to what they sell or are famous for, specifically for a show.

It confounds many western expectations that an artist's work should develop according to some internal stylistic progression or logic, and many commentators on Chinese art are often bewildered by the variety of work an artist is capable of producing; works that might appear to lack consistency or logical connection between them, so opening them to accusations of unevenness, or lack of authenticity. On the other hand, to stick to a style for which an artist is well known, leaves the artist open to accusations of commercialism, and often justly, continuing to produce, often en masse, variations on a theme or style with no substance. Neither position, however, seems unduly to worry the artists — even those whose practice was founded on critiquing the system see no contradiction in earning good money a decade later from pastiches of the kind of works they originally set out to discredit, nor seem to suffer any diminution of their reputation or critical edge.

Despite the plurality of style, and openness of approach, and although we initially set out with no preconceived theoretical framework for the exhibition beyond trying to identify the most interesting artists and works since 2000, certain themes began to emerge. If the art of the 1980s and 1990s could, with hindsight, be characterised as an art that sought to test the boundaries, and was characterised by a fierce cynicism, much art since 2000 is more personal and sincere, concerned with reflecting upon one's own place as an individual, rather than seeking to establish a collective position, in a society that is undergoing such rapid changes as to undermine any stable reference point. In short, a search for authenticity, be it private or public.

The turn from a fierce sense of cynicism and impotent violence to an art that reflects upon contemporary social reality is perhaps most telling in Yang Shaobin's new series of paintings, *800 Metres*. One of the few well-known painters from the 1990s to continually experiment and evolve, his new series of paintings draw heavily upon personal reflections from his own childhood: not just the subject matter, which is based upon the mining town he grew up in, but also the tradition of Socialist Realism he associates with that time. In the paintings, the epic optimism of the Socialist Realist style he uses is brutally undercut by the harsh working conditions of the present-day miners he depicts. Another artist who draws upon his own experience to seek to situate himself in the world, is Qiu Xiaofei. Although meticulously faked, his work appears as a genuine and sincere attempt to locate himself through moments of time that will themselves become eroded and lost, as fragile as the rapidity with which the past is being erased to build the New China. That this young artist's works should be constructed around memory, and the assertion of an individual's history, is itself striking, given the dangers people of his parent's generation faced in the context of the Cultural Revolution, where an individual's memories were subsumed by an official social history it was dangerous to contradict. Similarly, Zhang Hui based his work, *Factory Floor*, on memories of working at the 'East is Red Tractor Factory', and upon a real incident in which a worker lost his legs in an accident. Like Qiu Xiaofei, his meticulous recreation of the machinery and setting of the factory, although constructed out of polystyrene, is so realistic as to appear 'the real thing'. The work alludes to China as the world's factory, a subject picked up by Cao Fei in her work, *Whose Utopia?*, which reveals the reality of the personal dreams and desires of a number of factory workers which break lyrically into the mundane and tedious world of their everyday work upon which the new economic realities of China are based. Both realities are as real as each other, though irreconcilable. The question of authenticity, and the nature of the real, is taken further by Geng Jianyi in *An Unapologetic Act of Sabotage*, in which the conscious recreation of an originally unconscious set of actions undermines the sense of self constructed through habit and familiarity when subjected to observation.

Also concerned with questions of authenticity, but working in the opposite direction, and in a style completely different from the paintings for which he has become one of China's most visible artists, is Zhou Tiehai, whose work for the exhibition consists of the invention of three French desserts. The sheer accumulation of facts, anecdotes, presumptions, histories, theories and rumour presented in each of the texts on the subject of each

of the desserts, whose ever-widening sphere of references threatens to take in the whole of French history, undermines the authenticity of the texts as they seek the firmer to embed the desserts in the authority of a definitive history. The status of the real finds its most ambitious and humourous expression in Xu Zhen's work, *8848 Minus 1.86*, which consists of the summit of Mount Everest, presented in a glass refrigerator, amidst documentary evidence of the expedition, and whose title refers to the height of the mountain minus the artist's own height. Coincidentally or not, a report published by an international team of scientists using satellite readings some months after Xu Zhen's trip, found that Mount Everest was not quite as high as had been thought, pointing, perhaps, to evidence of global warming, or a shift in the tectonic plates. What was not in doubt was the horrified reactions by many viewers to the act of ecological vandalism that Xu Zhen had committed in sawing 1.86 metres off the summit, with some equating his act with the blatant disregard for the environment they perceived China was showing in its headlong rush to modernise, his arrogance as symptomatic of a newly powerful China oblivious to the concerns and interests of others.

Just as even the greatest global natural landmark, Mount Everest, can no longer be trusted to provide a stable point of reference, so too with the traditional certainties of a society suddenly subject to such constant and dramatic change. The challenge for the artist is to operate in a society in which every imaginable aspect of everyday reality is constantly subject to transformation so total and beyond anything most of us could even begin to envisage; when even the local authority takes it upon itself to transform the parched and dusty countryside that runs from Beijing airport into the city into a green and pleasant land through the painted *tromph l'oeil* of green grass to impress the Olympic Committee in its bid. In such a context, in which the line between truth and fiction is indistinct, the real is a shifting concept. As old certainties pass, new ones are continually having to be re-forged, if only as temporary fictions. The playful ambivalence to be found in many of the works, as much as the attempts to anchor a sense of self, no matter how unstable, are responses perhaps to a culture undergoing such rapid and profound change that anything appears possible. The real should not be equated with the truth, or with the universal, but as a fragmented kaleidoscope of truths, conflicting and of equal validity, constructed from social observation as much as from personal recollection. It points to the futility of all attempts to define a definitive truth, but perhaps in doing so, becomes by virtue of its recognition of that very impossibility, 'the real thing'.

art@lastminute.cn

Karen Smith
Independent Curator

Real Problems

In China today, every imaginable aspect of modern life is unfolding simultaneously. One might cite numerous examples to illustrate the complex nature of this social change: the widening gap between rich and poor; the challenge of implementing a legal system; the surging force of materialism; the problems of regulating the professions and of heading off corruptive practices; as well as the positive growth in opportunities for individual members of society, and the economic benefits that are slowly filtering through to the general populace. All are the result of the unbelievable rate of redevelopment, and its kaleidoscopic impact upon existing ways of life, community values, and individual aspirations.

But that doesn't help us understand how individuals are dealing with the need to adapt their mindsets and daily habits to the new world that these complex social phenomenon are directing. Nor does it explain the ways in which they are affecting personal experience, or how they currently inform contemporary art. Artists, whose choice of career largely renders them independent of mainstream society in China, still provide a good example of the contradictory nature of this modern macrocosm, and, of course, demonstrate in their work the various directions in which art is being lead.

Whilst his working practice produces some of the most challenging and arresting pieces of art to emerge from contemporary art circles in China, in terms of managing his art-career affairs, Gu Dexin belongs to the old school. He chooses to live entirely in the present moment with little thought for tomorrow—which is why all works are titled by the date upon which they were executed, and once completed are forgotten. You can call him to secure a meeting for a visiting curator a week in advance and he'll tell you he's not sure … that it's better to call him on the morning in question to confirm. This is not because he's busy, or because he needs to juggle his schedule, or because he likes to play hard to get. He is simply not used to thinking or planning that far ahead, and will certainly have forgotten. In this high-tech world of mobile phones—Gu Dexin is one of a tiny minority of urban Chinese people who does not own one—and email communication, this artist is perhaps an extreme case, but it was not so long ago

that all Chinese people lived this way. Dinner invitations were regularly received at 5:30pm for the same evening, and, more often than not, in person as very few people had a phone line in their home. By 2000, technology would have changed that, but the majority of older generation artists—who emerged from the mid-1980s to the mid-1990s—still largely adheres to such practices. It is almost as if the act of committing to anything definitively, of regimenting their days with scheduled appointments, infringes upon the personal freedom they fought so hard to secure.

The younger generation, these children of the reform era, whose experience and knowledge is tied to the modern age, operates using equally modern methods and mindsets that have no kinship with 'traditional' socio-cultural protocols. In contrast to Gu Dexin, Shanghai-based Xu Zhen prefers to have his time managed by a team of assistants who oversee his hectic schedule and order his priorities, as he shifts back and forth between his dual roles of artist and curator. Call him to make an appointment for that same visiting curator, and the response is much more likely to be "Xu Zhen can squeeze you in a week on Friday…"

So here, in a simple, yet telling example, we have a broad sense of the chaotic contemporary reality that the works in *The Real Thing* attempt to address—the pace of life, personal ambitions and social pressure, demand, change, new navigating old. These are works created by artists who, in myriad ways, are successfully withstanding the tempestuous winds of change. Not least, the recent tide of commercialism which is currently peddling a wide array of highly attractive rose-tinted spectacles, all of which serve to distort reality to various degrees, but each of an allure that largely conceals the inevitable complications that accompany self-deception. Against the rise of such overwhelming temptations, *The Real Thing* is the vision of eighteen artists who thus far have refused or avoided the spectacles, preferring reality without enhancement no matter how coarse the view. As Shanghai-based filmmaker Yang Fudong revealed: "In our small circle, we are quick to throw cold water on anyone who looks like they might compromise their work."

The force of change, then, is a true test of character, and ultimately of individual artistic vision. As the rule of ideology concedes ground to the practical politics of economics so, too, the *Weltanschauung* of Chinese art finds itself being undermined by commerce. The dramatic impact of the New York auction to which Simon Groom refers, encouraged a mass proliferation of auctions across China, each attempting to adopt a similar model. With the limited amount of works actually available in the marketplace—the number of contemporary artists is still surprisingly small—individual pieces are flipped from one sale to another with

foolhardy audacity, and no apparent concern for appearances or the possible long-term effect. But it is not commerce *per se* that is the problem. The great challenge to artists is in sustaining creativity. Contemporary art in China was forged in the intense climate of a culturally-specific framework that continued to be dominated by political ideology into the post-Mao years, little affected by Deng Xiaoping's 'opening and reform' policy until the late-1990s. Since 2000, the incremental dissolution of the absolute black and white parameters of the governing autocracy, which has latterly substituted harassment with a policy of *laissez-faire,* has begun to invalidate the type of ideologically-charged, artistic expression that this climate had encouraged. The political paradigm had informed the majority of aesthetic positions in the 1990s, a time when, to engage in contemporary art represented a distinct realm of creative practice that was, by definition, in opposition to that sanctioned by the authorities, making it relatively easy to formulate an aesthetic strategy. For, if, as Chinese artists believed, contemporary art was about breaking rules, about challenging the status quo, about using art as a conduit to provide viewers with out-of-the-ordinary experiences that forced them to consider philosophical questions from unconventional angles, then the nature of their political framework, its conservatism and constraints, as well as its lexicon and motifs, was a powerful resource to invoke. Even though today it seems that some of these symbols were ultimately overplayed, for the greater part of the 1990s, the deployment of these elements resulted in a rich variety of artworks of a clearly daring nature and unambiguous stance. Furthermore, the fusion of all the above also importantly served to identify the work with its cultural framework: and again, by analogy, the artist's defiance of it. It was this aspect of the art that initially fired the western imagination. Therefore, as politics began to take a backseat in daily life, and relaxed its grip on artistic expression, the contemporary art community lost a motivating point of reference that had long been an inalienable component of its character and identity. Addressing contemporary reality, articulating unfamiliar social issues, posing questions about the modern human condition, reflecting personal experience and engaging in general aesthetic debates, was far more problematic in the absence of an immutable authoritarian ideology. And without it, many artists began to look rather like the figures depicted in the water paintings of Cynical Realist Fang Lijun: adrift in an endless, monotonous expanse of water, with no clear direction, and nothing to orient themselves by, and nothing tangible to grasp on to in sight.

Adapting to new situations takes time. No doubt, the majority of artists will emerge from the struggle with which they are currently engaged to reassert their identity, although certainly not all will emerge triumphant. It is an

interesting and challenging moment to create an exhibition that accurately reflects the mood of this art world since 2000, especially where seven years have already passed, which is a lifetime in China. For reasons of all the challenges indicated above, those artists whose work continues to go from strength to strength, whose agenda and expression has not been tainted by the commercial incentives dominating the local climate, rather identified themselves as candidates for participating in *The Real Thing*. The exhibition evolved out of a combination of existing works and the opportunity it provided to some of the artists to realise ambitious new projects. Where the goal was to focus on the innovative, dynamic face of art in China today, the additional imposition of a theme or curatorial theorem would have been superfluous. It was, in fact, the final selection of works that prompted the title *The Real Thing*, not the other way around. In short, the real commitment of these individuals to art, the powerful reality that underscores the content of their work—rather, their blatant questioning of what is or is not real, instead of a passive acceptance of the official line—and the real quality of the basic artistry they draw upon. Brought together in one exhibition, these works, as diverse as they are, confirm the one real thing about contemporary China that is beyond doubt: the fact of every conceivable aspect of modern life unfolding simultaneously, the mayhem that ensues, and the valuable role art can play in analysing and documenting it all.

Real Time

Anyone who has attempted to work in China in recent years will confirm that regardless of all provision made for advance planning, of how meticulous the attention to detail that is applied, every project is ultimately executed in a frenzy of activity at the last possible minute. It was certainly a vital, if challenging, aspect of realising *The Real Thing*. Whilst this phenomenon is by no means exclusive to the art world, as an example, it illustrates the root of the problem, as well as the contemporary mindset brought to dealing with it. Creative expression depends on a process of thinking that requires time to evolve, which means that the lapse between the instant an artist agrees to participate in a project and the moment when a work receives its finishing touch, can be unnervingly protracted. This is less unnerving for the artist, who at least in China always comes through in the end, than for the exhibition organisers who must deal with potential blanks to fill, also at the last minute, should any artist fail to deliver. But here, the amazing speed at which projects are realised in China provides an extraordinary opportunity to witness the pace at which the nation today is capable of moving. The obvious parallel is in urban redevelopment, which has been the subject of wide media attention abroad, but it equally applies to the emergence of a skilled

force of industrial and manual workers, and how China has attained a level of sophistication in manufacturing and construction that was inconceivable even in the mid-1990s. The process of industrialisation is relevant to the art world, because it has inadvertently furnished contemporary artists with a ready source of working materials previously beyond their reach, and no shortage of foundries, workshops and factories equipped with skilled technicians for whom, against the need to meet profit quotas, an artwork is as lucrative a product as any other. This permits artists to conceive of extraordinarily complex structures, such as Ai Weiwei's monumental *Working Progress (Fountain of Light)*, which required an enormous workforce made up of crystal producers, steel workers, and engineers across China. Equally, sculptural works that are simply monumental like Gu Dexin's replication of the lighthouse boat funnel, the production cost of which would be prohibitive anywhere in the western world, where steel and labour command such a hefty premium.

Both of these works are also examples of how, in China today, highly ambitious projects are completed against impossibly short deadlines — Ai Weiwei's dazzlingly complex 'fountain' was completed in just four months from concept to finished piece, which included finding resolutions to all manner of engineering challenges. Gu Dexin's funnel proved even faster: a mere twenty days. But, as suggested previously, in China this is not considered unusual, for this same speed propels the nation's programme of modernisation and reform, and is the guideline used to plot the timeframe required to complete dauntingly large scale projects: not least, the stages by which Beijing would be transformed into an Olympic capital. The astounding rate of progress in the construction of the new terminal for Capital Airport in Beijing, designed by Norman Foster, is a fine example of the accelerated drive. But it is not only in Beijing that people are having to adjust to the increasingly manic pace that modernisation demands; it is affecting the population nationwide, and is in evidence in artistic communities as much as those of the white-collar workers or the labour force. Which brings us back to the issue of time, for the breakneck pace of life, thrilling though it might be, contrives to deny artists the one thing they need most: time — time to contemplate, time to create.

Standards of living have risen dramatically in recent years, which on the one hand frees most artists from the burden of working to live. (Most artists today are, in fact, able to live by art alone.) But the mental agility required to keep abreast of the times leaves little energy for contemplation and casual observation, for reflection, or thoughtful invention. Putting the doctrinaire nature of the Mao era aside — which entirely dictated what people were to think at all

times—this is a tragedy for a people heir to a long and fundamentally contemplative cultural tradition. Especially for artists. Freedom, they learn, comes at a price: artists might live somewhat independently, on the fringe of conventional society, but they too have parents, relatives, children, and are no stranger to navigating financial pressure wrought by tuition fees and healthcare. This inevitably has an impact on the type of art an artist is willing to create, and to keep on creating as personal circumstances change—as they become parents, and they themselves mature. In the same way that, in this era of ebullient economic growth, socialist doctrines are being replaced with materialist values, so the urgent need to achieve economic solvency finds the critical acclaim that formerly presided over judging artistic standing right up to the new millennium being usurped by market forces. More worryingly, the value of the aesthetic analysis and positions of China's art critics is losing ground to the power wielded by the size of the price tag a work can command as an all-important indicator of artistic worth.

This phenomenon has everything to do with China's accession to the World Trade Organisation in 2001, for in spite of the economic reforms that were in operation in the 1990s, in political terms, where China remained relatively isolated, transformation was slow. Accession to the WTO changed that: China had officially joined the global community. The nation was now ally, trading partner, and a monumental manufacturing resource. It is impossible to ignore this fact in any discussion of art in China since 2000, because it marks the radical shift in the focus of the national agenda from politics to economics. This has exerted a tremendous impact upon the form and ethos of contemporary art, as well as the role ascribed to it. Especially where, in this blossoming cultural arena, contemporary art provides local business people with a wide choice of products to satisfy their appetite for modern trophies of status; a fact the artists also find hard to ignore. This further negated the old bi-lateral order of defiant artists versus repressive regime, for in the new millennium, due to the Government's choice of *laissez-faire* approach, opposition to contemporary forms of art has, to a large extent, been minimal. China's political framework continues to determine the dynamics of society, of personal relationships and individual careers, but increasingly from behind a veil of economic policies which, for reasons of national advance as opposed to democratic intent, have placed responsibility for individual lives and livelihoods in the hands of the people: not all of whom are adequately equipped to fend for themselves. This is illustrated in works included in *The Real Thing* by He An, Wang Wei, and Zhuang Hui. These are examples of a positive seam of emerging concerns that give credence to the cautionary note signalled by Beijing-based curator Pi Li in his 2000 article *Between Scylla and*

Charybdis: The New Context of Chinese Contemporary Art and Its Creation Since 2000:
"...empty ideology cannot be a permanent reason for art ... Grasping the gist of
the new world situation has become an increasingly urgent issue...When
ideological differences no longer exist, Chinese experimental artists will have a
future only if they turn their attention to the deeper layers within Chinese society."

A further example of this can be found in *The Real Thing* in the series of paintings
created by Yang Shaobin, which look at the grim reality in China's unregulated
coalfields. His interest in this social issue begins from direct personal experience
as a child, growing up in a mining area, and this invocation of personal
observation is another emergent trend in stark contrast to the guiding faith of the
New Art movement, which from the mid-1980s right through the 1990s, extolled
emotional detachment and intellectually rationalised concepts as the first rule of
'avant-garde' artistic expression. This remains the approach taken by Geng
Jianyi, a first-generation pioneer and, to a large extent, though for different
reasons, by Ai Weiwei. In many ways, it is self-confidence that leads young
artists to draw on their own experience—a level of confidence that was not
widely felt in the post-Mao years when the New Art movement began, nor by
'avant-garde' artists in the 1990s who received regular, official reminders that
their work went against the grain. Filmmakers Cao Fei and Yang Fudong, and the
young painter Qiu Xiaofei, are proud of the personal experience they bring to
their art because it is this that makes their artistic vision unique.

These younger artists also seem more able to deal with the pressures placed
upon them by the hectic pace of modern life. This is where an ability to think for
one's self is essential: an ability that is taken for granted in democratic cultures,
but that until very recently was actively discouraged in China—in recent history
where intellectual conformity by indoctrination was perceived as a necessary
construct of Communism, but equally, is an entrenched aspect of basic schooling
in China, in which rote learning serves as the primary mechanism for
remembering written characters, and the content of the school syllabus'. The
struggle to achieve and to exercise 'independent thought' is essentially the root
cause of the 'last minute' approach to producing and completing artworks. Used
to a world in which black could become white from one moment to the next, and
the shape of tomorrow was always uncertain from one day to the next, artists
have become accustomed to conserving their energies until the very last
moment when there is absolutely no doubt that an event *will* take place. It is a
habit that is apparently hard to break. This practice is compounded by the fact
that the number of artists in China remains rather small—the number of
interesting ones far smaller—and that the demand for their work has increased

exponentially overnight. Artists suddenly find themselves grappling with extraordinarily packed agendas. It all results in a dazzling degree of last minute chaos. But again, whilst this situation is a major headache for curators, it injects an element of dynamism in the work that might just otherwise be absent. At the eleventh hour, with the pressure pounding adrenalin through their veins, artists have to decide whether to sink or swim. Most choose the latter, and in doing so switch into instinctual, intuited action. This is exactly the way in which the filmmaker Yang Fudong works, which is amazing given the consistent air of calm his works exude, but 'last minute' is the means by which he operates, giving nothing away until the camera begins to roll. It certainly explains the subtle undertone of tension that suffuses his film works.

So finally, out of more than a year of deliberation, of discussion, and many, many proposals later, we have a selection of artists, a finite group that stayed the course through the fluid protean process of identifying artworks capable of mapping a diversity of concerns, and not as permutations, or interpretations of a singular theme. These are artworks that are capable of standing up to close scrutiny on all levels. *The Real Thing* presents a slice of contemporary art from China today, what we perceived to be the most compelling cross-section of creativity from the era, and that further invoke the raw aspects of the local environment, which are integral to the work, and an integral part of the inspirations that give it form, content and direction. True to form, *The Real Thing* came together at the very last moment of the eleventh hour, and at a speed that, although invisible in the works, was fast to the point of being reckless. Napoleon is said to have suggested that the world should let China lie dormant, warning of how the lion would roar should the country be awoken. Others have described China as an eight hundred pound gorilla, which should not be messed with lightly. Whichever animal one cares to take as a metaphor for contemporary China, today the nation is awake, roaring, and on the move. Whether that motion is fast, reckless, formidable, or exhilarating, is a matter of individual perception. In terms of the gorilla analogy, the recent pace of China's forward motion suggests an unstoppable momentum. Whilst the advance is primarily economic, culture is clearly now getting in its stride. Not only is twenty-first-century China demonstrably thinking for itself, and finding its voice—one that in the future might just become a roar—but the best of its contemporary artists are in the process of unleashing a real cultural revolution that might just one day demand as much attention in the West as western art enjoys in the lion's den.

A Few Words...

Xu Zhen
Artist and Curator

001 Elementary and all-pervasive information concerning Chinese contemporary art:

002 the situation does not encourage optimism.

003 **It's rather chaotic...**

004 **People don't have high expectations of exhibitions.**

005 Many things just begin to make headway and people lose interest in them...

006 In our hearts, each and every one of us hates those with too much power, no matter if they are good guys or bad guys...

007 *The greater majority of questions are assault and battery.*

008 *We all have a sense of crisis...*

009 **We've made a profession of doing things unprofessionally...**

010 Artists by now ought to be able to maintain their independence and get their own attitudes straight, not let their energy become diluted, nor be lax about their career. This is becoming a serious issue...

011 It is so crazy...here we are in the world spotlight...facing a non-stop stream of visitors...with no shortage of exhibition opportunities...of course this is a good thing.

012 Right now in China where it's almost impossible to make a good exhibition, the wait for someone to break the cycle gains increasing significance...

013 **I think that there really hasn't been much advance in the last few years, other than an increasing number of individuals learning how to make their works fulfil the appearance of 'good artworks'.**

014 You still think that this kind of approach is the way to go?

015 Comrades, you shouldn't do things you might regret...

016 'Chinese contemporary' should not be a Chinese edition of international contemporary art.

017 We'll make better exhibitions next year...

018 To a real extent, it says everything about the problems with professional curators; where exhibitions organised by the artists themselves are better than the ones put together by a curator.

019 Accepting the situation is tantamount to supporting it; we should learn to be proactive, instead of accepting things passively.

020 The problem is that the artists shouldn't have to take the initiative. If all of us (artists) have options for exhibiting, then there would be less room for random selection, and the reality would change. It is necessary for curators to maintain their independence, to draw in their claws and to stop engaging in meaningless competition. We need solidarity.

021 Our artists spend a lot of time thinking about opportunities...

022 We should examine our path carefully...

023 Many Chinese people speak in a sophisticated fashion, but is it necessary to be sophisticated?

024 Contemporary Chinese art offers an alternative model of modernism. Its inscrutability, its non-rational and un-systematised force, and the graceless energy it abstracts from the experiences of daily life, are a crucial aspect of its character.

025 **'China' should not be just a term.**

026 We are afraid of moving out of Beijing or Shanghai, afraid of another long march, afraid to go to the countryside or overseas.

027 **Capitals will corrupt those artists who lack the force to resist them.**

028 Subtle power is surely more interesting than obviously powerful forces.

029 Why do we always kill each other? Chinese art is chaotic enough. We should be united. It's not good to be a laughing stock.

030 From my childhood, I have carried a feeling that everything my teacher told me would remain unchanged, so I always hope that as a teacher, everything I teach should be open to change no matter if it is understood or not.

031 It's so simple really: we should learn to make use of each other.

032 The work is extremely vibrant. Of course, western art is the result of a huge amount of experimentation, but comparatively speaking, these artists operated under a largely inflexible logic, and within their own small circles. However, Chinese culture sits amidst the upheaval of a society undergoing a dramatic transformation. This process ought to inspire some profound and

powerful ideas. It ought to be the foremost element that distinguishes Chinese art from western expression.

033 The point is not to turn art into a circus, regardless of whether it's amusing or not. Although many artworks may be rough around the edges, that they are sincere is all that matters…

034 Initially it was foreign interest that nurtured contemporary Chinese art. Increasingly it is fed by the hand of the Chinese Government. Officialdom stakes its all on the collusion between the authorities and businessmen, whose supporting role ensures the controlling interests of the powers that be.

035 I welcome the high-flying, deliberately abstruse and unpolished aspects of Chinese art. Contemporary Chinese artists are probably the most ambitious group on the planet. Some of their artworks are clearly not equipped for the rarefied air of blue chip galleries and major museums.

036 **What you choose to pursue is paramount. Even if I am vulgar, I can still belong to a higher realm.**

037 In international exhibitions, too much is made of 'culture' and 'diplomacy', which aside from aiding the establishment of national art museums, is a distraction that should put both curators and artists on guard, especially where it is perceived as being helpful to their people.

038 I already shot myself in the foot so it makes little difference…

039 It should be clearly noted that the issue of doing something for the common people or for the leaders is not a moral debate about right or wrong. People who attack curators for this line of reasoning are extremely childish. Ultimately, the point always rests on the quality of an exhibition and the artworks it contains. If there's no merit in the proposal for a work, then it's unlikely to blossom into something greater at a later date.

040 What we do is less important that what we aim to achieve.

041 The non-profit system is underdeveloped in China. Today, cultural development is an unwitting bedfellow of the commercial market

042 I am momentarily touched…

043 *At the present time, the development of the commercial sector is unparalleled, its influence extraordinary…*

044 We should put artists first, China second.

045 The significance of art criticism should not be measured by its ability to point out the rights or wrongs of other theories, or pass value judgments on theories or endeavours, but should instead be decided by the degree of mental awareness in evidence.

046 **Art criticism right now is developing at an incredibly slow pace, and lacks any real sphere of influence.**

047 We impose so many restrictions upon ourselves, that we deny our own peace of mind. It's not even funny.

048 There is no academic system of support independent of the commercial world to be found in China.

049 Those who maintain standards and still become rich are not to be blamed for becoming wealthy.

050 Chinese contemporary art skates on thin ice.

051 We are forever young, our eyes forever brimming with tears...

052 *My attitude is perfectly clear. We must let people do things, and if they violate certain laws or codes of ethics, then we should criticise them. The important thing is to allow things to happen. We should all learn to fear those exemplary students who never get their hands dirty.*

053 At times, such situations force errors in judgment. But the experience of a setback does not guarantee a lesson is learned. That's what makes it so interesting.

054 How do we make others understand that China is not a concept?

055 It is better to step back and keep focused on the bigger picture; not to seek out a logic that's not there. It's better to let things remain a bit muddy.

Thanks to www.heyshehui.com from which most of these extracts are taken.

('*hei shehui*' in Chinese carries a double meaning. '*hei*' means black but also sounds like 'hi' . '*shehui*' means society but when paired with '*hei*' (meaning black) means mafia. Of course, when spoken it sounds like 'hello, society'... unless one is making a specific reference to a mafia.)

THE ARTISTS

Text: Karen Smith

Ai Weiwei (b.1957)

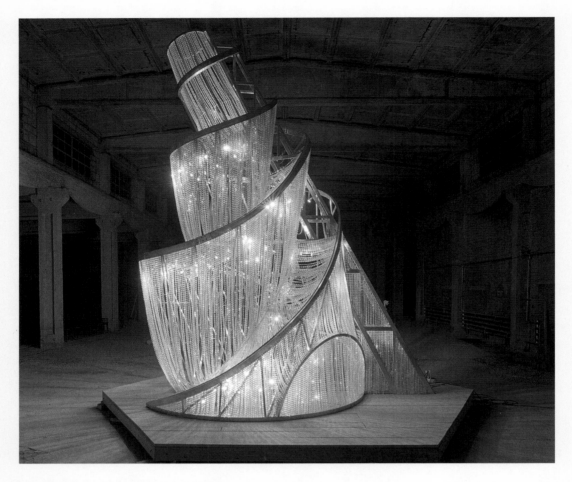

Working Progress (Fountain of Light) 2007
working drawing

Ai Weiwei came to art despising the political exigencies of a system that had sent his family into exile a year after he was born, and which condemned its society to a cultural impoverishment of immeasurable proportions. This intractable experience would later inform his work, but found initial expression in Ai Weiwei's discovery of Dada-inspired art when he left Beijing for New York in 1981, whose shock tactics and challenge to the socio-political status quo were to become distinctive features of his own work. His ability to deliver arresting statements in consistently elegant juxtapositions of material and form can be seen throughout his career, from the early works of 1986 such as *Violin with Spade Handle* and *Safe Sex* (a rubber raincoat with a condom for a pocket) through to more recent works, such as *Table and Beam* (2002) and *Fragments* (2006), where weighty philosophical abstractions assume the form of distinctly minimalist assemblages of materials. One of his most directly provocative activities involves his use of authentic, museum quality Han Dynasty (206BC-220AD) and Neolithic (4,000-3,000BC) vases, which he variously paints, whitewashes, or has been known to cover with commercial logos. His destructive approach to working with these pots is captured in photographs of Ai Weiwei dropping a particularly fine specimen from chest height causing it to smash spectacularly into a thousand pieces on the ground below. Reverence for antiquity clearly has no place in Ai Weiwei's world. His audacious affront to conservative traditionalists — which in addition to its reference to Duchamp, consciously invokes Mao's own command to the Red Guards to 'smash the old' — is a strategy calculated to provoke unsettling and uncomfortable questions about the role of culture, and its historical and ideological nature.

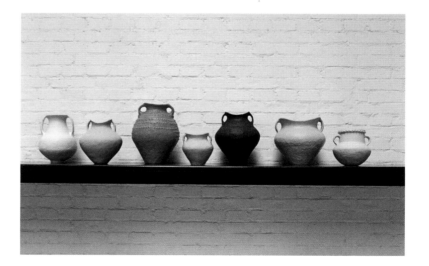

Painted Vases 2003
ceramic pots dipped in
poster paint

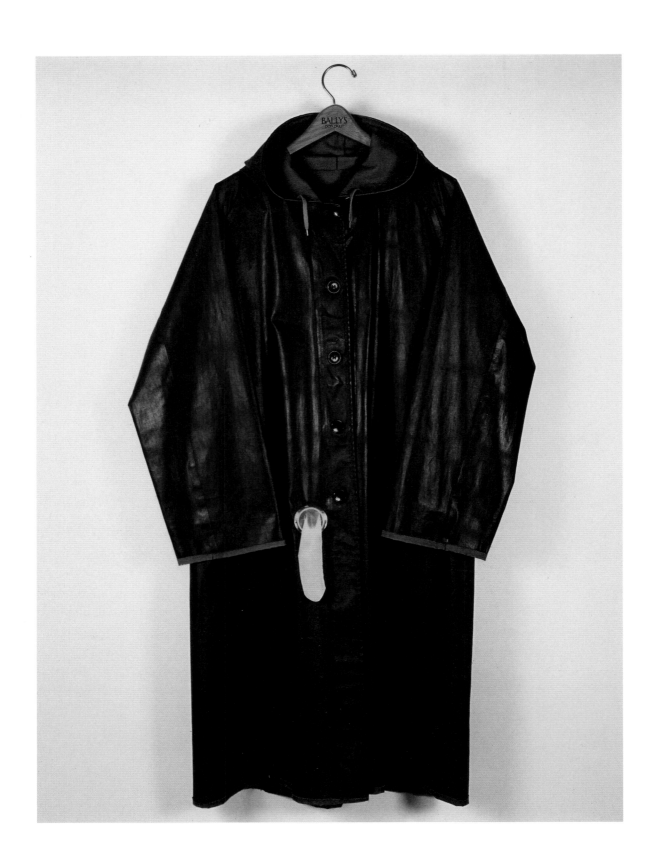

opposite page
Safe Sex 1986
rubber raincoat, condom

this page
Violin with Spade Handle 1986
violin, spade handle

Table and Beam series 2002
wood, various dimensions

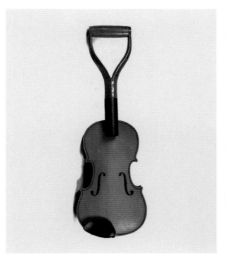
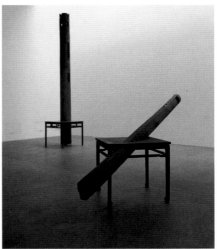

Ai Weiwei remained in New York for almost twelve years between 1981 and 1993. It was a self-imposed exile of sorts, and not because he was hard at work becoming the 'new Picasso' he had promised his mother before he left — he claims that when he finally returned to China she was extremely disappointed: "She told me, 'If you're really the new Picasso, then he can't have been half the artist he's cracked up to be!'" — but because China offered little room for artistic or cultural development. When the political crackdown occurred in 1989, little appeared to have changed. But then a brief return in 1993 to visit his ailing father — Ai Weiwei's first since leaving China — alerted the artist to a progressive creative element in China's cultural scene that was steadily gathering momentum. Ai Weiwei had the idea to document and showcase the work of these progressive artists who were furiously experimenting with new concepts and approaches, but had little outlet for showing the installations, performances and conceptual projects they were working on. The resulting series of books — *Black* 1994, *White* 1995, and *Grey* 1996 — were hugely influential in making visible a new and radically different kind of art, and created an important platform for debate.

This platform was the base upon which Ai Weiwei built his profile in the art world in China through the late 1990s, becoming as much tastemaker, as artistic *agent provocateur*. In terms of the impact he has had upon the contemporary cultural climate in China, Ai Weiwei is often referred to as a

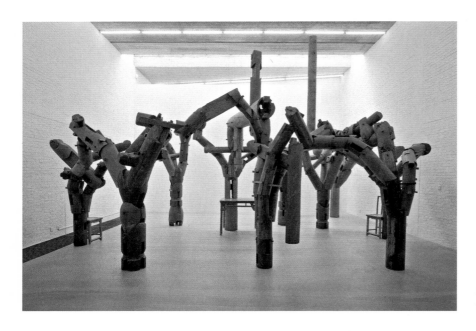

Fragments 2006
wood, mixed media

Renaissance man for the broad range of his knowledge and skills. In 1999,
he opened an alternative art space in a warehouse on the fringes of
Beijing, making China Art and Archives Warehouse (CAAW) the first of its
kind. In 2000, he curated the hugely influential show, *Fuck Off*, an off-
biennale event in Shanghai at the time of the Shanghai Biennale. Entirely
chaotic and without any curatorial brief, it remains one of the defining
events of Chinese contemporary art. The title Ai Weiwei opted for — *Fuck
Off* — has no correlation with a direct translation of the Chinese, which
would be 'a non-co-operative approach'. The idea of non-co-operation says
much about Ai Weiwei's sense of the hurdles to be crossed in producing
relevant exhibitions in China. The key issue being the inability of either
artists or curators to achieve an objective, coherent survey of art due to
the subjective nature of cliques of artists formed around a curator or critic,
and the often awkward, or deliberately contrary relationship that exists
between the various groups. Instead, appearing to invoke a stratagem
from *The Art of War*, Ai Weiwei made no attempt to fight this force, but
rather to use it, and as it turned out, not only to his advantage, but to the
benefit of all. The chaotic nature of the way in which works were displayed
in *Fuck Off* was remembered as the show's dynamic energy. The uneven
quality of works included was ultimately praised as the democratic choices
of a visionary curator.

Just prior to this, in 1999, Ai Weiwei designed and built a house/studio complex, thus adding architecture to his range of creative activities. Around the same time, he won acclaim for his design for a community fountain and a seating area in SOHO New Town, Beijing, and, in one of the residential towers, a large-scale installation configured to appear as if a building has just crashed through the walls and come to an angled halt in the double-height public hallway. Since these initial forays into architecture, Ai Weiwei's designs have found huge demand. In 2003, he was a key member of the design team at Herzog & de Meuron responsible for the astonishing 'bird's nest' Olympic stadium. Needless to say, this confirmed his capabilities as an innovative architect.

The experience accrued to Ai Weiwei through his architectural practice has had a visible influence upon his recent artworks, both in the expanding scale of his vision and the complex web of their structural form. One of the most arresting aspects of pieces such as *Forever* 2004, and *Fragments,* is the way individual components are assembled to achieve a physical structure. Ai Weiwei has an intuitive sense of the compatibility of various materials, and how others — such as bricks made of compressed tea, or the pieces of reclaimed wood that he is able to salvage from traditional houses and temples — can be reconfigured as elements within a larger work. Here, the seamless joinery of pieces in the *Map* series, begun in 2003, and the assorted off-cuts of wood deftly stacked to achieve *Kippe* 2006, are perfect examples of this extraordinary sensibility.

Maps 2003-5
wood, recovered
from Chinese temples

Kippe 2006
wood, iron

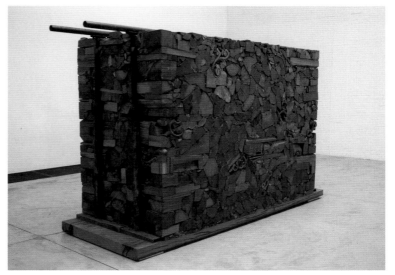

Working Progress (Fountain of Light) 2007

Whilst Ai Weiwei may not exactly be an idealist, he is a tireless champion of cultural and intellectual freedoms that, in today's China, suffer almost less at the hands of the authorities than from the current obsession for accumulating material wealth. *Working Progress* is the intellectual and visual embodiment of the free, creative ideals for which he campaigns.

There can be few more ambitious and culturally weighted works than Tatlin's *Monument to the Third International*, which serves as the model for Ai Weiwei's illuminated fountain, but *Working Progress* was designed very much with Liverpool in mind. For whilst the work can be viewed as an expression of the political or ideological mood of China today, it shares the idealistic aspirations of the young Soviet Tatlin in 1919, and directly references the era of industrialisation across Europe through the twentieth century that was responsible for shaping the present world. In Ai Weiwei's words, "responsible for creating the junk that we're still living with today."

In referencing Tatlin's work, Ai Weiwei reminds us of the Constructivists' Utopian ambitions for a brave new world, embodied in physical structures and amazing feats of architecture that would match the new age, and of which

Working Progress
(Fountain of Light) 2007
working drawings

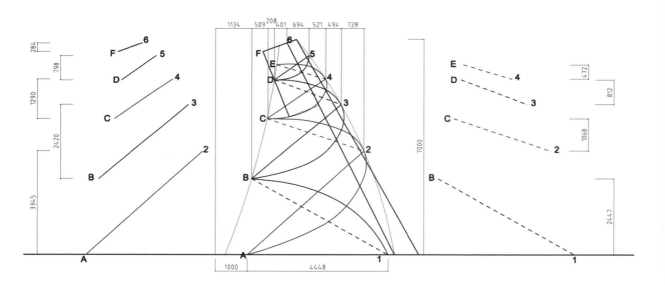

HEIGHT ANALYSIS

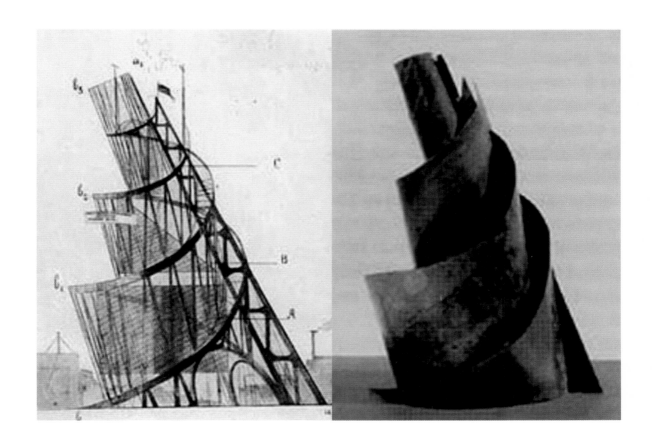

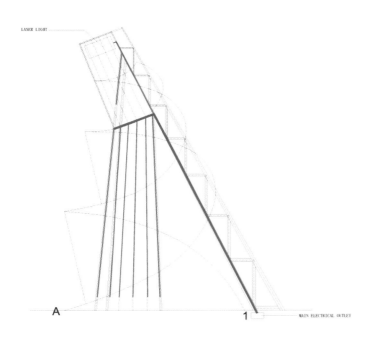

LASER LIGHT

A ⎯⎯⎯ 1 ⬚⎯ MAIN ELECTRICAL OUTLET

ELECTRIC POWER ORIENTATION ELEVATION

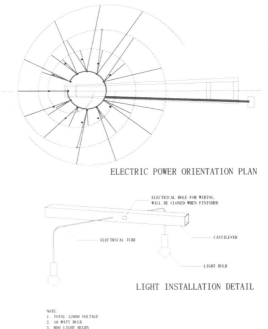

ELECTRIC POWER ORIENTATION PLAN

ELECTRICAL HOLE FOR WIRING,
WILL BE CLOSED WHEN FINISHED

ELECTRICAL TUBE ⎯⎯ CANTILEVER

⎯ LIGHT BULB

LIGHT INSTALLATION DETAIL

NOTE:
1. TOTAL 32000 VOLTAGE
2. 60 WATT BULB
3. 800 LIGHT BULBS

Monument is recognised as perhaps the most iconic. The majority of innovations speak primarily of their own times even as they augur the future, and *Monument* demonstrates the zeal of the Soviet Union's new regime in the honeymoon years immediately following the Bolshevik Revolution in 1917. Steel and iron were the very symbols of this new power and hope: a political ideal further reflected in the dazzling volume of glass that was to clad the external façade of the three main sections. As Ai Weiwei explains, "Glass served to emphasise the degree of clear, enlightened thinking behind Lenin's theories of an ideal social system." Of course, as he adds, "Whenever Man experiences a bout of revolutionary thinking, he always ends up boxing — caging, in this case — himself in." This was indeed the fate of the Marxist-Leninist societal structure that was engulfing Russia even as Tatlin built the first model of his *Monument* in 1920.

The original form of the *Monument* remains far ahead of its age. Although simple in inspiration, combining a cylinder aloft a pyramid atop a cube, the structure was intended to be a taller and more magnificent symbol of modernity than the Eiffel Tower, and would have been twice the height of the Empire State Building had it been realised according to Tatlin's vision. The spiral form, which dominates its external shape, injects a dynamic force of motion, but in 1920 was an almost impossible structure to achieve. That Tatlin himself never attempted to resolve the engineering challenges his work posed is customarily excused by the artist's pardonable lack of architectural knowledge. Perhaps Ai Weiwei would not have been moved to address its structural complexities had he not been involved in on-going discussions with the engineers Ove Arup in China to resolve the challenges raised by the bird's nest structure of the Olympic stadium in Beijing. Interestingly, this has a relatively similar structure to Tatlin's *Monument*, being one core shape about which the secondary steel structure is suspended or, in the case of the bird's nest, from which the internal concrete core is hung.

A primordial form in nature, the spiral upon which the *Monument* pivots is, in terms of architecture, found only in the ruins of primitive cultures, and in assorted pictorial impressions of the Tower of Babel. For Ai Weiwei the symbolism is perfect: "The spiral is a dynamic upward motion that ultimately goes nowhere". No matter how big it was conceived to be, the spiral of the *Monument* always moves in ever smaller concentric circles; a sentiment mirrored in the Chinese proverb that translates 'digging yourself into a hole' as 'burrowing up into a cow's horn'. For Ai Weiwei, then, "…the

Working Progress (Fountain of Light) 2007 plotting effects

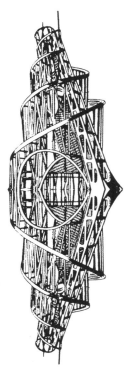

FOUNTAIN OF LIGHT CONCEPT

THE STRUCTURE FORM OF THE FOUNTAIN OF LIGHT IS INSPIRED BY THE MONUMENT TO THE THIRD INTERNATIONAL . THE INSTALLATION CONSIST OF A REVERSED SPIRAL FLOATING CHANDELIER WITH VERICAL PILLARS AND SPIRALS . THE REFLECTION OF THE CHANDELIER IN WATER IS THE POSITIVE. IT IS RELATED TO BOTH THE EARTH AND SKY, SCREWING OUT OF ONE AND INTO THE OTHER. AS SPIRALS ARE ABLE TO EXTEND OUTWARDS AND DOWNWARDS . THE CHANDELIER'S TOTAL LENGTH IS APROX 4 METERS LONG. SEVEN METERS HIGH. THE TOTAL WEIGHT IS APPROXIMATELY THREE_TONS.

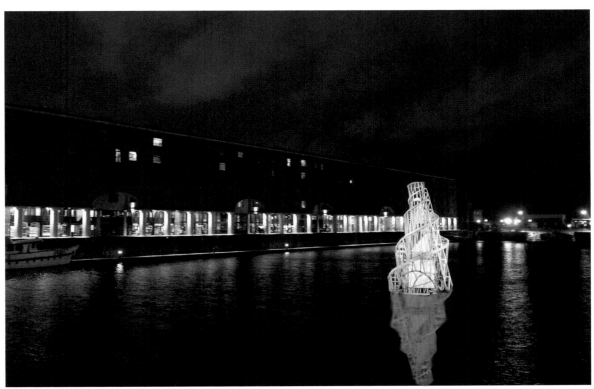

form of *Monument* defeats the very intellectual ideal it was meant to symbolise: ironically, it becomes a metaphor for the way in which power ultimately collapses in upon itself, for the romantic sentiments with which the rational mind is eternally in conflict always prove to be its undoing."

In terms of the broader picture of the industrial revolution, Ai Weiwei describes *Monument's* blend of form and materials, and the pride of its Modernist lines as ideally suited to its location in Liverpool, given the importance of the city's own industrial history. Liverpool's wealth and power derived from its ability to translate ideals of productivity and a manufacturing capacity set in motion by the industrial revolution, into tangible profits. Mao subscribed to just such an ideal, but the nation's manufacturing potential was not to be realised in his lifetime; unwittingly confounded by the ideology he himself imposed upon the nation, which constrained the very human spirit necessary to succeed. It took Deng Xiaoping and a policy of economic reform to unleash the industrial powerhouse that is China today. Here, one might point to another interesting paradox: it is said that in 1920 the Soviet Union neither owned nor could produce enough steel to build Tatlin's *Monument*. In China today, where *Working Progress (Fountain of Light)* was built, using local steel, it is also claimed that today there is not enough steel in the world to permit every home across the nation to own a refrigerator.

China continues to erect monuments to its own advance — the vast array of buildings constructed in honour of the 2008 Olympics in Beijing is the obvious example, but there are many more nationwide. Aside from Herzog & de Meuron's Olympic Stadium, and China Central Television's headquarters designed by Rem Koolhaas, few embody China's own age of modernism to the degree achieved by Ai Weiwei in his architectural projects but equally significantly, in his monumental artworks. Whilst *Working Progress* can be said to represent all these things and more, for the artist it is best described as a model of the human mind, trapped in the confines of a dogmatic political and ideological framework, and that, if set free, would be capable of achieving so much, ironically in the very name of the self-same constraining cultural framework.

Cao Fei [b.1978]

Whose Utopia? What are you doing here? 2006
video installation

In the past few years, Cao Fei has enjoyed an extraordinary following for her video work: a few years that are, in fact, the first of her career. As a twenty-something, who made her debut at the end of the 1990s, she is viewed as a key member of the much-anticipated 'new generation', set to break the mould created by the first generation of the avant-garde, who, as inheritors of Mao's cultural legacy, felt compelled to make art that defied it, and from which it proved hard to move on. Young and funky, Cao Fei is appealingly representative of China's new hybrid society, defined by the converging twin poles of an ever expanding process of industrialisation and a rapacious consumerist culture that is particularly prevalent in the Pearl River Delta (PRD) region (centred on Guangdong province, China's southerly economic powerhouse across the border from Hong Kong), where she was born. It is easy to see how interest in the sociological and political aspects of this area of China — made fashionable by another Guangdong native, curator Hou Hanru — could overshadow more aesthetic issues, and so draw a veil over the rather jejune mien of Cao Fei's early experiments with the moving image. Of course, the fact that Cao Fei is a woman may also have contributed to her rapid and widespread acclaim, given that women artists are a tiny minority in the Chinese art world. But whilst her most popular work *Rabid Dogs* 2000, might amuse at first viewing, the antics of the office dog-bodies are too much of a literal game of charades to have enduring appeal. The work never quite lives up to the well-articulated reasons Cao Fei gives for making it: "We are surely a miserable pack of dogs…", she begins, "locked in the trap of

Rabid Dogs 2004
DV, 8mins

modernisation…We need to bite but we dare not bark. We work tamely, faithfully and patiently like dogs…summoned or dismissed at the bidding of our master…So when will we be daring enough to bite our master, to take off the masks, to strip off the furs and be a real pack of rabid dogs?"

The comment gains particular force when set against the reality of Cao Fei's immediate environment, and in relation to the complexity of China's socio-political climate through the last half of the twentieth-century. Conceptually, *Rabid Dogs* is a biting rebuke of present-day white-collar aspirations — a pretended sophistication that is at once facile and vain. It also alludes to the dehumanising conformity that pervades the world of the modern office, irrespective of geographical boundaries, and is, objectively speaking, barely removed from the socialist machinery of the communist collective, in which everyone is reduced to little more than an obedient cog. Cao Fei is fully aware of the parallels that can be found between the present-day environment and that regulated by the State under Mao (1949-76). In spite of all aspects of social advance in evidence today, individual liberty is one commodity that China does not yet manufacture in significant quantities. Keeping ones head above water in the new economy-centred reality makes it a dog-eat-dog world. Unfortunately, *Rabid Dogs* never quite manages to transcend the memorable coupling of pantomime make-up with Burberry plaids — a subtle homage to Matthew Barney's *Cremaster* tartans, which is a reference for the aesthetic aspirations of Cao Fei's generation.

Cao Fei followed this with *Chain Reaction* 2000, a parody of B movie sci-fi, in which masked doctors and nurses, brandishing hypodermic syringes filled with candy-coloured fluids, are filmed from disturbing angles in nebulous spaces drenched in dramatic lighting. The same macabre aura is brought to the pseudo-sexual absurdity of *Burners* 2003. Both suggest adolescent appropriations of adult fetishes appropriate for a young art school rebel whose ready enthusiasm knows no bounds. Indeed, Cao Fei *was* a recent graduate when she produced these works, but she was also finding quieter moments to contemplate less theatrical visions that proved far more provocative. However, it was primarily works like *Rabid Dogs* and *Chain Reaction* that captured the imagination of the international art world, which begs the question of whether the response would have been the same if Cao Fei hadn't come from China.

But she was from China, and the need to 'explain' China beyond the mono-faceted story told by older generations of artists, who contented themselves with invoking the obvious politicised motifs they had grown up

with, was gathering momentum at the exact moment Cao Fei emerged. The early work suggested an intoxicating strain of new youth culture in China that tallied with interest in the nature of China's new social reality, and a deliciously fresh seam of creativity. It is to Cao Fei's credit that she did not allow her sudden fame to get in the way of her personal development.

COSplayers 2004, raised her game, not because it was immediately more mature, or because its content was more sophisticated. With its focus on the fantasies of a rising generation of video-game addicts, it wasn't intended to be. But therein lay its appeal: the mix of surreal fantasy and a familiar workaday urban reality. The success of *COSplayers* centres on its embodiment of this China-specific youth culture, which also lends it an edgy appeal. Cao Fei demonstrates an astute sense of the inherently naïve nature of this generation, and the posturing to which it is predisposed. On the one hand, she alerts us to the power of imagination that belongs to an age of innocence when anything seems possible, where the child is still young enough to be childish, even though the body seems almost adult, yet lingers in limbo before the child slips away and the gawky adolescent emerges. Yet, at the same time, Cao Fei points to the disturbing vulnerability of the players, who are immersed in a modern, virtual reality for which their parents are entirely unable to prepare them, and against which the same parents are powerless to protect them. Cao Fei invokes the 'cosplayers' to reveal a generation living in a virtual bubble.

COSplayers 2004
DV, 8mins

COSplayers 2004
DV, 8mins

Cao Fei puts it best herself: "In recent years a generation of 'cosplayers',
growing up in and around China's coastal cities, have been confronted by
the traditional values of the Chinese education system and subjected to
the pull of invading foreign cultures. A group of very young adolescents
who refuse to grow up, they are choked with passionate impulses and an
undisguised infatuation with personal fantasies, expressed through ways
and means only they understand and are comfortable with. Their
characters are filled with violence, and a thirst for magical powers. Faced
with the boredom and emptiness that accompany the lives of many of
today's adolescents, they escape inside this sub-culture cocoon to affirm
their own existence...Since they hide their personality behind their virtual
character, their sense of pleasure and heroics is experienced by their
virtual selves, not their natural identity. They are all prepared to shoulder
the burden of a split personality."

She also explains that whilst this addicted-to-the-virtual lifestyle is frowned
upon by society and family alike, these 'cosplayers' have been able to
make a good living in advertising, where they are employed to promote
consumer products, and thereby perpetuating the reality of the fantasy.

As a backdrop to Cao Fei's art and the concerns it explores, Guangdong
is central to her thinking, and to the choice of video as her preferred
medium. Although recently relocated to Beijing, her formative years

were spent in this vibrant, thriving region. Guangzhou, the provincial seat, is not an easy place for an artist: culture is not an obvious element of daily life in this city, despite its being home to possibly the most progressive and professional contemporary art museum in China. It is left to small enclaves of like-minded friends to make things happen. Ou Ning, Cao Fei's partner, was the driving force behind a small art house film society that was hugely successful in its day, which in part explains why moving images were a natural choice of expression for Cao Fei. This small, film-oriented community further provided a ready source of actors for her theatre works.

In moving on from her earlier works, Cao Fei has developed a keen grasp of camera angles, of timing and visual rhythm, as well as an eye for pairing disparate but not incongruous characters with their physical environment. Works like *Public Space/Give me a Kiss* 2002, and *Milkman* 2005, explore how eccentric characters synthesise their personalities with a disapproving society in the public arena. The latter, in particular, in which an aspiring singer is forced to settle for being a humble milkman, is compelling because it expresses a familiar, down-to-earth situation that anticipates the interior fantasy life that is at the centre of Cao Fei's *Whose Utopia?* which is her featured work in *The Real Thing*. The direct nature of the emotions expressed in these works is an aspect unique to Cao Fei's generation. In terms of the remarkable achievement that *Whose Utopia?* represents, all the human qualities upon which she draws extend beyond any national boundary, as does the gentle layer of humour that floats just beneath the surface of her work.

Milkman 2005
DV, 20mins

Whose Utopia? What are you doing here? 2006

Whose Utopia? What are you doing here? was produced as part of the Siemen's Arts Program, 'What are they doing here?', in which the company invited Chinese artists to make work as part of a residency within various sectors of its manufacturing plants across China. Cao Fei chose the Osram lighting factory located in Foshan, near her home in the south, where she filmed the work between October 2005 and April 2006.

Cao Fei explains the reasons for her choice: "In terms of the economic development of the Pearl River Delta, factories like Osram are creating a new arena and playing a role in the reform process and China's integration within the global system. Simultaneously, the force of the global market is making itself felt in China through these types of joint-ventures. As a result, the local economy is acquiring a role in the international scene on the backs of products created by a young labour force from the inland provinces, which in turn makes the location an equitable choice for manufacturers..."

Whose Utopia? 2006
video installation

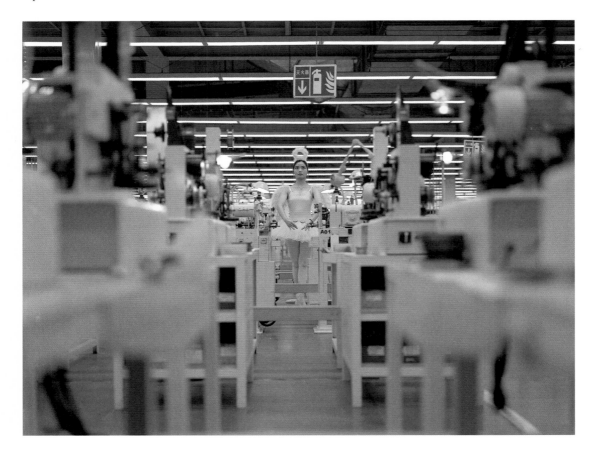

Whose Utopia? 2006
video installation

It is quickly apparent in *Whose Utopia?* how intimately Cao Fei knows this world of industry in the PRD, from the nature of the society it engenders to the impact it has upon the workers themselves, who are today by far the greatest proportion of its demographic make-up. *Whose Utopia?* paints a poignant and insightful portrait of the individuals who make up this rapidly expanding sector of contemporary Chinese society. From the young, wide-eyed country girls, and a generation of young men who were born to be farmhands, but who are today being replaced by modern mechanisation, to those who are slightly older, and who, once employed by the state, and having been made redundant, are now on their second or third careers. The work is at once an indictment of the socialist dream, and a conflicted tribute to those employees who, by dint of being employed, might just see a better tomorrow, and the future they dream of become reality. While other nations rail against China's ever-increasing manufacturing prowess, protesting against jobs that will be lost and income that will be diverted, the reality of the factory workers' existence gets ignored. It is worth remembering that they represent the very same class of workers that Mao set at the top of the social ladder in his attempts to impose his own version of a Marxist state. Cao Fei's response goes to the heart and soul

of the system, flawed and inefficient in Mao's time and yet, ironically today, this workforce is truly the engine Mao envisaged. It drives an economic reality, of which everyone wants to be a part. But even as the new social realities profoundly change lives, Cao Fei reminds us that people might sell their skills and labour, but ultimately not their souls.

Again, the concerns and emotions portrayed in *Whose Utopia?* do not belong to China alone, for they match the experience of factory workers everywhere where the individual is required to perform one task in a chain of actions along a production line, repeated shift after shift ad infinitum. *Whose Utopia?* begins by following the entire length of the various production lines that produce the Osram range, through a multitude of processes that assemble the numerous components of every individual light bulb. We see how molten glass is blown, pulled, and flooded with neon coatings, how the electrical elements are fitted with surgical precision, and the tungsten and daylight bulbs, and lengths of neon tubes are tested in a mesmerising carnival of light, all engineered to afford their end-users optimal choice. Cao Fei then takes us into the private fantasy world of the individual workers, whom we see dance through the warehouse,

Whose Utopia? 2006
video installation

pirouetting along conveyer belts, like the ballerina one dreams of becoming, or shadowboxing in the packing plant like the martial arts expert another once wished to become, or another who strums a guitar to the rhythm of light industry in the manner of a true would-be rock star.

The finale builds around a succession of long motionless frames held on the faces of these workers, who we now see anew for having shared their personal aspirations and dreams. These faces stare at the camera with extraordinary directness, an unflinching gaze that connects them to the external world, issued almost as a challenge to the viewer to defy to see them as the people they are, or assume that their dreams are any less real than the world they inhabit. The film ends with Mao's famous assertion that the future he promised was not simply a dream, an ironic, humorous, bitter, yet poignant comment upon the life of the worker as an individual in the China of today.

Whose Utopia? 2006
video installation

Geng Jianyi [b.1962]

An Unapologetic Act of Sabotage 2007
video installation

Geng Jianyi remains one of the most interesting conceptual artists at work in China today. He's been at it a long time, having emerged in the 1980s, when, as a final year student of the oil painting department at Zhejiang Academy in Hangzhou, his work set a small revolution in motion. The sombre content of his oil paintings were one of the sparks that set the New Art movement alight in 1985-6. They would also precipitate an entire school of followers, and forge a style of painting that remains popular even today. Geng Jianyi, however, has never stood still, and constantly seeks new challenges. He also operates with complete disregard for the recent commercialisation that has consumed the Chinese art world with tidal force. For Geng Jianyi, the market is irrelevant to his practice, and more irritatingly, a mental distraction.

Geng Jianyi is all about art: a purist through and through. He is the first to acknowledge a sense of uncertainty as to what qualifies as art or not, but one senses that, for him at least, that is the challenge, and what his explorations aim to determine. For this reason, he has never stuck to a particular approach, or formed an allegiance to a specific medium. He sees his role as being to challenge perceptions, of the social environment as much as of art. He has a particular fascination with the nature of individual consciousness: a person's cognitive awareness of the social reality in which they exist, which lies outside of the value judgements framed by the socio-political system, which everyone absorbs passively. Geng Jianyi's interest focuses on an individual's active capacity for observation. To highlight the debilitating nature of indoctrinatory systemic structures (especially prevalent in those environments devoid of democratic freedoms), Geng Jianyi has made much of bureaucratic red tape, the documents and forms of processes and procedures so familiar to Chinese society. In his work, this play on the familiarity with such tangible objects of social reality that are not usually associated with art, is always satirical in nature; not as obviously cynical as the vision offered by Cynical Realist painters, but without doubt the blackest form of humour visible in contemporary Chinese art.

Geng Jianyi would not deny this element of darkly humorous intent, but reiterate that his inspiration arises from a sombre reality, and that it is, in fact, identity that concerns him most. Through the 1980s and 1990s in China, the issue of identity was the most serious subject confronting artists. It is a theme he has systematically analysed now for almost two decades, employing a multitude of forms as conduits for doing so. These

Untitled (Portrait) 1995
oil on canvas

range from the deconstruction of physiognomies through painting, or in collages of paper cut-outs, to large format photographic portraits designed to confuse the eye, and further explored in photographic drawings created directly in the darkroom, in which he feels his way around features that he cannot actually see. His various experiments with the layering of faces to create a 'portrait', subject physiognomy to a psychological probing of

Untitled 2001
b/w photograph with
drawing

personality, manipulating external façades like the projected image of Mao — a symbol that stands for an actual person in the way that the reduction in a Warhol portrait signifies a persona — to understand how features acquire visual associations that the mind recognises before any active reading is required by the eye.

From static to moving images, Geng Jianyi deploys the human form as an anatomical armature, as a puppet he directs as the parameters of each psychological study dictate. In approaching the same question from every conceivable angle, he questions if identity exists if an individual has no conscious awareness of it. Do job titles, words describing relations in the family structure, or one's place within the social framework, ever equate to identity? Are we what we do? Can we own the 'condition of being oneself' without having a real 'sense of self'? Is it enough to be recognised by a 'set of behavioural or personal characteristics which distinguish the personality of an individual'? (*American Heritage Dictionary*, 2000 edition.) This subtext is primarily motivated by the blurred, shifting, and indeterminable nature of identities within a Chinese socio-political context that, in Geng Jianyi's experience — having been born in the early 1960s — habitually imposes absolute definitions upon everything and everyone. Coming to contemporary art,

How to...put on a jacket 1992
paper collage on board

The Second State (detail) 1987
oil on canvas, four-panel work
Sigg Collection, Switzerland

with all the attendant aspirations for individual innovation, in its earliest incarnation in the 1980s, his generation has firsthand experience of the complexities of overcoming a profound absence of self-awareness and perception; Communism relieved individuals of all such burdens.

A further element that has played a role in shaping Geng Jianyi's aesthetic was his intuitive, reactive response to the tenets of art extolled by the State, which subjugated all expression to the socialist cause. This meant that Art was understood to present the ideal vision of social reality, but that ultimately the reality it depicted was defined by a political ideology to which all forms of expression, and subject matter had to conform. As a response, in all his work, Geng Jianyi deliberately subverts the idea that art can faithfully imitate or encapsulate something as subjective as reality: a direct challenge to those who would pretend otherwise.

An Unapologetic Act of Sabotage 2007

Geng Jianyi likes to tell simple stories to illustrate the nature of the issues he explores, which serve as particularly useful aids in helping people from his own cultural background to engage with his works. In the context of describing the work he created for *The Real Thing*, the stories shed light on the philosophical nuances of ingrained Chinese attitudes such that point to the inspiration for the work he chose to produce, as well as the nature of the thought process that shape Geng Jianyi's particular approach.

'A grandfather possesses a magnificent beard of which he is extremely proud. One day, his grandson asks him, "Grandpa, when you sleep, do you put your beard inside the quilt or outside." Such a question had never occurred to the grandfather, but that night, when he retired to bed, the question perplexed him so much that he was unable to sleep. The next night was the same. Inside did not feel right, but outside was equally uncomfortable: the natural process of sleep was entirely disrupted by questioning something that he had had no previous need to consider. The issue was decided with the removal of the beard, which resolved the problem, allowing the grandfather to sleep soundly once again.'

This matter of consciousness is explored in *An Unapologetic Act of Sabotage*, as Geng Jianyi puts a similar question to a couple of unsuspecting bystanders. In a pilot programme, produced in the spring of 2006, the artist filmed a road sweeper at work in a street in Hangzhou. Geng Jianyi then approached him, and having assured the man of no mal intent, invited him into a studio at the China National Academy where Geng Jianyi teaches. Here, he showed the road sweeper the video recording of himself in action. Geng Jianyi asked if the man could repeat his actions, acting them out 'exactly as he had done in the street'. As the road sweeper contemplated his own image, the conscious mind attuned to the motion of the self in the most unexpected of ways, his earnest attempt to be natural demonstrates a marked degree of discomfort in common with the grandfather's attempts to sleep naturally with his beard.

An Unapologetic Act of Sabotage returns to this subject. Initially, the concept pivoted on a simple comparison as established with the road sweeper. But, as he thought about developing the idea, Geng Jianyi began to feel it might be too simple. He considered informing a chosen 'actor' of the concept before filming began, but realised that this would erase the element of

innocence that underscored the success of his first attempt with the road sweeper. His first thought had been to place surveillance cameras in multiple locations within a participant's home, so they could have no idea of exactly which period of their daily activities Geng Jianyi might select as the focus of the work. He would then write the actions in the form of a script. The actor would then have to act out the scene according to the script, and not from studying the filmed sequence of their actions as he had done previously.

Geng Jianyi soon realised, however, that if he wished to place cameras in a person's private space, he would have to leave them there for a long time in order for that person to became completely used to them. This forced him to reconsider the idea of working in an anonymous public space. The location he finally settled upon was a foot massage parlour, which by the nature of the activities it housed, lent itself to a rich range of cinematic possibilities, both in terms of scripting the scenes, and of the largely predictable interaction that would take place between his 'leading actors'. The clockwork regularity of the workers' routine at the parlour naturally suggested a masseur for one of these roles — each day as they arrive, they are required to sign in before changing into their uniform, taking breakfast, heating the water and replenishing the preparations they need in the course of their work. Then they wait until clients start to arrive, at which point they go through the motions of their soothing massage programme, in which even the sequence of actions is performed to a fixed choreographed format. The second role was logically claimed by one of these clients: where people go for a foot massages in order to relax, Geng Jianyi decided they would be completely at ease, and oblivious to the cameras he had set up in the intimate confines of a private room. And as people are usually in the habit of going to a foot massage parlour with a friend, the final works focuses on four people, two clients and two masseurs.

A total of seven CCTV cameras were set up at various points in the parlour. This allowed for a switch between locations that helps build a sense of narrative in the final work. Having recorded adequate footage, Geng Jianyi used the chosen sequences as the basis for a script, which he then presented to each of the four individuals, instructing them to learn their part for the re-enactment that would then be staged. And, as Geng Jianyi hoped, as exact in the measure of manner and expression seen in the original footage as was humanly possible.

An Unapologetic Act of Sabotage 2007
video installation

An Unapologetic Act of Sabotage is presented in two parts, as a 'before' and an 'after', each section comprising the range of different camera angles to represent the four characters. These two groups of images are divided in the middle by a separate screen across which the script rolls like an auto-prompt. For Geng Jianyi, the coercion of four individuals to participate in this type of project, and the fact that their performances occur simultaneously, is both more interesting and more challenging than his initial approach. The participants are not only made aware of themselves in front of themselves, but also themselves in front of other people. The quality of acting also exposes a layer of unconscious social attitudes between those serving and those being served. But this is not the only inevitable shift in attitudes emerging in tandem with social change. In *An Unapologetic Act of Sabotage,* we understand the degree to which all people are being forced to see themselves anew.

Gu Dexin [b.1962]

The original lighthouse boat in Albert Dock, Liverpool

It is tempting to leave this space blank — it is what Gu Dexin would prefer — but it would not be of much help for an audience unfamiliar with his work to get an idea of what makes Gu Dexin's art 'real'. Gu Dexin likes to let his work speak for itself, which on the whole it does rather well, being often monumental in scale, and directed at the eye and, above all, the senses. For the public, Gu Dexin's verbal diffidence cloaks the man with an air of mystery, which amuses even Gu Dexin given that he is, in fact, endearingly down to earth. He just doesn't like talking. Although he has particular views on art, most of which revolve around the utter futility of 'the system', of its art schools and institutions, art history and critical theory, it is rare to see him reveal even a hint of the formidable depths of his convictions on the subject in public. He prefers to treat audiences to one of his signature enigmatic grins.

As might be presumed, such views were formed in response to the *ad hoc* definitions of 'art', and the role of the artist, that were formulated by Mao in 1942 (at the famous *Talks on Literature and Art* in Yan'an, Shaanxi province, where Mao outlined the goals of all creative expression and the role of those who produced it, as spreading the word of socialist ideology), and which make Gu Dexin's approach to art all the more intriguing. The work remains unique in China for its use of site-specific space, of natural materials, such as apples, fire, and even pig brains, and for its appeal to senses (works are often drenched in perfume or carry the odour of putrification) other than just the mind or the intellect. It is also unique for being conceived as installations before most artists in China had even heard the word. Gu Dexin brings an immense level of intuition to his work, worked out of an instinctive feel for things rather than being directed by external influences, with the result that the works are idiosyncratic, often disturbing and bizarre, and completely original. Even today Gu Dexin does not visit museums or exhibitions, or look at catalogues or art magazines. Yet, he exerts an extraordinary influence within contemporary art circles in China, which can be attributed to his unorthodox invention, and the element of anarchy he brings to art deployed in the most courteous of manners.

Gu Dexin's initial contact with art was through painting, at the age of fifteen, alone, in a single room in a dormitory complex just twelve metres square. His four elder sisters lived in the room at the time, but worked during the day, permitting him to indulge his interest in art that his cadre parents vehemently opposed, and thus where they couldn't see him do it.

For a brief period, when Gu Dexin married, the cramped room was both home and studio. The couple now lives in a slightly larger apartment but the walls are still hung from corner to corner with layer upon layer of the paintings that Gu Dexin made in his teens. Of greater interest here, though, are the shelves littered with abstract, gruesome forms, or with smooth-skinned, multiple-breasted beings, limbs and lips entwined, each of which appear to grow out of a larger fertility mother, like an inverse stack of Russian dolls, which Gu Dexin sculpts from children's plasticine.

Perhaps Gu Dexin does not like to talk about his work as the words really cannot do the work justice, beyond being obviously visceral, intoxicating as well as offensive, and always compelling. Often the works will undergo some physical change during the course of an exhibition, and the majority of the pieces are site-specific projects relevant to the time and place of the exhibitions in which he participates. Without precise knowledge of the exhibition environment, or the specific location and environs of a work, Gu Dexin is unable — and often unwilling — to conceive a plan for a work. The relationship between location, and the physical nature of the place, as well as the cultural framework in which it is sited, plays an enormous part in his choice of form, content and materials. Here, a site visit to Liverpool allowed him to encounter the red lighthouse boat that inspired the work created for *The Real Thing*.

opposite page
Meat 1996-2001
photographic record of
artist action

this page
2001.12 12 2001
site specific installation
using apples, Shenzhen

2007/03/30 *(Lighthouse Funnel)* 2007

Fascinated with the idea of the flashing lights and bold red surface of the monster steel structure, Gu Dexin chose to recreate the grand funnel of the boat that served as the last working mobile lighthouse in Liverpool. Once the idea took root, there was to be no changing it, even given the tremendous challenges of finding the appropriate workers and materials to achieve the desired exactness of replication. Working from archived engineering plans that came as close to the original blueprint as possible, and from a good deal of creative improvisation, a team of factory workers from a local steel plant— located two hours east of the capital in the northern port city of Tianjin— embarked upon the process of recreating the structure for Gu Dexin's chosen contribution to *The Real Thing*, working to a scale identical to the original in almost every practicable detail. Importantly for the artist, in the final work, which he predictably titled *2007/03/30 (Lighthouse Funnel)*—2007/03/30 being the opening date of the exhibition—the light swings in rhythmic warning circles as the original did in the boat's working life. The only modification that the artist elected to make was to add the element of sound to the final work. Here, from the twelve loudspeakers that have been attached to the lower rim of the glass casing surrounding the light, Gu Dexin blasts a cacophony of sound bites that he selected specifically for the project. Within the confused din of the aural maelstrom the twelve recordings engender, we can still pick out individual sounds that have come to symbolise specific cultures—the various tones of police car sirens being the most obvious example—as well as more mundane noises heard on city streets and in the course of daily life—here, human cries mix with gurgling water, and a variety of loud bangs and clanking.

Each of Gu Dexin's animation works has a distinctly evocative soundtrack: a sound chosen because it helps to underscore the joke around which the cartoon sequences revolve. Gu Dexin began to experiment with animation in 2002, following the acquisition of a computer in 2001, and having mastered the use of Flash software. The first group of twenty animation works that resulted were shown at the Fiftieth Venice Biennale in 2003. Since then he has created many, many more, all following a similar format that is analogous to a cartoon strip. Firstly, the storylines are as to the point as an episode of Andy Capp. Secondly, none are of more than twenty seconds duration: most are, in fact, less than ten seconds long. Every single work in the series alludes, in one form or another, to abiding human fears of failure, rejection, and humiliation, and conveys a sensibility that is in stark contrast to the masculine aura of the installation and site-specific works, although still played out with the same

opposite page
Working sketch for *2007/03/30
(Lighthouse Funnel)*

· **64** ·

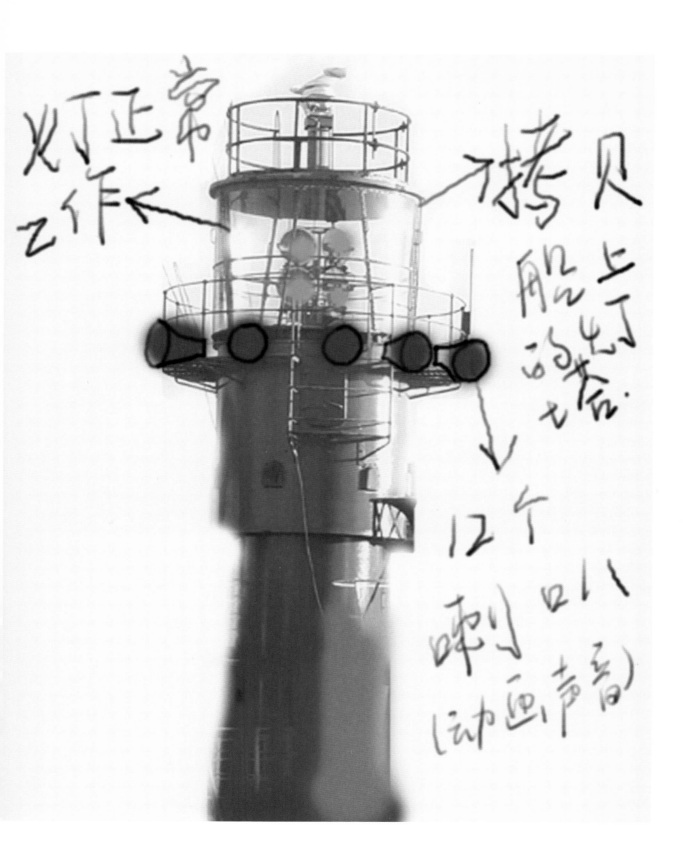

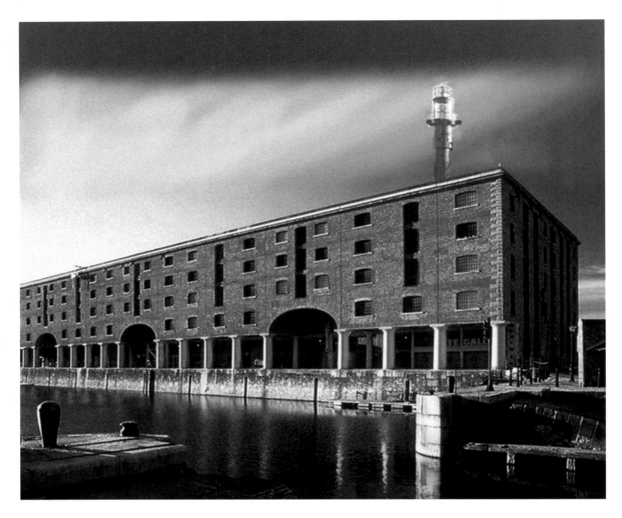

Initial idea for siting the
funnel on the roof of
Tate Liverpool

opposite page
Stills from the original
animations from which
the sounds used for
2007/03/30 were taken

degree of visual violence. Here, it is a violence softened by the medium, and
the average viewer's familiarity with the power of childlike simplistic forms to
convey urgent social messages. Again, this is in contrast to Gu Dexin's
general preferences for his installations which, courtesy of the natural,
'biodegradable' materials Gu Dexin uses to complete these three-dimensional
works, are overtly masculine to the point of being bombastic, hence the
frequently shocking experience for the audience of confronting them. One
must assume that the contradictory emotions that are embodied in these two
divergent seams of Gu Dexin's art are but a perfect expression of the balance
of *yin* and *yang* in his character. Following this logic, for this new work, the
conjoining of humorous, childlike sounds with such a potently virile form as
the lighthouse boat funnel, reveals an equally perfect understanding of how
the juxtaposition of opposites contributes to a consummately powerful whole.

He An [b.1972]

Thirty Minutes 2007
video installation

In terms of the Chinese contemporary art scene He An is a young artist, a fact he is keen to emphasise, as if being 'young' is key to what his art represents: "I am from that generation which was born and grew up after the end of the Cultural Revolution. We are proactive, full of enthusiasm, although we perhaps lack direction. It is my aim to arrive at a manner of expression that can reflect both myself as a young Chinese and the contemporary environment of China."

To date, He An has participated in but a few exhibitions in China, and has not been afforded many opportunities to travel abroad to experience other cultures for himself. He did spend an enlightening three months in Manchester in 2003 as an artist-in-residence at the Chinese Arts Centre, which merely inducted him in British bar culture, the dangers of too much techno, and the hardships faced by struggling would-be local artists, who juggle several jobs or survive on the dole, living from hand to mouth: He An had always assumed it was Chinese artists who had it tough. The experience was instructive, and back in China he put his energies into solving aesthetic problems creatively instead of buying obvious solutions.

"For young artists like myself, British artists Damien Hirst, Mark Quinn, the Chapman Brothers (whose work I particularly admire), and Tracey Emin, helped to open our eyes and ways of thinking about art. Even though most of what we saw of their work was small images in magazines, it was invaluable. For young Chinese people like myself, who have no tangible tradition to identify with or react against, their ideas and approach are hugely influential." Pursuant to this, He An's works reflect the impact of western mainstream culture upon the emergent youth culture in China, and its boundless enthusiasm for contemporary music, fashion, art, and ideas. This voracious appetite for absorbing information, for appropriation, and reinvention is a defining characteristic of China's new youth culture.

He An launched himself on the contemporary art scene in China in 2000 with a series of computer-generated images styled on popular advertising. Appropriating leading campaign slogans from sportswear giants such as Nike and Adidas, he subverted the messages, the slick iconography of style, by replacing the ideal sporting bodies with figures plucked from a grim Chinese reality — beggars, as seen increasingly on the streets of the cities, many of them disfigured or disabled. The image of withered limbs imparts a callous slant to the 'Just Do It!' hype. However, He An was not challenging social prejudice or the exclusory implications of the original

commercial message. His point was more about a fascination with abnormalities, weirdness, and deformity comparable to the exoticism of bearded ladies and Siamese twins which so fascinated the Victorians. It continues to underpin the content he explores as art.

His next project, *Fifteen Reasons for Fashion* 2001-2, related to the role of the Internet in connecting people from all social spheres, and the anonymity that chat rooms, which are enormously popular in China, permits, in the expression of fantasies that would otherwise not be voiced. He An placed a personal ad. on a Chinese site seeking young people willing to be photographed in the guise of whatever fantasy they had about being 'cool'. The result is a startling series of images, mainly of teenage girls, all of whom equated 'cool' with being scarred. The sleazy nature of associations between sexual allure and physical vulnerability invoke the morbid fascination with physical injuries and deformities as projected in David Cronenberg's *Crash*, ironically one of the few western films that is not readily available in China.

The experience of working with ordinary people drawn from the real world was important because it aroused an interest in attitudes, lifestyles, and the problems faced by stereotypical young people, especially those migrating from the provinces to the big cities in search of opportunities — predominantly financial — to make something of themselves. As single children, they carry the burden of supporting parents in their hometowns, whose working lives in most cases have been curtailed by social advance, which is leaving a huge swath of redundancies in its wake. There is always money to be made in the cities, but, as He An discovered, often by less

Fifteen Reasons for Fashion
2001- 2
colour photographs

Just do it 2000
digital colour photographs

than savoury means, and with little safeguards for health or morality. These experiences contributed to the form and content of He An's first sculptural work in 2003: a billboard-sized sentence, cast in fibreglass, which read "I miss you, please call me: 13701059553". This was sited in a sculpture park in Shenzhen, southern China, itself a magnet for immigrants. The work prompted thousands of calls, to what was He An's own mobile number, from runaways scared to call home as well as from parents desperate to find their children. Some were simply lonely souls with no one to talk to, others depressives and victims of broken hearts, whose stories He An recorded until the volume became overwhelming.

In major cities all over China, people are feeling the impact of the flourishing economy, the volume of media information, and adjustments in the socio-political circumstances. Exposure to Hollywood — for better or worse through the pirating of films made widely available by DVD technology — has opened doors to human experiences that were previously closed. Young artists like He An live in awe of a world of which their parents are largely ignorant. "Chinese society today is consumed by its desires for fashion, 'state-of-the-art' anything, riches and fame that we import from the outside. Perhaps this is typical of general trends in the modern world. But everything we see suggests a beautiful cultural environment, but it's one that easily gives rise to illusions..." Whilst some of these illusions centre on the kind of glamorised violence of contemporary films and video games, others are founded in rather more basic elements of daily life: the perennial questions 'What are we here for...What does it all mean?', are never far away. He An might prefer the self-delusion that he is still young, but the image is steadily being eroded by his own creeping maturity. The fact that he has yet to make his fortune from his artworks means he is extremely careful in the choices he makes about how he apportions his limited resources. Nothing gets diluted, which is the most potent aspect of his work. At the 2006 Shanghai Biennale, he made a work that took the form of a rippling string of neon running around the roof of a building, its ripples curving light around fragments of dialogue

from two well-known films, *The English Patient* and *Natural Born Killers* (the latter which, together with *Swordfish* and *Kill Bill*, He An describes as the coolest of films). The text was fragmented because the words were appropriated from abbreviated, locally-translated subtitles. However, these lines — 'An instant of my purity is worth a lifetime of your lies', (originally *Natural Born Killer* Mickey's response to the journalist who asks 'Was it worth it?' The response in the original Tarantino script is, 'Was an instant of purity worth a lifetime lie?', which in the final film became, '…was an instant of my purity worth a lifetime of your lies?') and, 'I Hate Ownership and Being Owned' (Katherine Clifton, the nurse asks the English patient Almasy, "What do you hate most?", to which he replies, "Ownership. Being owned.") — say as much about He An's personal ambitions as those of the society in which he is fast growing up.

Thirty Minutes 2007

He An's father died in July 2006. Even before his passing, He An had conceived the idea for a work. His father's death merely made the urge more compelling, but during the course of producing the piece, the initial idea changed. He An had originally been inspired to probe the seam of desperation and despair that stalks the present, and which his father's demise had forced him to witness. In the end, he elected to produce two parallel works that would reinforce the seriousness of the issue, not just in terms of subjective personal experience, but in the objective observations he was to record in interactions with a generic family residing in his family neighbourhood in Wuhan.

The original impetus behind *Thirty Minutes* was simply the hardships He An's family had faced as long as he could remember, and no matter how hard his parents tried to escape them. Added to this was the pain of dealing with the collapse of his father's physical health. His choice of the Xiao family for the parallel piece is interesting because, in spite of constitutional equality for women in China, the social reality is quite different. China is a strongly patriarchal society, especially in the countryside where the three Xiao women originate. The leading character is Xiao Xiangli, who was abandoned as a baby by a mother who travelled into the city from the countryside, hoping that, where she was unable to take care of her child, a more fortunate urbanite would. By coincidence, the women who found Xiao Xiangli was also orphaned in the city in just this way — a frequent occurance for handicapped children, especially for girls. Here, their adopting mother is sightless. The third family member is Xiao Xiangli's younger sister who was found also abandoned in a public toilet. Both mother and older sister now do what menial work they can to keep the younger girl in school.

In times of trouble, an obvious source of solace to which ordinary people in China turn is the counsel of a fortune-teller. Chinese fortune-tellers are of quite a different breed to the crystal-ball gazing, Tarot card-wielding mystics familiar in Europe. In China, fortune-tellers are seen as consultants to the psyche in the way that *fengshui* masters are authorities on living environments. Some read facial features, some palms, whilst others consult all manner of personal data from birth signs and blood type to relevant phases of the stars. Whether these are more accurate than a crystal ball is impossible to prove, but the position fortune-tellers hold, moreover, the *faith*

people have in their powers of perception in China, is as remarkable as it is widespread. Does this suggest a level of superstition not unreasonable in an agrarian-based society that has never been subject to organised faith? Does it simply provide a measure of spiritual comfort, or is there actually something in it?

Intellectually, He An sits on the fence on the issue. But following his father's death he felt in need of advice, comfort, and emotional release, and almost without thought turned to the fortune-teller. The experience was startling, for the fortune-teller told He An that his father had completed the task assigned to him: which was to bring He An into the world.

Almost as if desirous of testing the fortune-teller's power of insight, He An asks the same man to tell him the fortune of the Xiao girls. He presents a thirty-minute film of the three women in their home environment, going about the tasks of their daily life, as we listen to the voice-over of the fortune-teller, and a *fengshui* master further relates a comprehensive analysis of their fate and fortunes. In both versions of *Thirty Minutes,* He An invokes personal experience as a vehicle for presenting an unbiased, unadorned picture of the impact of social change. "These stories are typical of a new generation of immigrants from the countryside to the cities and the often chance events that leads them to put down roots in one place, and the nature of the means by which they survive. Like my father and mother, these three individual women were brought together by completely incidental circumstances. So by looking at these two typical stories, I believe it is possible to say something about the fundamental essence of this society."

Some people believe they are destined to suffer, that hardship is their lot in life. He An's parents were of equally humble origins, but born into an era, a society, in which workers were accorded the highest esteem — this has recently begun to change, and is exacerbated by the high number of immigrants from the countryside flooding into the cities. He An's mother continues to feel indebted to the Communist Party for rescuing her from poverty and rewarding her with the dignity of work in the new society, in spite of the financial hardships she now endures. That the rewards were ever meagre was irrelevant before the impact of economic reform became palpable. When He An's father became too ill to work, the cost of medical care far outstripped the family's monthly income, all their savings and anything they would have been able to borrow. The story is increasingly common across the country, which is why He An decided to make this the basis for a series of documentary exploration. It is the relevance of this social problem that lends *Thirty Minutes* such a powerful degree of emotional expression.

Li Yongbin [b.1963]

Face 2003
acrylic on canvas
160 x 190cm

Similar to Gu Dexin, who is also a former schoolmate, Li Yongbin belongs to the minority of self-taught artists who have come to play an important role within the contemporary Chinese art world. Just entering his twenties as the avant-garde (more familiarly known as the New Art movement in China) came into being in the mid-1980s, Li Yongbin belongs to the first generation of artistic innovators of the post-Mao era. However, not being an academy graduate, his discoveries of contemporary art practices were made in the company of similar outsiders who were unsympathetically relegated to the periphery of the artworld. These unofficial artists neither drew up manifestoes nor pronounced homegrown theories. Instead, quietly and earnestly, they shared experiences, and tested the ideas, methodologies, and techniques that they arrived at through trial, error, and intuitive individual endeavour. Although his 'outsider' status served to delay the moment at which he began to gain critical recognition, once acquired, the reputation stuck: Li Yongbin remains one of the New Art movement's most conscientious and discreet heroes.

Throughout the 1980s and into the mid-1990s, Li Yongbin concentrated on painting, until he became aware of the possibilities for using video as a medium. Having very limited means, and an equally restricted choice of cameras available through other channels, his first work was made using borrowed equipment. But from this first encounter, video was a medium with which he felt an immediate affinity. Never having had a regular job, Li Yongbin took up residence in the humblest of apartments, where he still lives to a degree of ascetic modesty that borders on destitution. Yet, encouraged by the initial results, he chose to devote himself to a medium that even today in China has yet to demonstrate a consistent earning potential. That aside — for it was the aesthetics of the medium that interested Li Yongbin — the more immediate problem was how to make video works without incurring huge costs: cast, lighting, sound, editing equipment and studio time all required significant funds. Undeterred, Li Yongbin used the minimal resources available to him: his living room became his studio, he filmed himself, and the concepts he brought to his performances were so profoundly minimal that the props and lighting effects available to him in his home were entirely adequate for his purpose.

Though no narcissist, in placing himself before the camera, Li Yongbin was primarily interested in the human face: not in terms of its physical or anatomical structure, but for its capacity for psychological projection. Indifferent to superficial outward indications of mood, Li Yongbin

Face II 1996
video

addressed the abstract qualities of personal experience that contribute to the individuality of a person's appearance. There is a pronounced seam of humanity in the work. From the very beginning of his engagement with video, whilst Li Yongbin explored his own facial nuances and expressions, a significant number of these were achieved in relation to his own family members, which point to the nature of these catholic relationships and the hold they exert through our lifetime. In 1994, Li Yongbin projected the image of his mother's face from the window of his apartment onto a tree outside. The projection begins in the pre-dawn darkness before the rising sun dispels the night. In the dark, the mother stares straight at her son, before the image fades incrementally into the brightness of the day.

His first formal work, *Face I* 1996, used the image of his mother's face again, this time superimposed over the artist's own features, as he sits motionlessly inside his apartment on a stool in front of a bare white wall. The piece is profoundly unsettling, as the blurring of the features of the two faces effects a grotesque third face in which the others seem trapped. Where a work focuses solely on Li Yongbin's face, his approach denies any

discussion of his own persona by directing the viewer's attention towards the fragility of the image being projected. Who it is we are watching is less important than the process of transformation that unfolds. The static focus on the artist's features with which many of the works begin, establishes a sense of stability and familiarity which is then dramatically undone as the tranquillity and cohesion of the features are destroyed in an extraordinary variety of ways. In *Face II* 1996, the camera is trained on a face reflected in the surface of a water-filled vat. The water is constantly displaced so that each time it calms to a point where it is possible to recognise Li Yongbin's features, a further disturbance of the water sends shock waves across the surface, violently twisting and deforming his facial features. Other works use steam vapour as a surface, the distorting effects of plastic subject to heat, and the drama of sudden bolts of lightning.

Lighting is a key element in the works. Li Yongbin dispenses with almost all the classical values of portraiture, with the exception of shadow, in which he exploits the sculptural qualities of light. The creation of a filmatic *sfumato* serves to infuse the works with an ethereal, theatrical depth: the face isolated in pools of light, whilst the body remains cloaked in darkness.

Face I 1995
video

Face IV 1998
video

The second important factor, which is essential to the experience Li Yongbin strives to achieve, is that of time. Each of the works is as long as the length of the videotape used to record it. Editing plays no part in the process — he has turned what was initially a potentially prohibitive expense, into a primary aspect of the experience of watching a work. A piece becomes a record of a performance, for which, in each case, Li Yongbin repeats an action, or remains motionless, until the tape runs out. Only in one work does the motion of the action build towards anything that might be construed as an ending. In *Face IV* 1998, the viewer is presented with an urban panorama, a steady stream of vehicles passing along a major ring road flanked by high-rise buildings. It is clear that the view we see is from one of these buildings, high enough up to frame a broad panorama, with a long perspective disappearing into a far horizon. At first, the quality of the image, which is slightly blurred and indistinct, seems to be rather poor, and only gradually do we become aware of a slightly muffled background sound that appears unrelated to what we are viewing. It is only after having watched an interminable hour of circulating traffic, where the only discernable change is in the intensifying golden light of the setting sun and oncoming darkness, that for a few brief seconds the face of Li Yongbin suddenly appears. Only then do we understand that the scene we have been watching is a reflection in a mirror, the strange sound that of the artist steadily scratching away the silver backing of the mirror to eventually reveal the ghostly apparition of his face through the glass.

As an artwork, *Face IV* is a determinedly brave undertaking, as it tests the patience and endurance of the audience almost beyond stretching point, but the laboured experience of viewing it reflects the artist's own preoccupation with the subjective nature of perception and experience, whilst commenting perhaps upon the nature of his existence in a society running headlong into an unpredictable, idealised future that has little sense of its own psychology and less time to give it thought. In his words: "In terms of art, I strive to visualise abstract ideas in my head, and to use the simplest technical methods to achieve this. The video camera has the advantage of being easy to use. It is this quality that allows me to work with time. This not only permits me to avoid external disruptions, but ensures the continuity of each work, meaning that each work is a continuous part of the same event. The greatest delight I get out of this process is the complete expression of a thought, and the sense of release when it is done. It's a bit like losing weight, shedding excess, scaling things down, and relieving oneself of unnecessary burdens."

Face V 1999-2001

Face V is somewhat different from the other works in the series in that it
takes the form of an installation, minimal as it is. The subject is special,
too, in being directly related to a childhood memory. Without specifying
the exact nature of the experience, Li Yongbin gives us a moment of fear
and uncertainty provoked by the approach of an unfamiliar shadow at the
window of a child's bedroom. Entering the empty space, we become aware
of the sound of a child's rhythmical breathing, as if asleep. The only
feature in the bare room is a window, at which the shadow of some
unknown and unexplained figure outside occasionally makes itself visible.
It shares, with all of Li Yongbin's work, a psychological sense of menace
and dread, articulated with the minimum of means, as powerful as it is
inexplicable.

Face V 1999 - 2001
video installation

Qiu Xiaofei [b.1977]

Art Class (detail) 2006
painting installation, plaster bust

In 2002, Qiu Xiaofei was a star graduate from the Central Academy of Fine Arts in Beijing. His painterly visions of the world bring a defiantly contemporary approach to subject matter from another time and place; that of the artist's own upbringing and formative years spent in the far northern city of Harbin. The paintings are predominantly based on his own memories of the city, of incidents that occurred there, and the people and the objects he delighted in. A typical series from 2002 takes the form of a dozen diminutive compositions, each of which represents a page from a tattered, much-thumbed family photo album. Every detail is retraced and carefully reworked into the tiny composition on canvas to such a degree of accuracy it is hard to tell the original from the representation.

Qiu Xiaofei's playful depiction of these images and objects from his childhood, all so delightfully distressed and weathered to appear as if they are genuinely of the past, has a serious aim. His goal is to give visual form to the invisible passage of time, and to the tangible wear and inevitable loss to which both memories and objects are subject. The works invoke a past that points not only to moments of time lost and recovered through memory, but also to the loss of physical spaces with which such memories are inalienably entwined against the rapacity of urban renewal and rural development that characterises New China. In depicting his past, Qiu Xiaofei recalls a personal experience that is also a record of the history that defines him. What happens to one's sense of self, he muses, when all those tangible elements that should be the stuff of memories have been dissipated? It is as if with every step he takes forward, another portion of his life is erased behind him, annihilating his past in the process. This gives him cause to wonder what will ultimately remain to prove that he ever existed? That is a comfort which, as an artist, he at least can find in his art.

Qiu Xiaofei's painting process and style are not revolutionary, but nor is he a traditional painter. The form, concept, and style he deploys all contravene the classical academic values that were instilled in him during his studies at the academy in Beijing. In China today, against a dominant trend to produce large 'museum-sized' canvases, Qiu Xiaofei's compositions are innovatively different in being small, and often knowingly naïve. As is the habit of many Chinese painters, he paints from photographs and memory rather than life, but, unusually, the works take the form of installations or studied arrangements of various objects and surfaces that he paints and models. Similar to the assembly of painted objects in *Art Class*, a significant portion of his works take the form of

perfect, sculpted facsimiles of familiar objects. These are painted in the manner of the *Photo Album*, to appear exactly as the objects upon which they are modelled. *Art Class* is unusual in deliberately leaving one face of the objects bare, untouched. This effectively demonstrates the skill Qiu Xiaofei brings to making us take an object for the 'original', rather than a contemporary reworking of it. Previous pieces, such as the toy cars, the first-aid box on top of a medicine cabinet, treasured picture and story books, the components of simple children's games, and the entire installation titled *It's 7:00pm!*, present the illusion intact, with nothing but the fact of these objects being situated in an exhibition space to suggest that there's anything special about them at all. It is this very siting that makes us linger, until we uncover the mystery: by which time we, too, are consumed by memories of similar well-worn objects that we also own, because the experiences they conjure reflect who we are too.

Qiu Xiaofei is not prolific, and perhaps because he is young and willing to take risks, his work is not all even in quality. There's an unusual maturity in the way he accepts this, and continues to experiment. In terms of energy and intensity, Qiu Xiaofei is an example of how far China has come in three decades since the Mao era (1949-76) when art was only about rules, and technical skills honed only to serve in the production of rousing, uplifting, and unifying propaganda images. As this type of politically motivated expression recedes into the past, Qiu Xiaofei heads a generation that has both the confidence and the wit to subject their effortless technical prowess to a little reckless freedom.

Art Class is the recreation of the drawings classes that Qiu Xiaofei attended as a student, again derived from memory. He doesn't show us the actual drawings in progress, but focuses on the situation itself, the spray of easels fanning out in a semi-circle around the mottled plaster bust of Aristotle, memorialised by Rembrandt who placed this 'pirate', as Aristotle's bust is affectionately known in China, under the contemplative eye of Homer. *Art Class* becomes the embodiment of aesthetic aspirations in China, and an approach to teaching that has become institutionalised. In this instance, whilst conjuring Qiu Xiaofei's past, it also remains very much part of the present.

Photo Album 2003
oil on canvas
21 pieces, each one 13x15cm,
cover 13.5x18.5cm

Car 2005
oil on modelling clay
19 x 9 x 8cm

opposite page
It's 7:00pm! 2005-6
oil on wood, modelling clay, glass
dimensions variable

Art Class 2006 Qiu Xiaofei

Art Class is a work I have been thinking about producing for a while. That's where it all began, my life with art, in the art classes of my youth. The image of those studio set-ups left a deep impression. So innocent, so naïve, so sombre. It's where I acquired my skills, yes…yet the memory of how it all came about reveals a less serious devotion to art…

In the year that Guns N' Roses became suddenly popular, I spent an entire afternoon in a music shop on Zhengfusi Street, browsing through the wreckage of American music imports — tapes and records bought in by Chinese dealers from music distributors who sold remainders off in bulk by the kilo! I was having so much fun I didn't even think about going home. At 60 *kuai* apiece, I couldn't afford the Guns N' Roses tape. Nor did I have the courage to ask the sales assistant to take it out so I could have a closer look at the sleeve. Either way, even without listening to the music, the band members were already my heroes. What the music actually sounded like was irrelevant.

Next door to the shop was the preparatory school that belongs to the Central Academy of Fine Arts. It was the summer of 1993 and back then, Guns N' Roses were everyone's rock star idols. My drawing skills weren't exactly on form that year, but I wanted to be in that school so badly. To be honest, I had never been interested in sitting in one place for hours on end, sketching a plaster model with the pencil in my hand going 'swish swish swish' all over the paper. Rather, I was captivated by the cool boys with long hair who used to sit at the top of the steps picking at their guitars with small coins. The melodies were irrelevant. The beat alone really affected me. I was mesmerised by the way they tapped out rhythms on their lunchboxes on the way to the cafeteria. Listening to those uninhibited sounds really made me want to be a part of it all.

Perhaps, more to the point, I distinctly remember three pairs of girls walking out of the school gates one day. Their ripped jeans exposed parts of their white legs that made my heart race. It's only looking back on that moment years later that I realise they were perhaps only a little above average in looks, yet in my imagination, I can still recall my fixation with those slithers of skin exposed by their jeans, and the swishing of long, long skeins of hair, as voluminous as the oversized shirts they wore; locks as feminine as the shirts were tomboyish.

Was this not enough? Back then I never worshiped teachers or artists at the school. For me, choosing art was merely a means to become part of that rock n' roll crew. I believed that as soon as I could get inside the school gates, I would be transformed from a country bumpkin in love with rock and roll into a genuine rock n' roll youth, plucking on my own guitar on the steps, surrounded by a crowd of breathless admirers. And who was not to say that our field-trips to the countryside to draw and paint from life would give me reason to ask those girls out on walks in the woods? I was just a romantic, guitar-strumming boy after all…

Art Class 2006
painting installation,
work in progress to give
the new objects their
painterly make-over

I was admitted to those gates. Little by little, all my dreams became reality. The more I drew I could hardly tell if my sketches were getting better or worse. Perhaps the question I should have asked is if they were 'conforming' more or less …Who knows and who cares! Lying in bed with my girlfriend in my dorm smoking a cigarette, and listening to Guns N' Roses was enough to make me forget about the professor standing over my drawing classes. Drawing after drawing, object after object, model after model, the whole infinite process.

It's fifteen years since I first sat poised with a pencil in front of a blank piece of paper pinned to a drawing board. Now every time I see a plaster model I am reminded that this practice was the means by which I could realise my small adolescent dreams.

It's dizzying though, looking back on those years, ten years of my youth that are the best years of a person's life: my golden adolescence spent sitting in front of plaster models of strangers in order to achieve my dream of being a rock star. Is that logical? What the fuck! Maybe I was always going to be more suited to being an 'art star' than a rock star. At least, when I see a drawing board stained with use propped up in front of a worn-out plaster model, and see the slanted gaze of that 'pirate' staring back at me, it goes some small way to explaining the experience that got me here. A whole life formed of memories of fragmented moments like these.

Our lives, the lives we long for, is everything a goal and a method of achieving it?

Art Class 2006
final intallation showing the two
different aspects of the work

Qiu Zhijie [b.1969]

Railway from Lhasa to Kathmandu... 2006-7
multi-media installation and performance work

Qiu Zhijie is the intellectual dynamo of the contemporary art world in China. Engaging in parallel activities simultaneously, displaying all the multi-tasking mental gymnastics of a *wunderkind*, Qiu Zhijie is as much art critic, philosopher, social historian, and curator as visual artist. In all of these areas, he is never far from the frontline in thought, endeavour, intervention, and innovation. It is a cutting edge that has all the physical appeal of a razor-sharp precipice, but Qiu Zhijie doesn't seem to care. Curatorial positions, performances, critical theories, and opinions flouted on web-blogs have yet to reveal any chinks in his armour: even in the face of the outrage his views inevitably court. Qiu Zhijie parries controversy with evident flair, and takes on his critics with cocksure conviction of his position, his politics, and the premises he advances.

Artistically, Qiu Zhijie is also one of a kind. His works belie the paradox between traditional 'Chinese' aesthetics and contemporary values: he is as much at home in the philosophies and practices of classical Chinese culture, specifically the techniques and history of calligraphy, which he writes with consummate skill, as postmodern discourse. He simply mixes and matches as the mood takes him, which is demonstrated to greatest effect in a multimedia work titled *Rewriting the Lanting Xu* 1990-7. This involved the arduous physical act of writing a thousand times an inscription known as the *Lanting Xu* — the preface to *Poems Composed at the Orchid Pavilion*, written by Wang Xizhi in 353, an exemplary work of literature and calligraphic skill subsequently adopted as a model for mastery of the art — across the same stretch of paper until the surface was consumed by a solid black film of ink. The final work comprises the black expanse of paper, a video recording of the process, and a series of photographic stills taken at regular intervals during the process.

Qiu Zhijie's skills and interests collide in a body of work that encompasses canvas painting, calligraphy, video works, installations, performance, and most recently, a seam of sociological investigations into a diverse range of topics associated with the changing cultural climate across China. Evidence of his zealous engagement with socio-cultural phenomena is present in a number of earlier video works. The title of one such example of the approach is *Ping-pong* 1997, which references an actual historic circumstance that has come to be known as 'Ping-pong Diplomacy' — a term coined to describe a new era in Sino-US relations which was launched in 1971, when China invited the US table-tennis team to visit China for a friendly game with the local national team. The phrase 'ping-pong' was seen as an apt metaphor for relations between the two countries leading

this page
Rewriting the Lanting Xu 1990-7
calligraphy on rice paper

opposite page
Ping-pong 1997
documentary video

In July 1987, the US Table Tennis Association proposed to raise funds to build a memorial, in China, to commemorate the function of ping pong in the initialization of friendly Sino-American diplomatic relationships.

up to this moment — engendered by the victory of the New China communist regime over the Nationalists who had a strong following in America. As a direct result of the sporting gesture, Richard Nixon himself decided to travel to China a year later in 1972, a visit that would change history. Qiu Zhijie's video work focuses on the training regime and ambitions of the students studying at a special sports school devoted to the task of producing table-tennis champions. Some of these students are as young as four or five years old, but all dream of being ping-pong champions: i.e., national heroes.

Qiu Zhijie was a pioneer in the field of video art in China, less in terms of his own innovations than in identifying a growing interest in the medium amongst young artists, and giving credence to the artistic potential of video art both in his writing and his curatorial activities. He was the driving force behind the first public exhibition of video art, *Image and Phenomenon,* in China in 1996, in Hangzhou, and another the following year in Beijing, which remain hugely influential exhibitions. There is little that Qiu Zhijie has not attempted in the name of art. Although he rarely lingers in one intellectual space for long, and is constantly travelling, he is latterly less of the 'red guard of the avant-garde', a label ascribed to him in the late 1990s by artists who experienced working with him. Teaching now occupies a large amount of Qiu Zhijie's time — he is an associate professor at China National Academy, Hangzhou — but there is no reduction in the intensity of his output or his passions. If anything, the students enable him to achieve more than was ever in his power as an individual artist working alone. They also deserve credit for the part they played in helping Qiu Zhijie to realise his project for *The Real Thing.*

Railway from Lhasa to Kathmandu... 2006-7

Qiu Zhijie's philosophy is simple: "Artists are only as good as the language they use to express themselves; to express real feelings. Real personal feeling must reflect an historical sensibility, a social experience..."

How he deploys it is rather more complicated: "In June 2006, I took a group of students from Hangzhou on their annual field trip. We went to Luhuo in the far west of Sichuan on the border with Tibet, which is home to a significant number of Tibetan nationals. I had already begun to use these trips for specific topic-based investigations into a wide variety of socio-cultural phenomenon specific to the location. This one was all about unravelling the idea of Shangri-La: its origins, location, and myths, as well as the reasons it became popular when it did in the West in the aftermath of WWI in tandem with the perceived bankruptcy of capitalist ideals."

Qiu Zhijie had visited this region before, but this visit would result in a new relationship, and the idea for the project *Railway from Lhasa to Kathmandu*. The idea is based on the true story of Nain Singh, a 33-year-old Indian man who, in 1863, was given the task of journeying across Tibet, from the Indian side of the Himalayas, to the capital, Lhasa, in order to amass enough data to construct an accurate roadmap of the territory. His employer was Captain T.G. Montgomerie of the Royal British Engineers in India, upon whose directives Nain underwent a two-year training programme, which included learning to walk in a precisely measured fashion, so that every one of his steps was exactly 33 inches. The precision of his stride allowed Nain to calculate the distance covered, which he blasphemously recorded using a string of prayer beads. Orientation and altitude were read using a mercury-filled teacup and a thermometer inserted into his walking stick. Notes describing his route were concealed in the prayer wheel he carried. The data accumulated on this expedition (and subsequent forays) laid the foundation for an increasingly accurate mapping of the Tibetan plateau and the mountainous border regions, of particular importance to potential conquerors of Everest.

Naturally, the impetus at work behind the British survey — which represented one segment of the Great Trigonometric Survey 1802-66 — wasn't that innocent. There were always complicating political motivations for 'visiting' Tibet. Geographical knowledge merely served to fuel the ambitions of so-called adventurers for exploring this eremitic land so

Railway from Lhasa to Kathmandu... 2006-7 documentary photographs

Exchange note and object exchanged as part of metalware amassed for casting the new railway track

removed from the developed world. In turn, stories of its impenetrable nature and preferred state of detachment fostered an aura of mystery and spiritual purity on what little was known of Tibetan culture and society. Over time, exacerbated by the repeatedly rebuffed attempts of foreign expeditions to make headway across the border towards their goal, the capital Lhasa, and against the background of the debates provoked by the rapidly changing socio-political reality engendered by WWI, attitudes shifted. The horrors of war prompted yearnings for a social model of peace and harmonious living and the sanctity of a spiritually cogent society, and Tibet gradually became viewed as the very model of Utopia.

"Thus, the idea of Shangri-La was born. Of course, in the late 19th century, the British were motivated less by seeking enlightenment than in unlocking borders that would assist in the formulation of political, economically-driven policies. What followed in the early 1900s (beginning with the expedition led by Francis Younghusband in 1904) wasn't exactly an invasion, but it certainly changed the course of history for Tibet."

"The second background to the project is the launch of the Qinghai-Tibet Railway on July 1st 2006, which is without doubt an epoch-making event in Tibetan history. It struck me that nothing the British could have done back

Installation plan

then, nor even the imposition of Chinese sovereignty (in 1959), will have as much impact upon Tibet and the traditional way of life as the opening of a railroad connection between Golmud and Lhasa. The railway will be the instrument that will destroy the myths about Tibet, as it will allow everyone to discover its mysteries. The image of monks on motorbikes wielding mobile phones is hard to imagine, but it's part of the new reality. The railway is the modern world's invasion of Tibet. None of us can predict what it ultimately means for the Tibetan way of life. It has already changed so much from the old, traditional ways.

"I was thinking about this situation as we prepared for our trip. As we embarked upon our research, I came across the figure of Nain Singh — the first person really to penetrate Tibet. I have always been fascinated by maps, so it all made sense. I decided that, as a contemporary homage to Nain, I would walk the other way, from Lhasa to Kathmandu, attempting to follow exactly the same protocols he had at his disposal for mapping the journey. I would wear a fetter on my ankles to restrict my strides to the same exact measure of pace so as to record distances covered, and adopt the same techniques for calculating altitude and orientation. This journey, my 'map', and all accompanying documentation, are the core of the work.

"I was also keen to find a way to help the people in the region — there's much poverty there. I had previously met a number of artists in the area. Most put their skills to make paintings that are called *tanka*. Traditionally these depict deities, lamas and bodhisattvas [a Buddhist version of Christian altarpieces, for they focus on stories from the lives of these figures, miracles as well as moralities, as a means of disseminating spiritual values and preserving religious codes]. For Tibetans, art represents a liberating force that can be a catalyst to enlightenment, even the scary visions of hell, gods of war and destruction. Most are produced anonymously — the painters have no concept of critical acclaim, celebrity or financial gain. They must be selfless in order to be open to enlightenment. It occurred to me that this was a perfect format for depicting the incredible story of Nain Singh. The narrative begins with Nain's training in the Himalayas. It then follows Nain on his journey on foot into Tibet, as he records the distance with his prayer beads, as he analyses the position of the sun and the stars against the horizon, and how all these observations are recorded on his prayer wheel."

At the same time, the journey offers an ironic comment upon the fact that the next leg planned for the railway, from Lhasa to Kathmandu, heads back into the very territory the British once sought to protect.

"So I decided to forge the first section of the future rail track, to which end I collected as many metal objects as I could obtain from the local people along the route of the journey. These were melted down and recast as a length of track. I decided to suspend this in the space to remind people that this is the highest railway in the world."

Weather conditions meant that Qiu Zhijie could only complete the first 600km of the 800km journey in 2006. The rest was completed in early 2007, when, despite the harsh conditions, the only real obstacle to his successful descent into Nepal came from the painful chafing of the fetters eating into his ankles as he attempted to keep up with the masterful stride of each pace that Nain had established as the benchmark to be matched.

Sketch for one of the
tanka paintings

Wang Gongxin (b.1960)

Our Sky is Falling! 2007
video installation

The development of new media art in China owes an enormous debt to the pioneering experiments undertaken by Wang Gongxin in the late 1990s. At that time, contemporary art in China was barely a decade old. Video was still an emergent medium which, in the absence of concrete examples of the technical and creative sophistication that were by then standard amongst western practitioners, was approached more in terms of how artists could direct the action, as opposed to manipulating the actual moving images. The interests of Chinese artists lay foremost in performed actions — performance art, effectively — and the atmospheric aura of their staging, which rendered the majority of works little more than variations on a documentary recording. Initially, Wang Gongxin also chose to work with live footage, which he recorded both in the city and in his studio. The difference lay in how he used it as the constituent for constructing conceptual works. Having first made use of video as a component of installation works, such as *The Sky of Brooklyn: Digging a Hole in Beijing* 1995, and *Myth Powder* 1998, he quickly developed an interest in the creative potential of new media technologies, which allowed him to have complete control over the visual elements of the images filmed. This extended beyond the capacity to compose sequences through editing, to a new realm of visual effects, not simply courtesy of a software programme, but which the artist could programme a computer to generate himself.

In the late 1990s, the level of sophistication brought to the works that Wang Gongxin produced was far in advance of the general local under-

Spring Breaks the Ice 1985
oil on canvas
100 x 100cm

standing of the aesthetic applications of video. Installations pieces such as *Baby Talk* 1996, in which close-up images representing family members engaging in baby talk with an unseen infant, were projected on a film of milk in a crib in place of a mattress, and *The Old Bench* 1996, an actual bench in which a section had been replaced by a monitor replaying an exact scale image of the missing square, are good examples of Wang Gongxin's approach. Something of a perfectionist in his execution, the volume of his output has always been measured. From 1997, it became even more so, as he concentrated his energies on familiarising himself with every conceivable aspect of available computer applications related to the virtual moving image.

Baby Talk 1996
video installation

The first work to which the newly mastered techniques were applied was *Face*, completed in early 1999. The format mocked the grand scale and style commonly used for portraits of the leaders through the Mao era in which Wang Gongxin grew up. Here, the model, a friend of the artist, appears at first to be as pedestrian as the nation's patriarchs were made to seem exalted. But then the image, which is projected onto a large rectangular picture plane, its boundaries enclosed by a florid gold frame, begins to undergo a rather disturbing transformation. Using the motion of laughter to activate the features, Wang Gongxin points to the nuances of expression that belie the shapes the features adopt: lips might smile, whilst the eyes sparkle with fury; a drooping of the features might suggest boredom, sadness, rejection, whilst again the eyes may tell yet a different story. We are reminded of the hollow laughter in one of Geng Jianyi's iconic four-panel oil paintings, *The Second State* 1987 (see page 56). There is a further echo of the style of Bill Viola's video works here, similar to that experienced in *The Six Heads* 2000, from *The Passions* series, in terms of the exaggerated expression of emotion, the powerful drama of the sound track, and the use of slow-motion segments throughout the work. It is this sensibility towards staging the real that resurfaces in *Our Sky is Falling!*, the work Wang Gongxin made especially for *The Real Thing*.

Wang Gongxin became familiar with Bill Viola's body of work, and the innovative use of the medium by other artists such as Gary Hill and Tony Oursler, from the period he spent living in New York between 1985 and

1993. Their work would totally change the way he thought about, and approached, art. When Wang Gongxin left Beijing, he was considered an exemplary draughtsman and realist painter in an art world that believed technical proficiency was the only criterion by which art was to be judged. Accustomed to the lavish praise his work commanded, Wang Gongxin arrived in New York confident of his ability. The discovery of an entirely different system of values used to evaluate and judge contemporary art in place in the West, led to a long period of reflection, and a determined effort to assimilate western practices and attitudes that emphasised individual endeavour and innovation. It was a process of trial and error that rewarded him alternately with bouts of self-doubt and confidence, as he attempted to carve out a conceptual path, drawing on a range of previously unimaginable source materials. The works produced through this period demonstrably reflect the incremental victory of clarity over confusion.

Like Ai Weiwei, Wang Gongxin first returned to China in 1993, before settling permanently in 1995. Between 1994 and 1996, the home he and his

Face 1999
video installation

artist wife, Lin Tianmiao, occupied in the centre of Beijing, was integral to his artistic practice. Here, they created an open studio, to which members of the local art community were invited to witness works in progress, and the finished works often invoked this context as an integral element of the ideas and experiences the works sought to describe. It was an effecient means of contextualising the work: "When I returned to Beijing, I found that there was no place to show contemporary work by conceptual artists. In China, where artists had to deal with the expense of materials and funding an exhibition, as well as giving consideration to possible political implications in the work, most artists simply waited for a chance to show their work abroad. Showing in our own home allowed us a great deal of freedom." However, by 1996, Wang Gongxin had begun to show an interest in more filmatic avenues of visual representation related to video.

Following *Face, My Sun*, produced a year later in 2000, evidenced a huge technological leap forward. Projected across three screens, we watch a collective of peasants, spaced at an even distance from one another across fields that expand towards the horizon. The drama is provided by the descent of a huge bright sun, which expands and contracts as it sinks, watched all the while by the peasants in awe as if in the presence of a supernatural force. In the same year, Wang Gongxin made *Karaoke*, probably one of the most painful experiences achieved in contemporary Chinese art to date. It points not only to the aural assault effected by bad karaoke, but the paradoxical uniformity of delivery all individual performances strive to achieve as an exact imitation of their favourite star. *Fly* 2002 was a much more comfortable experience, and more accomplished both conceptually and visually. Here, we are presented with a solitary figure in a non-descript whitened space, with the focus deliberately blurred. The gestures of the man match the rhythm of the sound track, the fly-by buzz of a housefly, which becomes increasingly angry against the fly's relentless persecution of the man. The soft focus sharpens in tandem with the increasingly urgent flailing of limbs and as the camera moves in on the aggravated man, who by the end of the sequence is slapping his own face in his futile attempts to be rid of the aggressor. For Wang Gongxin, *Fly* can be read as a metaphor of the time when so many external forces seemed to exist just to confound artistic expression: "Art has to be related to society. My experience of living in New York allowed me to look at China anew: the problems of modern society, high technology, communication, and commerce." In looking anew, it seems he discovered how much like a cauldron of frustrations contemporary society had become, with so much turmoil bubbling just beneath the surface.

opposite page
Fly 2002
video

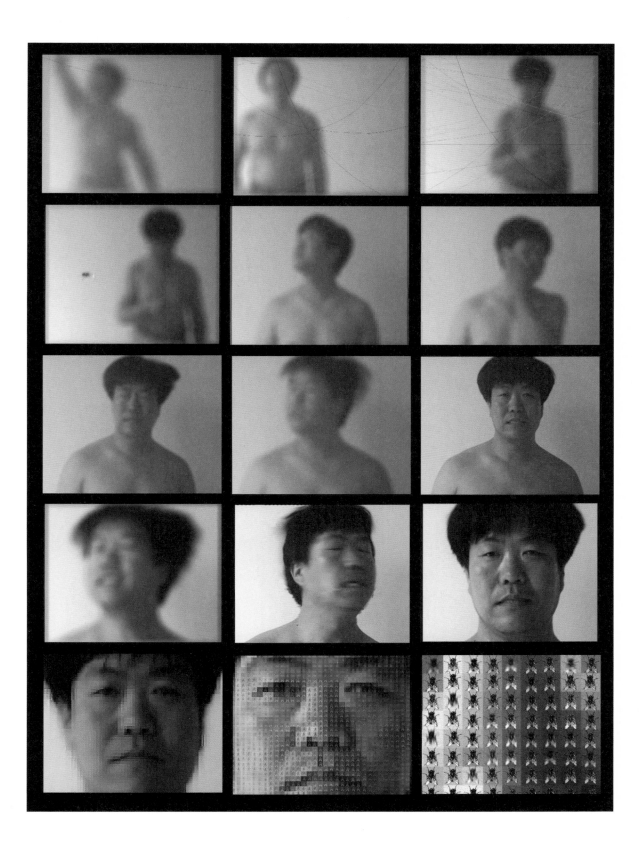

Our Sky is Falling! 2007

Our Sky is Falling! is Wang Gongxin's personal illustration of the fragile façade of this new society, where the frustration and insecurity felt by older generations sits uneasily with the general will to optimism demonstrated by its contemporary youth. This fragility operates as a tension in the work, which makes *Our Sky is Falling!* a very different experience for viewers compared with Wang Gongxin's previous video productions. The main departure here is from the more conceptual style he appeared to prefer, evident in recent examples like *Blind Talker 1, 2, 3* 2005, which were also far from direct in their communication of the ideas behind the images. In terms of content then, *Our Sky is Falling!* shows evidence of a new approach in presenting a distinctly personal take on the infirmity and vulnerability of contemporary existence in China. In the western mind, the link between personal experience and the subjects that artists bring to their expression is a common phenomenon. However, it is uncommon amongst Wang Gongxin's peers in the art world. This generation chose to focus on mental disciplines—rational thinking, philosophical analysis—which were used to smother or minimise a display of emotion, primarily as a means of breaking away from, and disassociating themselves with, the high drama of Socialist Realism. They are, understandably, not given to parading their private emotions in their artworks.

But, ironically, this is now the very generation most touched by insecurity. Whilst being afforded career choices, the reality of really working for a living, of having to perform or risk being dismissed, lends the certainty of the meagre benefits tagged to the lacklustre jobs-for-life held by their parents, an appealing degree of security. That those born to this generation effectively straddle two worlds, old and new, gives them a point of comparison between the past and the present. They see the holes left by the demise of a unifying ideology and community spirit that wealth, consumerism, and material comfort might plug but cannot fill: and this is clearly the sentiments that Wang Gongxin invokes in *Our Sky is Falling!*.

In terms of structure, or narrative, *Our Sky is Falling!* delivers its message through a simple scenario staged within what we assume to be a dining room in a private family home. From our vantage point, we see a man presumed to be a father sitting at a table reading a newspaper, next to his son, who is absorbed in his homework. This peaceful, everyday scene is unexpectedly disrupted as the man's newspaper and the boy's schoolbooks are sucked into the air by an apparent gust of wind. Father and son stand up

Our Sky is Falling! 2007
video installation

in alarm. Their sudden movement draws other family members to their side. The gust settles, but the air is not completely still, for the faintest trickle of dust now falls from the ceiling above them. In the light, the particles are transformed into glittering reflective specs, which act as a momentary distraction, until the trickle from the ceiling becomes a torrent, and the entire interior is obscured by falling debris. The final image shows the same family stranded in the vast open landscape without any form of protection or shelter.

The work touches on many different aspects of contemporary China, a number of which are obvious, and which are also echoed in the works of other artists included in *The Real Thing*, but from rather different angles. Whilst the characters in He An's *Thirty Minutes* attribute their fate to destiny, and Zhuang Hui's *Factory Floor* points the blame at careless action and the lack of provision for such eventualities, *Our Sky is Falling!* makes a more ominous inference concerning the continued helplessness of the individual against the forces of progress, modernisation, and local authorities, in whose economic and social agendas individuals have no say. If one's home is one's castle, then *Our Sky is Falling!* shows the ability of the external world to strike right at the heart of human sanctuary. It would suggest that at this point in the process, nothing is sacred, nor refuge exempt, for not even the haven of home is assured.

Wang Peng [b.1964]

Passing Through Beijing 2006
performance video

In 1993, in Beijing, Wang Peng made a brave undertaking in the name of art. Bricking up the entrance to the Contemporary Art Gallery, the official exhibition hall of the preparatory school attached to the Central Academy of Fine Arts, and located slap-bang in the centre of the capital, wasn't going to win him any friends. Not only was this a cultural framework known for an authoritarian control of all artistic expression, its leaders demonstrably lacked tolerance or sympathy for even Modernist aesthetics, much less postmodern attitudes. If Wang Peng had laid the bricks himself, the situation might have been easier to resolve, but he employed a couple of professional brickies, which ensured that the entrance was sealed tight, and required equally professional help to dismantle it.

Such an action performed by a contemporary artist in any other part of the world might simply represent yet another outlandish act in a long line of similar expressions. In the context of China, circa 1993, when the views expressed by the authorities in 1989 demonstrated in no uncertain terms its disdain for individualist and confrontational artistic adventures outside the sanctioned territory, the act could only be interpreted as a deliberate confrontation. For Wang Peng, the work was intended to draw attention to the barriers that had already begun to divide contemporary art-making from its potential audience. The approach was simply the most direct means at his disposal. Whilst such a barrier could be said to protect what lay behind it, he was also making a public space off-limits to the very public it was intended to serve. This point was relevant in China at the time, where all exhibition halls and museum spaces functioned solely to propagate the State's ideological agenda. Although technically public spaces, where the art put on public display within their walls was primarily propaganda, the phrase 'public space' does not equate with western notions of public buildings. Thus, in part, it was the spurious nature of the wordage that Wang Peng sort to expose.

Contemporary artists were painfully aware that the type of art actively encouraged by official channels was subject to the same limiting rules as had been dictated by Mao. The Contemporary Art Gallery had been the site of several attempts to showcase new artistic endeavour. Immediately preceding Wang Peng's intervention, two artists of the same generation had attempted a joint presentation of their works: an attempt thwarted by certain political references discerned in one of the artist's work. Wang Peng explains, "It's ironic that their work forced the museum to close, then

Wall 1993
the bricked up entrance
to the Contemporary Art
Gallery in Beijing

mine forced it to open!" The regularity with which exhibitions were closed
during this time was due to the watchful and wary eye that the authorities
had kept on cultural activities since 1989, as a means of containing further
outbreaks of what they considered spiritual pollution.

In the event, Wang Peng's *Wall* attracted little attention beyond the
immediate wrath of the museum's conservators and officials of the
preparatory school where Wang Peng himself was a member of the
teaching faculty. The failure of *Wall* to reach the public decided Wang Peng
on a decisive course of provocative actions designed to encourage the
audience to participate in an art experience. For this reason, he often
elected to hold these events in very public spaces.

Untitled 1984
performance, ink, paper

Wang Peng's interest in conceptual expression began as early as 1984, when he enacted the very first (known) performance work in China. This took place in Beijing, in the same high school mentioned above, in the year before he became a student at the Central Academy. The impetus was an instinctive urge to rebel against the claustrophobic constraints of the cultural framework, and provoked by the pressures of the exams he had recently sat. In the company of close associates — one of whom photographed the event — he is shown cavorting naked in a large studio, covering himself with ink and making a series of body prints. With hindsight, this was a formative experience that played an essential role in allowing Wang Peng to break free from imposed artistic conventions.

In 1994, Wang Peng conceived a group of works for a solo show in Beijing, each of which required some form of active participation. The following year, in seeking a broader audience, he moved his practice beyond the confines of a regular art venue into the public realm, taking up residence in a dilapidated pavilion on the northwest corner of the Forbidden City for a period of three days. In the context of Beijing, this pavilion sits on the boundary between the historic heart of the capital and the commercial and financial centre of the rapidly modernising metropolis. The major conservation work that has since been implemented within the Forbidden City had yet to begin in 1995, but the pavilion, which was in a particularly

Three Days 1995
site-specific performance

serious state of disrepair, had already been ear-marked for renovation.
Before this got underway, in the raw chill of a Beijing March, Wang Peng
set himself up with a small camp bed, a tape recorder and a camera, and
occupied the daylight hours systematically photographing the site from
every conceivable angle. Friends were invited to visit, an invitation also
extended to members of the public, and all conversations were recorded
for use during the second stage of the project, which took place six months
later, when the renovation work was complete. Wang Peng then returned
to the pavilion, inviting people back to view the transformation that had
taken place. All the photographs recording its former state of neglect were
laid out across the floor, whilst the recordings of those earlier
conversations provided a soundtrack to the visual experience. This
prompted a lively discussion about the nature of change, and the impact of
the modern world upon the cultural heritage of the past. The pavilion thus
became an unwitting metaphor for heated debate about any number of
opposing forces: old versus new, conservation versus restoration, stability
versus modernisation, change versus constancy.

Wang Peng has never been a prolific artist, preferring a few carefully
chosen actions of major impact to a great quantity of works. Whilst he
does not have a very high profile or position of influence in contemporary
Chinese art circles, his work is relevant to any discussion of the issues that
lie at the core of contemporary art in China, and represents an
extraordinary barometer of the prevailing attitudes.

Passing Through 1997-2006

In the autumn of 1996, Wang Peng travelled to America to take up an artists' residency at the Vermont Studio Centre. As a transitory visitor, temporarily resident for three months in an unfamiliar place, Wang Peng conceived of a performance about the state of 'passing through', about the feeling of detachment from everyday life, simply floating on the surface. A performance work was not destined to attract much attention in the provincial setting of Vermont, with its sparse population spread out across the rural state. At the end of his stay, Wang Peng headed straight for the bright lights of New York where he remained for the next three years. Whilst juggling the task of surviving and trying to take in as much culture as possible, he returned to the idea that inspired the performance in Vermont, which resulted in the first recorded version of *Passing Through* — the sequel to which he produced in Beijing for *The Real Thing*.

From the time he arrived in New York, Wang Peng was a regular visitor to Soho, still the primary district for contemporary art, and was struck by the high public profile contemporary art enjoyed in New York, which stood in stark contrast to the low visibility of contemporary art in China. Significantly, even ordinary people with little interest in or knowledge of art *per se* demonstrated a respectful acceptance of artistic practice, of the right to freedom of expression in whatever form this might take. Wang Peng set out to illustrate this in *Passing Through New York*, by taking a line for a walk in a literal sense. Concealing a ball of fine string in his jacket, one end of which is attached to the railing outside of his apartment, the video shows Wang Peng setting off to walk around the district. As he walks down the streets and across the roads, he is seemingly oblivious to the confusion he leaves in his wake as the string unravels behind him through a hole in the back of his jacket. Passers-by regard Wang Peng and the string with curiosity, surprise, very occasionally with momentary irritation, but no one makes any attempt to interfere with the string, often going out of their way to avoid contact and the possibility of breaking it. Nor does anyone question him as to what he is doing.

The reworking of this idea, almost a decade later, in Beijing, is timely. On the surface, much has changed. Contemporary art has acquired a degree of legitimacy that could not have been imagined in 1993 when Wang Peng built his *Wall*, nor even in 1997 as he made *Passing Through New York*. The extraordinary volume of art activities that constitute the vitality of the

scene today in China is a phenomenon that is only a few years old. *Passing Through Beijing* offers an intriguing parallel with its New York counterpart. Here we see the same kind of evasive actions, curious gazes and expressions of surprise. The straight-talking for which Beijingers are notorious finds expression in people asking aloud: 'What the bloody hell is this then?', and enjoys a bemused response, even eliciting a grin from a neighbourhood sergeant on patrol. Complete strangers are brought together to untangle themselves from the web Wang Peng weaves. To his surprise, Beijing residents reacted in many ways similar to the New Yorkers. Yet, looking beyond the superficial similarities in their responses, the lack of direct interference or confrontation — which surprised Wang Peng most of all — relates to an aspect of Chinese social behaviour that has nothing to do with an understanding of art. Had they been asked, not one of the Beijing passers-by would have conceived of Wang Peng's piece of string as a work of art. Instead, their reaction was entirely in keeping with the boundaries of interpersonal relationships: Wang Peng was here just another stranger. So by placing these two version of *Passing Through* side by side, we understand the subtle nuances that are less about differences between people than the social conditioning to which they are subject. The project also reminds us that appearances can be deceiving.

left
Passing Through New York 1997
performance video

right
Passing Through Beijing 2006
performance video

Gate 2001

Wang Peng moved back to China in 2000. The following year, he made his public debut with a work that pays clever homage to the memory of *Wall*.

Having received an invitation to *Gate: An Exhibition of Wang Peng's Performance and Video Art*, guests duly turned up at the appointed time. No one saw anything out of the ordinary in being asked to wait outside the gallery until the artist was ready to let them in. Few paid any attention to the monitor stationed just outside the entrance to the space, nor to the camera trained on the door. When a sizeable crowd had gathered outside, Wang Peng let everyone into the space. In the time it took for people's eyes to become accustomed to the darkness of the unlit interior, and to realise that the space was empty, Wang Peng had secured the doors with a heavy-duty chain and padlock. As we see in the final video work Wang Peng made to document the action event, he bought the strongest lock he could find, but left the key with the mystified shopkeeper: "What use is a padlock without a key?" the poor man asks as Wang Peng walks towards the door. Wang Peng's invited audience was about to find out.

Once inside, the clearly disgruntled audience began to realise that they had in fact been locked into the gallery. Although many remain convinced that the whole thing was a hoax, as time wore on, the people locked inside the space became increasingly angry. Wang Peng was apparently fully prepared to take the risk of physical reprisals, but in the event, the unwitting participants focused their anger on the door, and finally succeeded in breaking it down, though not without some assistance from a crowd of late comers that had gathered outside and who had been watching, with some amusement, the activities of the trapped audience on the monitor placed just outside the door. As the people burst forth from their confinement, their relief at being free — particularly for those who had succumbed to an urgent need to relieve themselves — turned frowns to smiles, and within a relatively short time, everybody began relating their experience and describing their part in the dramatic escape. No one took issue with the artist, but nor did they congratulate him on providing them with such an experience. Overall, they seemed to view the event as more of a joke than a work of art. Where the audience was composed of high-profile art people — all invited participants were notable artists, curators and critics — *Gate* unmasks the pervasive parochialism of Wang Peng's art world contemporaries, and demonstrates his steadfast resolve to challenge the conventions and boundaries of art.

Gate 2001
site-specific action,
video

Wang Wei [b.1972]

Temporary Space 2003-7
installation
12 b/w photographs (each one 125 x 85cm) presented as lightboxes,
and a 12-minute video of the original performance

Wang Wei's works are like successive experiments carried out in the cause of a sustained investigation into space. Each of his works explores the nature of physical space as it is experienced in human terms, more often than not as a psychological, rather than simply a physical, experience. This is primarily achieved in the installations Wang Wei makes that invite the viewer into a constructed space. But it is also approached through other means, such as those brought to *Temporary Space* 2003-7, the work that is included in *The Real Thing*. Here, the viewer was actively excluded from the work itself in the very act of its construction by a team of lay workers, whom Wang Wei invited to collaborate on the project. The nature of the metaphor and symbolism invoked in the process of building a space that deliberately sought to keep the audience outside, resulted in a work of immense force and impact.

Wang Wei is a relatively young artist, whose debut work was the remarkable *1/30th Second under Water* made in late 1998, and shown as part of the exhibition *Post-Sense Sensibility* held in Beijing in early January 1999. *1/30th Second under Water* comprises a series of colour transparencies set in luminous lightboxes that were inserted sequentially into the raised floor of a specially constructed passageway that was located at the start of the exhibition. Thus, the viewers had no choice but to pass through the narrow confines of this corridor if they wished to see the show. This meant walking

1/30 Second Underwater 2002
lightbox installation

70KG and 3.2 Sq Meters 2000
installation

across the lightboxes, an uncomfortable proposition to begin with, made
more so as each of them contained an image of a figure apparently
trapped in water beneath the glass surface of the lightbox itself. Being on a
one-to-one scale, the illusion of people struggling for air underfoot that
confronted the audience, combined with the restricted space of the

construction, provoked a powerful sense of claustrophobia. It is a good example of how Wang Wei uses art to make the viewer fully aware of his or her relationship to space: those successive experiments that work with varying degrees of 'atmospheric' pressure.

Wang Wei believes the fact that we are so often quite unaware of the impact that the spatial proportions of our surroundings exert upon us, is a direct result of how we experience the violent and unpredictable age in which we live: the protective barriers we seek to erect, the safe distance we feel impelled to maintain. The sense of distance that Wang Wei deliberately creates between the viewer and the figures in *1/30th Second under Water* is an aspect he further plays with in other works, and to great effect. In *72kg and 3.2m^2* 2000, for example, he created the illusion of a figure trapped in a steel case just 3.2m^2, in which the protagonist almost tears himself apart in his desperate attempts to break free — an illusion achieved through a combination of the video, which is shown through 'portals' in the steel case, the disturbing sounds apparently emanating from within, and the strips of pork skin scattered around the base of the case.

Continuing his preference for siting works at the entrance to an exhibition, in 2001 Wang Wei designed *Close Contact* as a mechanism for forcing viewers to weave through a small, glass-walled labyrinth that was barely wide enough to squeeze through sideways, a ploy repeated using a similar format for the Guangzhou Triennial in 2005. This marked the start of a new ambition: to remove any barrier between the viewer and the work, and so deny any sense of security or comfort. Following *Close Contact*, almost every piece Wang Wei has made dissolves the boundaries between the work and the viewer. The viewer is physically forced to enter the work, setting up a confrontation that has to be met and engaged head-on. The artist leaves no room for circumnavigation.

Wang Wei has developed these interventions through a range of dramatic approaches, the most extreme perhaps being *Temporary Space*, which was made in 2003 at a relatively early stage of his career, but which he still continues to develop and extend. *Trap* 2005, is a case in point. A work of astounding ambition, *Trap* literally took the form of an enormous wooden bird trap measuring five metres by six, with a height of 3.5 metres, situated within a gallery and meshed within a web of iron scaffolding that created a second cage-like structure. That the structure of the installation had been expanded to occupy the entire exhibition interior, measuring almost four

hundred square metres,
took the scale far beyond
the normal proportions of
bird to cage or trap, or
just simply reducing the
viewer to the human
equivalent of a bird. Wang
Wei chose to temporarily
constrain the audience in

a cage of aviary-like proportions, which only made the sense of frailty and
helplessness of a captive avian more potent, because at no time did the
'trap' suggest the claustrophobic dimensions of a prison. This was
encouraged by the fact that the wooden 'trap' was up-ended, its trap-door
mouth gaping open at the sky, its function literally subverted. But if this
momentarily suggested that the artist was trying to make a protest
against the nature of hunting, or entrapment, then such a suggestion was
again countered by the cage in which the impotent trap was itself ensnared.

This installation pivoted on each element being trapped inside another.
Although viewers could move as freely around the space as each of the
three hundred birds that Wang Wei released in the work for the duration
for the event, the nature of that motion was dictated by the spatial
constraints of the structure. Every step taken further into the mesh of bars
and scaffolding was potentially treacherous, as visitors were forced to
navigate hurdles at both shin height and eye-level. The birds lodging in the
uppermost reaches of *Trap* might have had fewer obstacles to navigate
but, as many discovered to their peril, the glass of the windowpanes
proved the most illusory trap of all.

Trap was a surprisingly beautiful work, imbued with a palpable air of
pathos. Being physically enmeshed in the complex web of horizontal and
vertical bars forced the visitor to consider how such an enclosure might
be experienced by birds trapped in the confines of a cage: an unnatural
habitat imposed upon a creature that humans see as the very symbol of
freedom. Structurally, the weave of iron against wood, the symmetry of
lines, and the minimalism of the materials used, combined to create a
powerfully honest questioning of how space is experienced, and how
individuals read and respond to constructed environments: why what, for
some people feels like an enclosure or a prison, for others feels more
like a nest whose borders represent security. *Trap* is an important work

amongst those pieces Wang Wei has created to date, but not one that can be easily recreated outside of China, where public concerns for avian rights would not countenance the use of living specimens in an unnatural public arena. *Trap* was recreated in America in early 2006, but without the birds.

Whilst *Trap* is an iconic work, the impulses that inspired Wang Wei to attempt such an ambitious project relate to his involvement with a group of artists who joined forces with the sole purpose of supporting individual practice and experimentation. Against the increasingly commercialised nature of the art world, where market forces are undermining the ambition of artists to be innovators, visionaries, or commentators, this loose-knit group of artists, musicians, writers and filmmakers, based in Beijing, was determined to explore alternative modes. Going under the name of 'Complete Art Experience Concept', the group embarked upon a series of activities that began with an exhibition entitled *Incest*. This comprised works individually produced by the group's members, but which were then subject to manipulation — once a week — by a group member other than their creator. Wang Wei produced a series of monumental replicas of the type of architectural columns associated with Socialist architecture, but using a range of soft textures for the surface of each work. These were not fixed, but hung from the ceiling so that they could, if pushed, swing pendulously around their mooring. Against the natural energy and confidence engendered by the group dynamics, which certainly contributed to the scale and concept of *Trap*, *Temporary Space* is firm evidence of an innate talent and Wang Wei's capacity for conceptualising issues using entirely innovative mechanisms to give them visual form.

Trap 2005
installation
wooden bird trap (6 x 5 x 3m)

Temporary Space 2003-7

Temporary Space is all about structures in motion, which by the early 2000s, was a phenomenon being witnessed the length and breadth of the capital. The idea of injecting movement into usually static architectural elements into artworks was first invoked in an installation, *Hypocritical Room* 2002. In this work, Wang Wei made a rectangular, tent-like structure on castors, which allowed it to be rolled around the exhibition space at will, propelled by four people concealed within the four walls. Each of the external faces of the four walls bore the image of a section of the space, which Wang Wei had previously photographed and digitally reproduced on the canvas wall on a one-to-one scale. The 'room' was thus almost invisible when stationary, and suddenly, alarmingly visible when in motion.

As a concept and artistic process, *Temporary Space* also sought to make the invisible visible, and once again centred upon the construction of a room that confronted viewers with its external façade. Here, too, the action was controlled by those on the inside, who were only visible in the early stages of the work, and also at the end, when they deconstructed the space that Wang Wei had conceived for the exhibition space, this time at the Long March's 25,000 Transmission Centre at the former machine tool factory, now more familiarly known as '798', in the Dashanzi Art District in the north-east of Beijing. It is hard to imagine a more fitting location or environment for the project. 798 is home to many former workers latterly forced to hire themselves out as labourers, as factories within the city boundaries were systematically closed, and has itself become the site of constant redevelopment as the former factory units are refitted to become gallery spaces, design workshops, artists studios, and even privately funded museum complexes. Though just a few years ago, in 2003, when the volume of rebuilding work within the 798 complex had yet to reach recent proportions, it was the growing numbers of migrant workers in the neighbouring district of Wangjing, itself a satellite sector of Beijing that was initiated as recently as the late-1990s, which caught Wang Wei's attention. It is relevant here to mention that after graduating from the Central Academy of Fine Art in Beijing in 1996, Wang Wei was assigned a day job as a photographer for *Beijing Youth Daily*, the second most widely read newspaper in the capital. In this instance, professional and personal interests converged, and having completed his photo assignment, Wang Wei decided to invite a group of workers to eat with him, which provided him with an opportunity to learn more about their lives and the hardships

they endured. In his essay about the project, curator Phil Tinari describes at length the workers' origins, the economic pressures that forced them to travel to Beijing, often on the same donkey cart that then served as their primary asset for earning a living in the capital — albeit confined to the outer fringes of the city — and how the rapid expansion of Beijing, that today embraces six concentric ring roads (where, even as recently as the mid-1990s, to go beyond the half-constructed third ring road felt like entering a no-man's land), provides small opportunities for these workers to subsist on menial labour.

Their work is labour intensive, and physically draining, and restricted to a market that is rapidly diminishing. For a brief period around the turn of the millennium, these workers collected bricks from the huge number of derelict or demolished buildings, which made for a ready supply. They took these bricks to the outskirts of the city, where, in their small make-shift communities, they were cleaned, the mortar that had held them in place painstakingly chipped away, until the bricks could be delivered to a wholesale intermediary ready to be used again. However, the rapid changes in construction techniques and materials used, has greatly reduced the demand for bricks at the same time as the bricks themselves are becoming scarce as the majority of the older buildings have now been demolished. Moved by necessity's devotion to an exhaustive routine demonstrated by these workers, Wang Wei relocated the process to an art space by inviting ten of the labourers to work for him on a project which took the form of a process of construction and demolition over the course of a three-week period. The migrant workers collected 20,000 old bricks, which they delivered to the exhibition space, to construct a space within the space, $100m^2$, and four metres in height. Once completed, and the exhibition finished, the structure was dismantled, and the bricks taken away to be cleaned and re-sold. So a temporary space quite literally, but one that invited viewers in only to restrict their viewing experience to a narrow corridor of space that ran around the perimeter of the construction in progress. The work highlights the plight of the workers, and questions the force of such rampant redevelopment, and how many of the building projects are by their very nature creating divisive zones, effectively laying down exclusory social boundaries that would have as yet unimagined effects upon those 'included' as well as those inadvertently 'excluded'.

Temporary Space 2003-7
installation
b/w photographs of the original performance

Xu Zhen [b.1977]

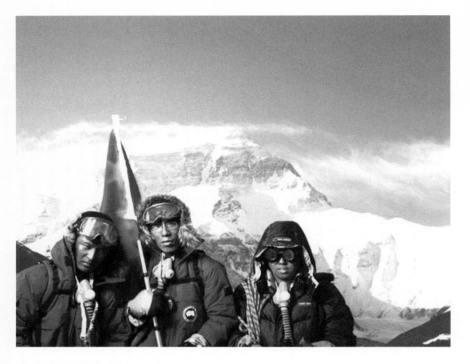

8848 Minus 1.86 2005
video installation

Xu Zhen is the maverick of the Chinese art world. There have been others to occupy such a role before him, but no one does it with quite such effusive panache. And if it seems that the term 'maverick' sounds harsh in its suggestion of Xu Zhen as a radical iconoclast, a quick glance at his brief but notorious career — he graduated a mere decade ago in 1996 — illustrates just how much of a firebrand he can be. No one who knows Xu Zhen is in any doubt that he likes to mix things up a bit: more than a bit, because he's rarely satisfied until he has achieved a degree of anarchy. For this reason, the humour, the vein of socio-anthropological or somatic phenomenon he delights in presenting in his artworks, have a sharp, acid tang: like the barb on a fishhook that catches even the big fish by surprise. This comes as less of a surprise to those who know that his approach to art began back in 1998, when he quite literally flogged a dead cat. That, at least, is his story, claiming that the cat was already dead when he found it, and decided to make it the subject of his extraordinary action work, *Throwing a Cat*. Giving reasons of utter nihilistic boredom for what happened next, Xu Zhen then proceeded to demonstrate that, in his apartment at least, there was more than enough room to swing a cat, as he hurled it around the room and off the walls for 45 minutes, leaving a very nasty mess. For the world outside of his immediate collective in Shanghai, this was the action that signalled his arrival.

Thus, at the tender age of 21, Xu Zhen emerged as one of the handful of founding artists of a small, tight-knit group of contemporary artists based in Shanghai which, due to the force of its economic focus, had always had a problematic relationship with art. The first major collaborative exhibition produced by this new group was called *Art For Sale*, and was held in Shanghai Plaza in 1998. The artists' products on display included jars of pureed human brains, photos of one artist masturbating, and Xu Zhen's video installation *From Inside the Body* which opens with the camera trained on a nondescript pvc sofa jammed tight against a wall. This focus remains static as a young couple enter this stage and sit down, apparently consumed by the search to identify the source of an odour. They first sniff themselves, then each other, before finally stripping each other of their clothing in their hunt for the offending smell. Since then, Xu Zhen has played a leading role in defining the scope, nature, range and ambition of contemporary art, not just within Shanghai, but also across China. He is today viewed as a natural-born leader of the new generation of YBA (Young British Artists) acolytes — many of whom in Beijing would do more than flog a dead cat (the approach never really got off the ground in Shanghai, where Xu Zhen was

born and raised, and continues to live and work). Together with his primary cohorts, Yang Fudong and Yang Zhenzhong, Xu Zhen continues to demonstrate how it is possible to make serious art in Shanghai and not succumb to the overtly consumer-orientated life that is the animating spirit of the city.

Throwing a Cat 1998
performance video

In the past few years, Xu Zhen has become as much instigator as artist, organising a number of exhibitions and directing a series of projects that he doesn't exactly curate, but which he certainly drives, often behind the scenes. One such project, a major event scheduled for June 2006, in a warehouse space on a plot of land in Shanghai due to be redeveloped, was promoted as a cluster of solo exhibitions by thirty artists. This monumental undertaking, a year in the making, was forced to close on its opening night due to the graphic nature of the content of several works. Xu Zhen's piece, *An Animal* 2006, was cited as one of the main reasons for the closure. A three-screen projection, it showed what appears to be a panda keeper masturbating a male panda in order to extract semen to be used

An Animal 2006
three-screen projection

A Problem of Colour 1998
colour photographs

for artificial insemination. As Xu Zhen explains: "Set in a quasi-scientific environment, *An Animal* unambiguously plays with China's proud national symbol, the panda...A recognisable symbol for China, and an agent of diplomacy, the panda has long been a favourite of the public...The work drastically subverts the notion of innocent cuteness by framing the edgy action of a panda, being masturbated, ejaculating, and then sleeping peacefully in a crate, as if resting before being sent off to yet another unknown destination."

The play with reality upon which *An Animal* centres has been a dominant feature of Xu Zhen's works in the last few years. It is evident in the early photo work, *A Problem of Colour* 1998, in which a succession of naked male figures have 'Carrie-like' trickles of blood dripping between their legs, to his manipulation of the hands of the landmark clock on the tower of the former Shanghai Jockey Club, now home to the Shanghai Museum of Art, so that they spun round furiously for the duration of the Shanghai

Roadshow 2000
performance video

Biennale in 2004. Other works include videos like *Roadshow* 2000, where he performs with all the force of an outraged 50 Cent; object-based works that include making elephant-sized tampons for *Female Hygiene* 2001; a monument to swearing, to which he gave the title *We put the monument in the other place* 2004, intended for a mountain top in Iraq; and blood-filled mosquitoes that sit on a gallery wall and pulse rapaciously, entitled *The Last Few Minutes* 2005.

8848 Minus 1.86 2005

8848 Minus 1.86 combines all these elements into a work of astounding ambition and immediate provocation. The explanatory text by Xu Zhen begins with a factual account of the Himalayas of which Mount Everest is the highest peak. It introduces the origin of the Tibetan name — Qomolangma, which means mother of the universe — and the English name, given by Sir Andrew Waugh in honour of Sir George Everest, British surveyor-general of India and the man responsible for the Great Trigonometric Survey of India through the 1800s. It explains how the height of this great mountain was ascertained: In 1856, the British put it at 8,848 metres, and although fluctuations have occurred in the years since, the consistent mean height remains 8,848 — the measure Xu Zhen takes as authoritative, even though the results of a survey published in 1999, following the setting of a GPS unit on the highest bedrock by an American Everest expedition, claim a definitive measurement of 8,850+-2 metres. Xu Zhen's text goes on to state that on May 22nd, 2005, a Chinese team would ascend Everest to measure its height again, promising to publish its findings the following August. Only at the end does it mention that, "the Chinese citizen, Xu Zhen, and his team would climb Mount Everest, and cut off its top: reducing its height by 186cm", which happens to be Xu Zhen's own height. A task which, to the casual viewer, the team carried out successfully.

The work, then, consists of the summit of Everest, the souvenir of the ascent made by Xu Zhen and collaborators, presented in a large glass refrigerator, together with documentary evidence of the expedition. When first exhibited in Shanghai, the installation was greeted with a storm of outrage from several international correspondents based in the city, apoplectic that he had had the arrogance to chop the top off the most famous mountain in the world. Xu Zhen's perceived crime against Nature was incidentally affirmed by an entirely coincidental report on China's national news that Everest was a couple of metres shorter than previous estimates had claimed.

Each one of Xu Zhen's works seems to have the power to exert a significant influence on both contemporary practices in China in general, as well on the specific artists around him. He clearly has no patience for conventional, out-moded ways, which, despite being an attitude shared by many artists, is an approach few allow themselves to act upon in as

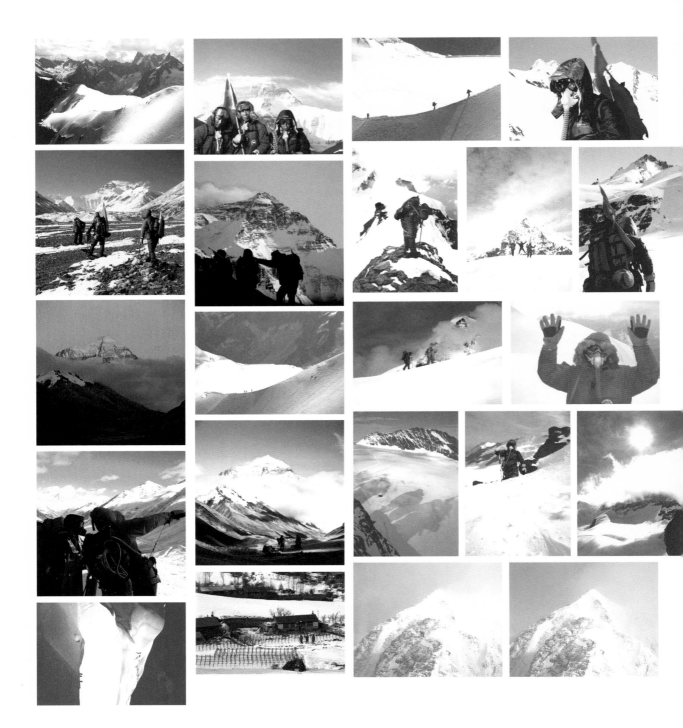

8848 Minus 1.86 2005
video stills and documentary photographs

opposite page
8848 Minus 1.86 2005
the summit of Mount Everest
preserved in its refrigerated
container

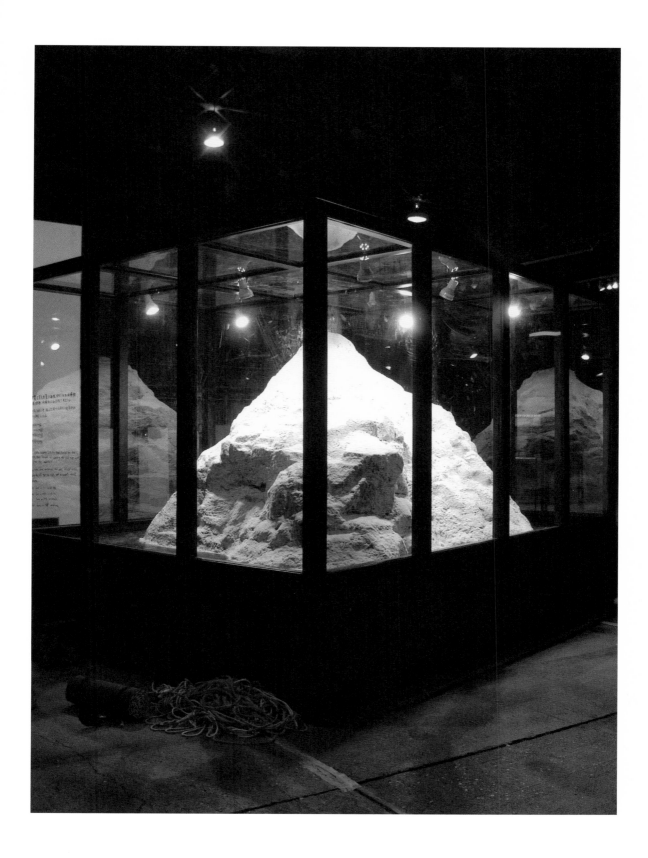

fearless a manner as Xu Zhen. His urgent desire to confront every aspect and value of a society he perceives as banal, hypocritical, or plain conventional, extends to his own approach and practice as an artist: he consistently dares himself to tread where most other artists fearfully exercise a degree of self-censorship. It is precisely this approach that makes Xu Zhen's work so appealing, and goads curators into giving careful consideration to proposals for projects that they know to be entirely unworkable. For *The Real Thing*, Xu Zhen submitted a whole series of proposals, each of which proved too provocative, too dangerous a brand of reality, to be tenable in a truly democratic context, where freedom of expression is free as far as it doesn't encroach upon the freedoms of others.

Fought Bill Gates in USA 2006
digital photographs

opposit page
Venus de Milo, the inspiration
for *Disco Venus* 2007

Following are just a few of his suggestions:

· Arrange for a group of people to burst into the exhibition space, pounce on someone and strip them of their clothing before running away.

· Gather up a comatose drunk from the streets each night; lock them up in the museum whilst still asleep for viewers to watch what happens when they wake up the next day in the strange new environment.

· Give a burglar a number of disposable cameras and have him photograph the interiors of the homes he robs, then display the images in the gallery.

· Create a replica of the *Venus de Milo,* with one important alteration; give her the ability to wiggle her hips like a disco diva.

· Issue each visitor to the exhibition a knife with their ticket: a big one, at least 20-30cm, so they can't conceal it in their bag and make off with it, but are forced to brandish it through the exhibition.

Of course, we could have chosen to display images from the series of photo-shopped images of Xu Zhen and his friends beating up various powerful international figures, *Fought Bill Gates in USA...Fought Koffi Annan in New York....* etc. These photoworks convey the sentiments, but somehow felt like a compromise. Xu Zhen's work is all about the real thing, for which in terms of his art, there is neither a good, nor practicable substitute. But who could resist the *Disco Venus*?

Yang Fudong [b.1971]

East of Que Village 2007
multi-screen film installation

Since his emergence on the contemporary Chinese art scene in the late 1990s, Yang Fudong has become recognised as a talented visionary amongst the younger generation of artists in China, and unique amongst those working in video or film. Even the video works have a sublime, cinematic quality that could be compared in sensibility to the films of Ingmar Bergman or Andrei Tarkovsky, or August Strindberg or Dostoevsky in literature. But despite these comparisons, Yang Fudong's visual references and rhythms remain firmly rooted in his own cultural context, and relate strongly to Chinese cultural sensibilities. This is particularly evident in the poetic, ambiguous and veiled structures around which the films revolve — of the individual shots as much as the sense of narrative. Although it is perhaps to date most readily admired in the film-styled series *Seven Intellectuals in the Bamboo Forest*, the same cultural sensitivity is firmly visible in this work, *East of Que Village* 2007, the film specially commissioned for *The Real Thing*, which sees Yang Fudong return to his birthplace, and which invokes all the sentiments accorded this place in literature and historic drama, as geographical fact and Chinese ethnographic myth.

Yang Fudong graduated from the oil painting department of the China National Academy of Fine Arts (CAN), Hangzhou, in 1994. It is worth mentioning because he comes from Beijing in the north, which inspired the mood Yang Fudong explores in *East of Que Village*. China is a huge country that is, ostensibly, as different from region to region as Europe is from nation to nation. Yet the greatest difference is that to be found between north and south, where the character of each region remains quite distinct, and broad cultural differences can sometimes be hard to cross.

Similar to the impact of Goldsmith's in the 1980s and 1990s, the London art college widely credited as the crucible of BritArt, CAN has been similarly influential in engendering amongst its graduates a certain style. These graduates constitute some of the most important members of the New Art scene in China. Yang Fudong was studying at the high school of the Central Academy in Beijing when a small group of 1989/1990 CAN graduates arrived in Beijing, which was fast becoming the heart of the art centre in China. "Their works impressed me with a feeling quite different from what I was being taught as 'art' at the school. Later, when I arrived at CAN, I felt there were great gaps between what I had been taught in the Central Academy preparatory school and what was taught at CAN. I enjoyed this feeling, and let myself explore the difference." This

exploration of difference began in 1992, his second year at CAN, and took
the form of a three-month vow of silence, during which Yang Fudong
communicated only through messages written on whatever surface
happened at the time to be to hand, including his own body. The teaching
faculty was highly unimpressed by the project — which Yang Fudong titled
Living in Another Space — and interpreting his silence as insolence, tried to
force him to speak. Other locals were caught completely unaware, like the
owner of a convenience store near the campus who assumed Yang Fudong
was mute, only to be utterly shocked when the artist suddenly began to
speak. "I was put on report at college for *Living in Another Space*, but I didn't
care. I was experiencing many emotions at this time and felt it was
important to explore the feelings, to follow an idea, and allow everything to
evolve naturally without preconception."

After graduating, Yang Fudong returned to Beijing. Without a job, he didn't
have much choice in his next move. But even though he would later say
that this period felt like a waste of three years, he did manage to find
private sponsorship to make his first major film work, *Estranged Paradise*
1997. Yang Fudong's interest in photography and film began as a student in
Hangzhou, and continued in Beijing, where, being unemployed, he spent
most of his free time watching films. In 1997, with the equivalent of £2,500 in
his pocket, he set off with his crew and actors back to Hangzhou — "best to
be somewhere I was familiar with" — and spent one month filming the
ethereal *Paradise*. It is the story of a couple, whose themes touch on love,
relationships and loss, and which explores the impotence of life without a
job, and therefore without money or purpose. In a sense, it was a

Estranged Paradise 1997
b/w film, 78 mins

continuation of the artist's wish to 'explore my own feelings' that he had felt so strongly whilst at CAN. *Estranged Paradise* establishes all manner of visual linguistics and approaches that would come to characterise his style. Filmed in moody black and white, the spoken dialogue is minimal, with the emotions and ideas conveyed through atmosphere and stillness. The rhythm is slow and tortured, the atmosphere languid, with a pervading sense of claustrophobia. We feel the waves of despair that overwhelm the male lead as a suffocating cloud — metaphorically embodied in the cloying mists that veil the horizon in every scene of *Paradise*.

The return to Hangzhou was a decisive factor in Yang Fudong's subsequent decision to move to Shanghai: "I was keen to do things in Beijing, but was prevented by the problem of earning money and surviving. When I finally moved to Shanghai, I felt like I'd been wasting time in Beijing. I could do things in Shanghai because I could work, which just didn't seem possible in Beijing."

In Shanghai, Yang Fudong found a job working for a French-owned computer game company for which he helped to create 3D animations: "Working everyday was a chore. The job carried a lot of pressure from working to consistently impossible deadlines. In the beginning, my friends said I wouldn't last long, that I'd go crazy after a few months, but in the end I stayed for over three years." The same feelings that provoked Yang Fudong into *Living in Another Space* as a student in Hangzhou, resurfaced in his decision to live in Shanghai: "It's not my hometown, so life is different as an outsider, easier perhaps. People think differently in different environments. I like the way Shanghai makes me think." As much as in his films as in his life, a sense of distance is one of Yang Fudong's defining characteristics: a space for the artist's own thought and freedom to work as much as the space within the work for the viewer's own freedom of thought. Again, as Yang Fudong himself reveals, one of the fundamental reasons he feels more at home in Shanghai, is that, "People in Beijing live gregariously, but in Shanghai they don't even keep in regular touch by phone. Artists don't hang out unless there's a reason to do so. In Beijing I feel like a stranger, a cold feeling. Yet, alone in Shanghai, I am comfortable, although I still feel rootless. This has been the main influence upon the way my work has developed."

The first video work produced in Shanghai, *City Lights* 2000, offers a vision of the emotional isolation of the urban existence of young people in this metropolis. Choosing colour as more reflective of Shanghai's glamorous façade, Yang Fudong takes a quartet of slick twenty-somethings and drops them in the generic and characterless quarters of a hotel room, where they dance silently to a medley of tunes. Beyond the window, the glittering city lights dance into the distance below them. Although urban, and clearly benefiting from the city life, yet still these young people are totally alienated from their surroundings. This is an idea further echoed in one of the few photographic works Yang Fudong has produced, *The First Intellectual* 2000. Yang Fudong would return to colour as the mood demanded. His work *Flutter Flutter — Jasmine Jasmine* 2002, was one of the most poignant and convincing works to be shown at that year's Shanghai Biennale. Developing the theme of youth and its relationship to Chinese modernity, this two-screen work explores the yearning, burning desires of twenty-somethings in today's Shanghai, a city that seems intent on recapturing the glamour of its heyday in the 1920s, an international outlook, and cosmopolitan affluence. It has everything that should encourage confidence in culture and the self, and here two young lovers talk confidently and frankly of how they met, what attracted one to the other, and what each believes the future holds. But it is that uncertain sense of what the future may hold that imperils the confidence of their faith in the city and each other.

Although Yang Fudong uses colour again in recent works such as *Close to the Sea* 2003, a ten-screen video installation, and short films such as *The Half Hitching Post* and *The Revival of the Snake* (both 2005), it is the black and white *Seven Intellectuals in the Bamboo Forest* series, begun in 2003, that is generally viewed as his exemplary work. *Seven Intellectuals* investigates the structure and nature of modern Chinese identity, in the light of ancient mythology and classical culture, through the prism of individual personal memory and lived experience. Each film in the five-part series presents a voyage into ideas and feelings that are never fully articulated, or in need of rational explanation, and are again centred on the experience of estrangement felt by his own generation. Just as with *Estranged Paradise*, *Seven Intellectuals* is also deeply personal, reflecting

Close to the Sea 2003
DVD installation

Jasmine, Jasmine —
Flutter, Flutter 2002
video installation

Yang Fudong's own mood and state of mind, and is the reason he gives for making it in five parts, so that the work evolves naturally over the period of time required to produce it, reflecting his own personal change and development. Much relies upon the intuition and experience that his actors bring to their roles. All are friends, none are professional actors, but they are clearly familiar with Yang Fudong's vision.

One might surmise that the characters are intended to be perceived as being lost, confused, yet any reading is complicated by the confidence they project and the almost obsessive neatness of their modern, starched attire. The effect of the black and white film is to speak of the image of China projected beyond its borders through film and media throughout the twentieth century, whilst also referencing a range of traditional arts from cultural antiquity. Multiple vignettes invoke the poetics of place: famous national vistas that were early on immortalised in Chinese brush painting, and which remain largely untouched and unmoved by modernity. However, the subtle suggestion here, so gently aligned with the journeys his modern figures make, is of tourism as one of the trappings of modern 'means' that is beginning to invade unspoiled natural landscapes, and leave an indelible imprint on nature and the spirit of the land. The modern, though archaic, nature of their attire, and the accessories they carry, point to figures out of time, lost, and dropped into a world of timeless and classical beauty, emphasised by his use of black and white film, into which they do not fully belong.

As with most of Yang Fudong's film works, *Seven Intellectuals* has the absolute minimum of spoken dialogue, the majority of words conveyed through the use of subtitles that accentuate the poetic mood of the setting and the actions, neither of which ever approach the logical progression of a plot. Music, as always, plays a vital part in the final work, and is specially composed by a local Shanghainese musician once the final edit is done: "My goal is to present the audience with a feeling I have experienced, one that I believe to be interesting, and with which I hope a few like-minded people might identify. I can't please everyone of course…but if I don't follow what interests me, then how can the work be interesting to anyone else?"

East of Que Village 2007

It is one of those strongly-felt experiences that Yang Fudong was able to draw upon in his new work. *East of Que Village*, which draws upon those bitter, cold feelings that he associates with Beijing, and with northern China in general, and which have come to embody for him a sense of isolation and loss. This is important, not just in terms of his own personal experience, but in exploring the sense of isolation that is increasingly present within China's contemporary society as communities are broken up and scattered on the winds of redevelopment, and as economics drive a wedge between the have-everything–imaginables, the have-a-littles, and the have-nots. Loss is found here, too, in the reflection upon those shifting social values. In *East of Que Village* he finds a poignantly emotive means of communicating these concerns, and in orienting the vision through the eyes of 'man's best friend', plays directly to sensibilities and sensitivities that again, know no national borders—certainly not in western nations. Yang Fudong's first working title for this piece focused on the word 'dog', which reflected the leading character he had envisaged to be the conduit for his message. To this end, *East of Que Village* centres on a moment, or series of moments, in the life of an untamed and untethered pack of dogs, surviving at the most basic level of existence, in an arid, desolate, and unforgiving expanse of northern landscape, flat and wide like the desert, the grasslands of Mongolia, or the loess plains of Shaanxi. The chosen location is, in fact, an isolated village in rural Hebei, which, in the depths of winter, is as equally forbidding as any of those mentioned.

This inexorable emotion is further reflected in the attitude of the handful of humans, who appear in the work, also at a distance, engaged in their own dogged struggle to survive. As Yang Fudong explains: "The backwoods existence of the villagers who live in Que Village is bleak and basic. The people have to work hard to scrape a living. Every family also raises dogs, primarily to guard the house and keep intruders at bay. The dogs' survival depends upon these people, yet in the eyes of their so-called owners, a dog is just a dog. There's no room for emotional attachment."

The issue Yang Fudong points us to here is the value of life, and the desires an individual has a right to expect from his or her existence. Against all the excesses of the modern reality unfolding across the urban centres in China, the people's personal ambitions are shifting. As they all succumb to huge expectations of a great future just around the corner,

East of Que Village 2007
Production still taken on
location for the multi-screen
film installation

individuals are quick to forget what it pains them to remember of their
past.. Modern Chinese society is demonstrably keen to put poverty behind
it wherever possible. Yet, in a country with such a huge population, almost
sixty per cent of it still rural, what of life in the Chinese outback? And
where dogs were once a common feature of northern restaurant menus,
the bigger question is surely the value of a life and the opportunities that
Fate puts in our paths, and leaves to our own hands to seize.. In *East of
Que Village* the reality is simple, as Yang Fudong reiterates: "Like their
human masters, the dogs in Que Village fall ill, die, are abandoned, or sold
for cash.. Yet, the dogs will never see that a little way to the east of Que
Village, there is a path to the outside world."

Yangjiang Group [b.1994]

Zheng Guogu [b.1970]

Chen Zaiyan [b.1971]

Sun Qinglin [b.1974]

If I Knew the Danger Ahead, I'd Have Stayed Well Clear 2007
firework project

The explosive nature of the Yangjiang Group's project for *The Real Thing* —
a firework display titled *If I Knew the Danger Ahead, I'd Have Stayed Well
Clear* — is a perfect example of the energy its leader, Zheng Guogu,
channels through his works. Since his artistic debut in 1994, Zheng Guogu
has tackled an extraordinary range of ideas and media that defy simple
categorisation by form or style. The one theme that can be described as
a constant in his work is his reference to the socio-cultural attitudes of
his generation. Equally, his artworks are heavily influenced by the climate
of his local environs in the Pearl River Delta (PRD): a distinctive regional
character that similarly underlies the issues pursued by video artist Cao Fei,
also a native of Guangdong. Zheng Guogu's concerns are in evidence in his
first work, which he titled *Consumption is Dreaming; Consumption is Venting
Frustration* 1994. This title also paraphrases the particular nature of his
formative experience of life in the PRD, China's largest manufacturing base.

Zheng Guogu's next work, conceived and executed in his hometown in
Yangjiang, a small coastal town outside of Guangzhou, was aptly, if
literally, titled *Planting Geese* 1994. Zheng Guogu planted a gaggle of geese
up to their necks in the middle of a field, shortly to release them again, but
not before he had connected the points of their various locations with trails
of white pigment in straight, even paths between one interred bird and the
next. This was followed by a flood of poured Chinese ink — the birds
themselves given a shower of black liquid. It is a curious and
unconventional work, but is relevant to a discussion of Zheng Guogu's
approach to art, due to its collaborative nature — *Planting Geese* is the first
work credited to the Yangjiang Group, which comprises a handful of young
artists also living in the area, and who regularly come together to realise
projects and events, and who also had a hand in the firework project.
Second, it demonstrates Zheng Guogu's unconventional use of ink, an
unorthodox approach to which he returned in 2002, again with the
Yangjiang Group, this time to produce a project titled *Are You Going to Enjoy
Calligraphy, or Measure Blood Pressure?* The use of ink and rice paper here
was startling, more so for the extraordinary use of additional materials
such as wax, which turned the familiar two-dimensional presentation of
calligraphy into a collection of three-dimensional forms. These combined
to create a physical environment into which the viewer could enter.

This was the first example of the Yangjiang Group's innovative use of
materials. But it was the performance project that led to a radical new
approach to photography, for which the Yangjiang Group leader, Zheng

Guogu, is particularly renowned. By the mid-1990s, a number of contemporary artists had begun to experiment with photography. Much of the exploration was related to performance art: a photograph could record and document acts that could not take place in the public realm. Intuitively, Zheng Guogu, together with Chen Zaiyan and Sun Qinlin, turned to photography for much the same reasons, but the means by which he presented the images were instrumental in pushing the medium beyond its status as simply a neutral recorder of fact. The project featured the collaborative performances of the Yangjiang Group, and resulted in a series of photography-based works titled *The Life of Youth in Yangjiang*. The first, *My Bride*, was realised in 1995, soon to be followed by *Honeymoon, Illicit Sexual Relations, Fraternising* and *Fighting with the Police*, which were all completed in 1996. On a superficial level, these works validated the play-acting style of performance art that was in vogue in the capital, yet where the majority of these pieces reflected private fantasies and personal acts, the subjects chosen by the Yangjiang Group spoke of observable social phenomenon, and the mindset of a generation, of a youth culture, that had yet to become visible in the north. With the geographical location of Yangjiang and Guangzhou just across the border from Hong Kong, Guangdong youth was particularly conscious of the unsupervised squandering of cash and time enjoyed by the progeny of the Hong Kong elite.

What makes the final works unusual is the visual format used to present them. It had become Zheng Guogu's habit to underscore a narrative form for the performances by printing the images the size of tiny contact prints,

The Life of the Youth in Yangjiang 1996
colour photograph

Planting Geese 1994
Yangjiang Group activity

which he arranged in rows on a single sheet of paper like a storyboard for a film. Here, we see cruel mockery inflicted by a gaggle of coolly dressed gang members (the Yangjiang artists) upon individuals who clearly don't belong to the clique. As the titles of these individual pieces suggest, the group engages in street fights, taunts innocent girls, and generally creates mayhem. As photographic records of events, none of these activities are intended to deceive the viewer, for they are clearly staged: the girls are not really scared, the fighters cannot be said to exchange real blows, and the hairstyles and outfits of the group members are just too immaculate to be credible. This is more ambiguous in *My Bride* and *Honeymoon*, where we see a doe-eyed Zheng Guogu go through the motions of an ideal wedding in the company of his romantic bride. These were, however, the initial forays with the medium that were, for Zheng Guogu, necessary to the process of breaking the mould.

The practice of using multiple images to complete one work creates a compelling rhythm in the *Youth* series. In the next phase of photographic works, this rhythm is seen to play as important a role in the work as the content. This series is titled *Ten Thousand Customers* — ten thousand being the number of works Zheng Guogu determined to produce — and arose from a desire to create a multiple that was within reach of anyone desirous of owning one, although the market value these accrued is rather more than might be described as affordable to all. Zheng Guogu is only part of the way into his projected production volume necessary for completing this project, but the time factor has allowed the process to evolve in unpremeditated ways. Each one of the ten thousand pieces is intended to be unique. To date this has been achieved by altering the content — this ranges from studio shots of small toys and models that Zheng Guogu collects, to frames taken from films and television programmes, to random images downloaded from the internet — or by altering the colour balance during the printing process. As part of the evolution of the idea, more

recent pieces are grouped together to explore a single topic from a variety of angles. Since the late 1990s, Zheng Guogu's photographs have inspired numerous followers, but perhaps the most important contribution he has made to the advance of contemporary photography in China has been to dispel the air of preciousness in the work that had crept into overly posed images of artists performing solely for the camera, as well as validating the idea of the multiple.

The Yangjiang Group's projects are largely tied to calligraphy, which was the starting point for the structure and form of the firework project. Each of the three Yangjiang Group members follows an independent career, but it is the Group's founding member Zheng Guogu who is most active, and who fires the majority of interventions. The nature of those sparks is illustrated in many of his works, but is most readily seen in a series of compositions with the title *Computer Controlled by a Pig's Brain*. The main idea concerns the manifestation of chaos, as the title suggests, represented by myriad logos and barcodes from the commercial world, which Zheng Guogu randomly applies to the picture plane. The effect, however, is rather more decorative than chaotic, since they are never quite as arbitrary as the image that the reference to the pig's brain or indiscriminate computer activity conjures. The works in this series have used many different materials, from faux fur as the ground instead of canvas, plastic transfers for the logos instead of stencilled markings, and, most recently, machine embroidery programmes to bond the motifs to the canvas, or man-made fabrics of choice.

Zheng Guogu's work entered a new phase with a series of major structural projects. These include the exhibition structure for *Canton Express*, in which

Computer Controlled by a Pig's Brain – Special Edition 2005 oil on fabric

Exhibition structure for
Canton Express 2 2006
Tang Gallery, Beijing

the works of Chinese artists were displayed at the Venice Biennale in 2003, as well as a scale reconstruction of the He Xiangning Museum in Shenzhen in an adjacent public park in 2003. The former pivoted on a steel structure, which was also the approach used to replicate the museum. Here, he used a simple steel frame to map out the spatial volume of the museum, reflecting the original building in the abstract via a dynamic, transparent form. Most recently, he collaborated on the structure of the exhibition display for the second part of *Canton Express* shown at Tang Gallery, Beijing, in 2006, transforming the cavernous gallery interior into an interconnected labyrinth of bare freight containers.

Since 2004, Zheng Guogu has been teaching in another southern Special Economic Zone, Zhuhai. But that is not the reason that he prefers to remain close to home at a time when increasing number of artists are moving to Beijing. In the 1990s, Beijing had yet to be viewed as the capital of China's contemporary art world. A number of cities owned thriving communities that took pride in their distinctive regional character. Today, many of these communities have disintegrated as more and more contemporary artists are drawn to establish themselves as part of the Beijing art scene. Zheng Guogu, who could not be persuaded even to leave what many view as the limited artistic community of Yangjiang for Guangzhou, is staunchly loyal to the surroundings that inform his ideas, to his faith in the important role distance plays in maintaining individual artistic independence, and to the Yangjiang Group. In 2004, he demonstrated the strength of his allegiance to Yangjiang by moving his entire house -hold into Vitamin Creative Space in Guangzhou for a solo show he called *My Home is Your Museum*. Thus far, he has yet to be proved wrong.

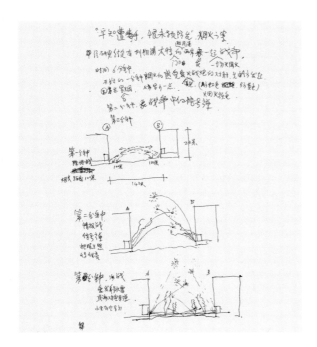

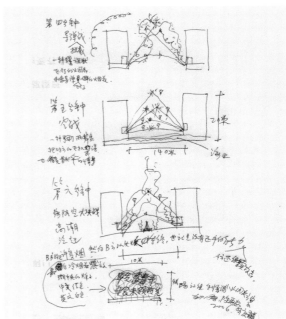

Battle Stations

In the face of confrontation, exposed to a desperate situation, one side of two opposing forces breaks the deadlock and fires the first shot. The war begins as red-tailed firecrackers that burst across the open battlefield, immediately followed by flaks fired in quick succession into enemy territory. The enemy is momentarily confused by the spread of white smoke, but thus suffering the inflicted damage, returns fire, bombarding the opposition with a spray of yellow firecrackers. The two forces respectively exchange fire of white shells.

Intelligence Gathering

The battle momentarily appears to calm down. But then each side of the opposing forces launches a series of illuminating coloured signal flares in an attempt to expose the position of the enemy. At this moment, white and yellow anti-aircraft take to the skies.

War at Sea

Meanwhile, on the open stretch of sea, the two opposing fleets take to the water. One naval vessel gains the advantage, and fires a blanket of blue missiles, which skim the surface of the sea. The enemy warship attempts to demonstrate its superior firepower by shooting purple tailed-missiles over the water. Both fleets persist in intense bombardment, firing volleys of red shells and white bombs. As a result, several clusters of white smoke rise from different locations on the sea, indicating a toll in casualties on both sides.

Sea-to-Air Missile Interceptors

Now, one side launches a volume of red spiral missiles, which the enemy force successfully heads off with blue missiles and, in quick succession, a counter force of destructive yellow rockets. Surprisingly, green enemy missiles appear midair to intercept them. The missiles collide fiercely, sending flaming green and yellow flares into the sky, which slowly rain down into the sea.

Air Raid

Following this round of missile offence and interception, one side now dispatches three aircraft to initiate a surprise air attack. The enemy responds by ordering its air force divisions to head the enemy off, instigating a battle in the sky. Some of the aircraft are shot down, and as they crash, the pilots bail out of the planes. Amidst the smoke that now rises, parachutes float down before dropping into the sea from the sky. Smoke now clouds the sky.

Sea-to-Ground-to-Air: The Final Battle

Recovering their ground, both sides must now engage in an all out battle to the end. Red and white firecrackers hit the air as rounds of firecrackers fly across the water. Illuminating yellow and green signal flares, spiral missiles, and intercepting missiles are simultaneously released from each side. One side continues the attack with a mass of firecrackers, not letting up even as the target appears to be losing ground — signified by the release of white smoke. Finally, the defeated force is completely destroyed. The battle is won.

With victory won, the words " If I knew the danger ahead, I'd have stayed well clear" ignite across the scarred battlefield.

Yang Shaobin [b.1963]

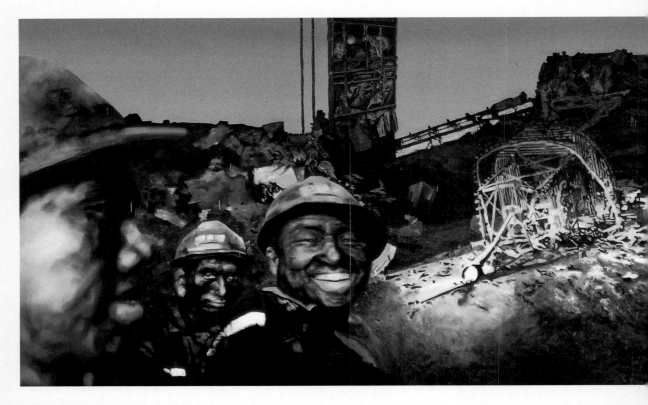

800 Metres No.8 2006
oil on canvas
260 x 450cm

When Yang Shaobin first took up painting in the early 1990s, he quickly became caught up in the heady, pseudo-revolutionary bravado which we now know as the Cynical Realist movement. Although he was one of its best-known artists, then he was more a follower than a leader. As Cynical Realism began to gain in recognition and become the predominant style, the subject matter began to override other, more painterly, concerns. Whilst the subject matter has always been fundamental to Yang Shaobin's work, he has progressively distanced himself from the cynical referencing of local political and cultural concerns in favour of a more universal vision, which, allied to his interest in painterly expression, has allowed him to become one of the most powerful voices in contemporary Chinese art. Due to the academic nature of their training, the majority of artists in China are technically brilliant, although few prove to be innovative. With hindsight, one could say that Yang Shaobin had the advantage of not having studied at one of China's academies, forced instead to rely upon his own wits and natural instinct. As a result, he is extraordinarily innovative. In the *Art Diary*, written for the exhibition catalogue *Faces behind the Bamboo Curtain* in 1994, Yang Shaobin wrote; "I am an artist, not a scholar, all I need are good instincts, and to be happy when I work."

One of the first artists to be represented by a gallery, from 1993 Yang Shaobin enjoyed regular showings of his work in Hong Kong. The recognition it won him was not without its frustrations. Yang Shaobin recalls it as being limited to a narrow fascination with China's socio-political circumstances that prevailed through the 1990s. His early works reference these concerns: the portrayal of men in uniform, clumsy in attitude, their features drawn back in hollow laughter, was a reflection of Yang Shaobin's own observed experience. In addition to the regular confrontations with the authorities that were part of everyday life in the Yuangmingyuan — the first independent artists' community in the capital — after secondary school and before a three-year art course at Hebei Technical College, he had been assigned to work in a local Public Security Bureau office, of the kind found in every Chinese neighbourhood. "It was incredibly boring. To pass the time, I used to make sketches of people waiting to file complaints, which they hated because they didn't know what they were for." None could imagine they would serve as inspirational subjects for Yang Shaobin's compositions.

Yang Shaobin was born in Handan, Hebei province, a hometown he shares with the best known of the Cynical Realists, Fang Lijun. This friendship led

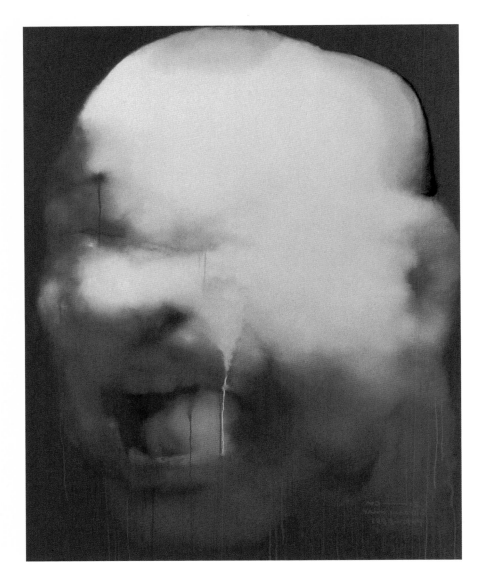

Untitled 1999
oil on canvas
180 x 230cm

Yang Shaobin to leave the porcelain factory where he had worked for
seven years after graduating from Hebei Technical College, and move to
the now-legendary Yuanmingyuan artists' village in Beijing. His initial
intention was to further his studies at the capital's Central Academy of
Fine Arts. In the event, the option of going it alone was harder to refuse.
"Getting started wasn't easy. I hadn't had much experience of art before. I
wanted to find my own form of self-expression but in the beginning, this
proved problematic. Where to start?"

Encouraged by the reaction the early Cynical Realist works were eliciting, Yang Shaobin, too, made paintings steeped in satire, largely peopled with men in uniform and depicted in a palette of colour as garish as it was acidic. "I wanted to remove the aura of mystery and power that uniforms assume. The people who wear them are as human as the rest of us: it is their uniforms we fear."

Yang Shaobin might have continued with this mode of self-expression were it not for the break-up of a relationship in 1994. Losing a girlfriend did more than alert him to the frailty of the heart: it revealed the emotional damage that one human being is capable of inflicting upon another. As a result, Yang Shaobin began to explore expressions of violence: the effects of suppression as well as expression. By 1996, he had produced a large series of fight scenes based upon photographs of himself and his older brother wrestling and apparently inflicting real pain. These fights are set against non-specific landscapes, but the aura of jungle-like density they suggest, seems to allude to an overwhelming force of base nature, human and animal. As the series progressed, so the backgrounds became more abstract, the colours bolder. The paint surface also changes: the brush marks loosen up considerably, until individual strokes are drowned in diluted swills of semi-transparent glaze. Drips, splattering, and liquid washes flow over the picture plane, throwing into stark contrast the visceral reds and pinks of the warring fleshtones.

Butterfly 1993
oil on canvas
170 x 170cm

Lipstick 1996
oil on canvas
130 x 130cm

By late 1996, this had evolved further to a single, monumental focus on the face, fronting a large close-cropped head, the features bloated, bruised, bloodied, floating in a sanguine cloud of cold alizarin. These paintings are incredibly beautiful, but it is the beauty born of a fascination with the repulsive. It is a strongly masculine world, in which violence predominates and seems an addictive inevitability, a theme Yang Shaobin carried into the next major series on the subject of international clashes and incidents in the early 2000s, and was in part made possible by the increasing coverage of foreign news on Chinese television, and significantly, the non-official versions of events available through the internet. The explosion in access coincided with dramatic events in the Middle East, and the invasion of Iraq. In 2006, some of Yang Shaobin's most directly explicit work in this series was suitably paired with that of Hermans Nitsch in a two-man exhibition in Beijing. The parallel themes of the body and violence he showed here related to the conflicts in the global village. Reports on the plight of ordinary people in these conflict-torn regions turned his attention to similarly dire realities closer to home, and led to *800 Metres*, a series of reflections upon the dark social reality of coalmining, a highly sensitive issue in China, which even the official Xinhua News Agency reports describe as the 'deadliest job' in China, done in what are described as

I'm always afraid something is about to happen, but then it's all OK 2006
oil on canvas
diptych, each 190 x 350cm

Invisible Enemy Lines 2005
oil on canvas
diptych, each 210 x 350cm

The big guy suddenly realised
this was not an internal
problem 2005
oil on canvas
120 x 280cm

'killer mines'. *800 Metres* returns Yang Shaobin to a world he witnessed as a child in his hometown, Tangshan. The taint of coal dust, the black faces of the miners, and the whispered perils of the pits, all left a strong impression upon him. Today the extent of the blackness that envelops entire mining communities has spread unchecked in the race to feed the country's huge energy needs and satiate its voracious appetite for coal. Today, China's coal production accounts for almost 40% of world supply. China also claims 80% of deaths worldwide from mining accidents—about 6,000 in 2006, according to the official count (and even that is claimed to be a 20% improvement on recent years).

Whilst depicting the miners 800 metres below ground at work in the subterranean network of tunnels, Yang Shaobin also shows them in their polluted housing communities. Here, then, none of the usual seductive colours, but instead a striking shift towards what appears a more conventional form of realism in an unquestionably drab palette. With an unerring eye for detail, the artist offers an ironic comment upon, and total disdain for, the utopian allegorical idealism that underpinned Mao's preeminent brand of Socialist Realism. *800 Metres* invokes an accurate, if unsavory portrait of a contemporary industrial poverty trap from which there is little escape.

800 Metres 2006 Yang Shaobin

The works created for the *800 Metres* project are a hybrid of elements
found in previous phases of my painting. They focus less on a political
issue than on a reflection of the multifarious and shifting world of my
personal thought processes in recent years.

In 2002, my creative inspiration all but came to a dead end because I could
no longer identify any interesting topics worth painting. I bemoaned the
fact that the world was too quiet, lacking new stimulation, and encouraging
a stagnation of minds. But then came the terrorist attacks of 9/11 in New
York, and the invasion of Afghanistan and Iraq. I was reanimated, and
experienced a whole new fervour for my painting.

Although I gathered much visual information from the media reports, I
never sought to express scenes of war directly in my paintings, but took
these issues as a point of departure. I wanted to tell of the secrets and
cabals that lead to wars and the pivotal events of history, some of which
might be fabricated, or that are simply a clash of faith, or culture with
time—most of which the public never gets to see. The paintings are all
centred on my personal understanding of politics: a belief that so much
about politics is manipulated behind the scenes. Naturally I have reason to
fear politics: I have witnessed its deadly and bloodthirsty nature. In my
paintings I aim to convey a sense of disquiet, that hidden agenda which it
is often hard to put a finger upon, but which is really responsible for the
horrors the modern world is facing. It's the psychological inferences that
interest me.

This method of mixing metaphors and techniques opened another space
for me. It allowed me to return to the local coalmines in the town where I
grew up. I felt that this direct experience was one that I could make
credible use of. I had grown up being presented with the world as
described by Social Revolutionary Realism. Looking back over history, as
portrayed through the art works of that time, it feels as if I am being
returned to my childhood, and a world that was kind and pure. These
paintings are drenched in sunshine and fresh air, beneath eternally blue
skies. It was a time of collectivism, where workers were the knights of the
state; a state that had given unparalleled glory to the proletariat. But that
time has passed. When I returned to the coalmine again after an absence
of so many years, the situation is little short of dire. There were fatal

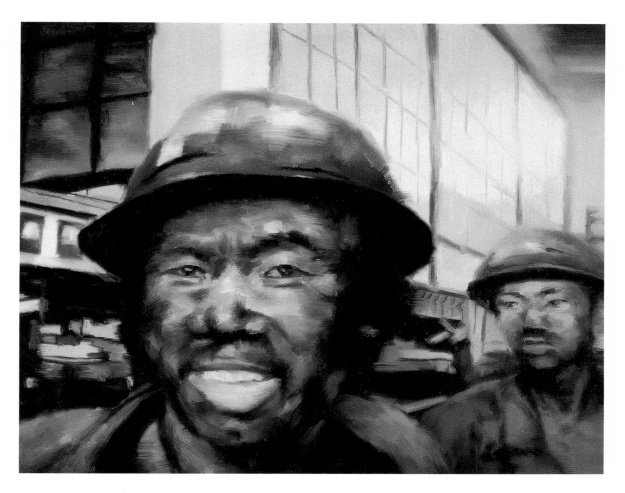

800 Metres No.17 2006
oil on canvas
80 x 100cm

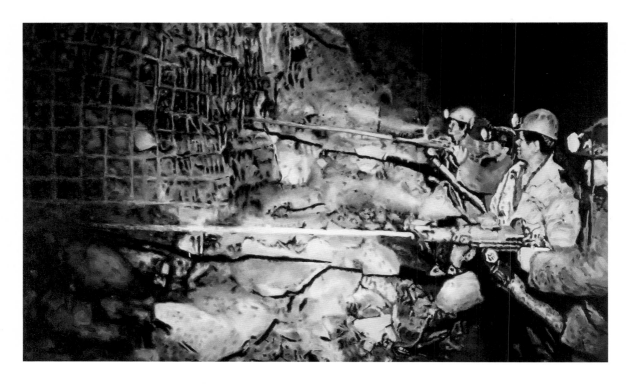

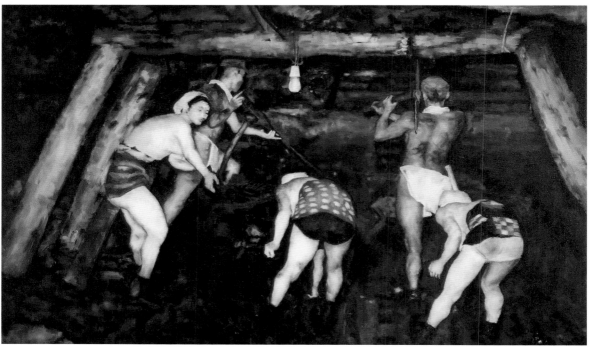

800 Metres No.16 2006
oil on canvas
80 x 100cm

opposite page:
above
800 Metres No.2 2006
oil on canvas
210 x 350cm

below
800 Metres No.3 2006
oil on canvas
210 x 350cm

accidents in thirty mines in 2005 alone, and there is no small number of children and women amongst the fatal victims whose lives the mines claim. I worry about the current speed of development and expansion of market consumption. For this reason, I also recently chose to make a video work alongside the paintings that criticises this problem. I can only marvel at the vitality of these workers, and the life force demonstrated by their children. Why? What kind of lives do these people have to live for? What of the so-called 'basic necessities' view of life in which life is just about survival: an absolute bare life little different to that of a dumb animal. Against all the ideology pertaining to China's socio-political history, how should we view this situation today?

Such ponderous realities inspired me to create *800 Metres*. During the Cultural Revolution, all artistic expression was tied to Revolutionary Realism. But the grand illusion it presented was simply a necessary function of political propaganda, churned out according to formulaic templates, which were then used to perpetuate this kind of art. I hope that *800 Metres* will be read as a real critique of history and contemporary reality.

Zhou Tiehai [b.1966]

Fake Cover: Art in America 1997
print media on paper
27.5 x 23cm

Though no medical man, Zhou Tiehai sees himself as the spin-doctor of the Chinese art world. His fame rests upon his success at peddling a cure for ills he decided were afflicting the fledgling clutch of contemporary artists who made up the scene through the greater part of the 1990s. True to the style he established in the early years of that same decade, his cure was more than a little tongue-in-cheek: a panacea in the form of an extensive series of canvas works he terms *Placebos*. The function *Placebos* are intended to fulfil mirrors that of their medicinal counterparts in every aspect: which means to the degree that placebos are fake medicine, Zhou Tiehai's *Placebos* can be described as 'fake' art. Each individual piece in the series is a slickly air-brushed reproduction of a recognised masterwork from western art history, but with one distinctive difference: the substitution of the head of 'Joe Camel' of cigarette branding fame in place of the real heads of the figures portrayed in the original works. The pun on the sound of 'Joe', as in camel, and Zhou, the surname, is all part of the prank. Zhou Tiehai's *Placebos* span almost three centuries of high art, and where the number of works already runs into the hundreds, they are surely the last word in postmodern appropriation.

The primary motivation for the *Placebos*, though, is neither appropriation *per se* nor is tied to the problem of 'fake'. Instead, Zhou Tiehai experienced a pressing need to highlight the chaotic variety of standards by which art in China is judged and promoted. The disparity in standards was — and to some extent remains — in evidence from the start of the New Art movement in the mid-1980s, and yet, ironically, the truly chaotic nature of so-called criteria was far more prominent as the West began to put out feelers in the East in the early 1990s — China's contemporary artists made their debut at Venice in 1993 and, for western audiences, coming out of almost total obscurity. The situation was particularly pronounced as the painting styles of Political Pop and Cynical Realism — emerging in the early 1990s and applauded for subverting political motifs and mocking the local ideology — became the focal point of international interest. This proved confusing for Chinese artists: from the late-1980s, as they learned of more current developments in art, practice and theory, the primary principle of post-Modernism was read as meaning that anything, everything, could be art as long as an artist said so — mere oil painting and sculpture surely passé. Whilst the interpretations were not untrue, postmodern tenets stemmed from an evolutionary progression of ideas that were entirely without context in China. This didn't make it any less exciting for Chinese artists: postmodern ideas were thus approached

There Came a Mr Solomon 1994
mixed media on paper
230 x 350cm

opposite page
Will 1997
stills from unrealised b/w film

without prejudice by artists who were also not constrained by respect for art history. But even they knew that freedom to do anything in the name of artistic expression was dependent upon the resulting artworks being recognised as contemporary, and in line with established international criteria. Against the trials of making and presenting contemporary art in China, by the mid-1990s artists had attached excessive importance to coming to the attention of western curators.

One of Zhou Tiehai's most cynical works, *Will* 1997, describes exactly how this could happen and how real, and fervent, the ambitions were that fed the strategies it unleashed. Originally intended as a spoof film — the process was terminated by the authorities half-way through filming — Zhou Tiehai subsequently mapped out the plot in the manner of a storyboard; key scenes adapted to a series of grand tableaux. The satire is biting as he presents various cliques of artists mapping out strategies to kidnap visiting curators: they analyse styles of artistic expression, and prevailing tastes to identify what type of artworks will be of greatest appeal to collectors and museums. Next, we see exclusive cliques of artists wine and dine foreign visitors, holding the competition at bay…although they are soon forced to confront one another as they queue up for an audience with a visiting curator, a scenario presented by Zhou Tiehai with the artists characterised as patients waiting to see a doctor. So, then, here are those ills that were responsible for inspiring *Placebos*.

From the outset, Zhou Tiehai positioned himself as an outsider; an independent commentator who skirted all cliques and eschewed all local trends. His first works were produced together with a fellow graduate, Yang Xu. Decided upon an anti-painting strategy, the pair worked upon sheets of newspaper and cheap packing paper that they glued together directly on the wall, adding to and subtracting from the expanse as the image took form. The content and style of the drawings and the phrases scrawled across them centre on a sharp criticism of art world nepotism and ambition, which prioritises international fame and securing a place in art history. Zhou Tiehai implies that concerns for individual creativity and innovation are secondary at best.

In 1995, Zhou Tiehai made his views even more explicit in a series of magazine covers that parody those of publications like *Art in America*, *ArtNews*, *frieze*, *Stern* and the *New York Times Magazine* (completed 1998). All are recreated as format-perfect copies in the style of the original magazines, but with headlines and images that make pointed reference to specific concerns and events with which the contemporary art world was preoccupied at this time — 'Too materialistic, Too spiritualised' reads Zhou Tiehai's version of the cover of *Newsweek*. The form and content of the

Maurizio Cattelan 2006
acrylic (airbrush) on canvas
240 x 300cm

Untitled 2002
acrylic on canvas
243 x 160cm, 243 x 200cm,
243 x 136cm

series demonstrates his grasp of the mass media's role in shaping public opinion, and gives voice to his doubts about the motives of journalists and editorial policies. "Before, I thought that to be an artist all you needed was your work to be good. I discovered this was not the case. You have to be on a list." The disproportionate amount of space given to those artists who were adept at branding and marketing themselves was all the evidence Zhou Tiehai needed.

Humour is ever present in the approach. Asked to put a price on his large drawings in 1994, Zhou Tiehai's response was simple: "It is valuable enough to be carried in a Louis Vuitton trunk," which inspired a work on paper depicting a smartly uniformed porter wheeling the famous trunk in which we assume just such a work is concealed. *Je le transport dans un sac de Louis Vuitton* shows a fine grasp of individual cultural sensibilities that he brings to his special commission for *The Real Thing.*

Following *Placebos* — which centre on appropriations of western art — Zhou Tiehai decided his audiences needed a pick-me-up. The result was *Tonic* 2000, similar in approach and intent to *Placebos,* but this time appropriating and simplifying masterworks of Chinese art history. Thinking about ingrained national cultural

characteristics that become symbols of a nation's cultural heritage is best reflected in *Untitled* 2002, which is Zhou Tiehai's summation of the notional values of 'British-ness', 'the American Way', and 'Chinese-ness': one eccentric and anachronistic, a second crystallised by the events of 9/11, as ever on the trail of a hero, and a third obdurately in thrall to a five-thousand-year history. Works of this type would have been an obvious choice to represent Zhou Tiehai in *The Real Thing*. In recent years, his output has entirely focused on painting — although he maintains a whole studio of assistants who execute the works for him — so he was ready for a change...and a challenge. This new gastronomic departure for the artist sees many of his on-going concerns converge in a rich culinary amalgam of cultural sensibilities.

Here, Zhou Tiehai creates three desserts he calls *Le juge*, *Le diplomate*, and *Le ministre*, which are intended as parodies of French patisserie delights, like the Napoleon cake — which is today more familiarly referred to as *Millefeuille* — and a form of naming not unfamiliar to those amongst British people partial to a slice of Battenberg. Each of these three desserts has been produced according to the type of innovative combinations of flavours and textures for which French food is famed. An air of authenticity is provided by a convoluted pedigree that comes with each one, written like the history of a revered national treasure — revered because it embodies the very essence of the local character with which the locals are proud to identify themselves. Zhou Tiehai chooses France because the nation is synonymous with cuisine. The inspiration for individual dishes, mapped out in the histories, comes from a diverse source of art historic images — eighteenth and nineteenth century engravings in the case of *Le juge* — as well as literary sketches and legendary figures from the grand plays of French laureates, and actual historical events. All of these things are configured into a plausible faux lineage that is hard to dispute. But then, surely the proof of every pudding is in the eating...

The World's Leading Art Magazine Vol. XXX nº 197 Winter 1997 US $7 International

Flash Art

中国 又来了个 顾 磊 克

LOUIS VUITTON gives China's artists health check

Fake Cover: Flash Art 1997
print media on paper
27 x 20.5cm

Le Ministre

Le ministre, a fruit soup, usually served cold, was known long before the 18th century when sweet dishes first became distinct from savoury ones. The idea was that these sweet plates would be consumed during that pause in the meal when the main dishes were being cleared from the table—in French the verb 'to clear' is *desservir*, hence the etymology of the word *dessert* as the name given to these sweet dishes.

A relic of these heroic times is the black cherry soup, common in the French countryside. Similarly, the red cherry soup from Magyar, both of which belong to a medieval tradition. These cherry *ministres* were served rather indifferently; sometimes being almost savoury, sometimes warmed and paired with a special wine. Significantly, they could be served at any time during the course of a repast. Discerning gastronomes, however, saw in this harmless practice, the spectre of an aberration: for, if this random practice were to become the accepted fashion, what was to stop hosts from serving not a sweet dish to complete a meal but beef tripe in a *diplomate* sauce, or a dish of grated carrot and pickles?

A grasp of good taste is ever fragile... It has thus taken centuries to determine what should be served as the last course of a meal, especially given the synonymy between *dessert*, *fruit* and the *finale* of a meal. Before this, the nature of this finale depended not on the ingredients *per se*, but on a certain co-ordination between the kitchen, the service staff, and the dining room. The subtlety of this play inadvertently engendered a series of brilliant reforms, the most precious of which is certainly dessert culture—at least, in a period when Russian practice had little likelihood of supplanting French customs, which of course was not the case in the time of Nicolas Pavlovitch (responsible for giving the world *pavlova*). In the pre-Revolution age in France, the progressive acceptance of *le ministre* following the need to serve a patisserie course, was to set in motion a radical change, almost inconceivable in today's world, which was to have this type of 'dessert' served after the soup course.

Despite *le ministre's* long history and empirical role in defining the basic principles of modern gastronomy, the expression that emerged to designate 'dessert' in French cuisine during the second half of the 20th century, was *'nage de fruit'* (swimming fruit). Less esoteric than the name *le ministre*, this expression was perfectly suited to the less educated clients of fashionable restaurants, who preferred this dessert to the sterile-sounding 'fruit soup'. The need to distinguish the relationship between these three—*ministre*, *nage* and soup—resulted in a precise hierarchical definition.

The 'soups' which *le ministre* has been used to describe covers practically every fruity liquid that has ever been served as a dessert, regardless of it being thick or runny. By contrast, *la nage* is more likely to contain fruit cut in small cubes, or simple wild berries that are submerged or that float, and even fruit served in a syrup.

However, there is an essential difference with *le ministre* that is unrelated to its position vis-à-vis soup or *la nage*. Among those sweet plates which find themselves named after a profession, that of *le ministre* is most intriguing. Objectively speaking, a multitude of desserts—even a basic pie—could be categorised as a fruit soup if strictly defined in line with the explanation given above. The name, however, is without clear rational; and the arbitrary nature of its composition was a cause of frustration to free spirits. Thus, *le ministre* fell foul of sarcastic assaults with which *le diplomate* and *le juge*, and even for that matter, *la religieuse* and *le mendiant* were well acquainted. Numerous hermeneutists maliciously asserted that *le ministre* is so called because the full-of-himself bearer of the portfolio could not imagine a more exquisite pleasure than to assist to the stream of sycophants who came to lick his boots and serve his excellence a nice little soup...

Other specialists account for the name in terms of its reference to the phrase 'a ministerial secret' or 'a ministerial wooden tongue', which speaks of false (hollow) promises, sabre-rattling, and a sequence of 'cream tarts'. All of which are meanings equally expressed by the mention of an 'insipid soup', or even a 'marshmallow soup', which is used metaphorically to articulate the most disgusting, cloying demagogy by the narrow-minded popular caste.

These assumptions might be amusing but are nevertheless false. The true reason for the name is childishly simple. In Italian, soup is *minestra*, which the Italians like to remind those French ignorant of this appropriation, that this is probably the origin of their *ministre*.

The clarification of the unexpected relation between 'soup' and *ministre* came about by way of three Roman words. First, the Latin *ministre*, which means 'servant'. Logically, the root is related to the words 'administer', and 'administration'—*administrative* power was the *serving* of the people. Therefore, the words server (waiter), serve, *desservir* (clear away) are also part of French table vocabulary. The etymology suggests, however, that the root of this liquid dessert is found in the opposition between the Latin words *ministre* and *magister*. The first one derives from *minus* from which come the words 'moins' (less) in French but also 'minuscule' and 'minable' (scummy, pathetic), whereas the second comes from *magis*, which means 'more', which produced 'maitre' (master) and 'magistral' (magisterial). The common understanding of the power of the magistrate and the humble status of the minister has crossed the centuries: the authority of the people having been carved in stone. The Declaration of the Peoples' and Civilian Rights on August 26th, 1789, attests to this very fact. Article 11 stipulates the 'Freedom of communicating beliefs and opinions is one of Man's most precious rights; every citizen can therefore speak, write, and print freely'. Article 15 adds: 'Society has the right to ask any administrative agent to answer for his administration.'

At a time where ministers move more mysteriously than God, like a wafer in a deserted church tabernacle, there is no doubt that such a self-effacing servant would persuade a sceptical crowd to view him with a different eye. But equally, he would draw the line at allowing too great a change. The high priests of dessert-making would be sure to exercise their veto over any unauthorised tampering with convention, especially should it lead to a desecration. *Le ministre* remains an essential experience of French cuisine that would be impious to tarnish. Besides the presidency of Matignon, most administrations hired talented chefs to sate the appetites of working ministers, as well as those of their family and close relations. Pastry chefs contracted to the State know that there's no need to skimp on the expenses required for luxurious foodstuffs and all manner of sophisticated equipment necessary to fulfil their tasks.

These unconscious manifestations are but references to the dimension of servitude that the character of the

minister ought to own, which is echoed in the choice of ingredients of which *le ministre* is composed. Most of the known recipes in European gastronomic history leading up to the versions currently in use, list either complex or basic combinations of wild berries such as strawberries, raspberries, gooseberries or cherries, with a preference for the latter, especially soft-skinned acidic varieties like Morello or black cherries. These retain their full-bodied fruity taste, even with a powerful soaking of red wine and spices. These should include notes of cinnamon, black pepper, and cloves, and the whole is usually seasoned with citrus zest. These *ministres* attain a deep crimson body colour far more disturbing than the grenadine finery of common cherry liqueur *ministres*. Fearful of running aground on this reef, dessert chefs rush to enrich the original soup with a selection of black berries, such as blackberries, blueberries or blackcurrants. The sanguine monochrome of *le ministre* is attenuated, its consistency enlivened, and the seductive contrast of textures enhances the flavour, with a note of sharpness and surprising sensations. To the red and blue tints, a little white colour was deemed expedient to enhance the patriotic aura of this dessert in recognition of its patrician origins. It is surely a paradox to imbue this innocent rustic fruit soup with a political connotation simply to satisfy a *fin-de-siècle* fad, which has little inkling of the historical process that engendered this transformation. Served in 'verrines', that is little crystalline glasses, *le ministre* has in recent years thus acquired the decorative addition of little cubes of marshmallow on the end of a brandy-legged stick. Delicately suspended just above the scarlet liquid, this wobbly overlord recalls those tyrants of the old regime, who were cheerfully knocked off the doorstep of the ministry by a jubilant crowd seeking to rid the citadel of its air of snug consanguinity, and show its public servants what the country looks like from the wrong end of a bayonet.

It is common knowledge that this marshmallow cube is only the most recent ornamental accessory in the panoply of fanciful artisans, and that its association with *le ministre* is fortuitous. The version of the dessert sold in nice neighbourhood pastry shops is not liquid, neither does it go in for such decoration. Even though it looks chic, and justifies a higher price. Most of all, it highlights the combination of colours provided by the various components of the dessert. It is beautiful, of course, but sterile. The invention of this brilliant but perilous asymmetry gives the metamorphosed fruit a joyful accent. But, Carême would shiver in his tomb, he for whom patisserie was akin to architecture, even on a par with sculpture. Marshmallow added thus enfeebles the construction of this dessert, whose structural decadence is inevitably reflected in the taste it provides. The layers of cream and compote are two thick and too numerous to be tasted simultaneously. The result is a juxtaposition of parts rather than a convivial partnership between them. Finally, the inserted biscuit is reduced to the modest role of a dry partition wall between two elements that would taint each other. Only a substance of dull consistency could fill in this role. So here we have the modern muddle of a dessert intended to assuage the flavours of litchi and mango compôte with a caramel and *fleur de sel* (French sea salt), mascarpone cream, a marriage of comparable textures, all perfect delights in their own way, but in a union that has no justification. The tenderness of coconut marshmallow, with its crispy surface may just be a judicious decision: the outer consistency, in contrast with its inner softness, compensates for the deficiency of the viscous lower layers. On paper, who can deny the sumptuous appeal of *le minstre*, but in reality it simply doesn't work...

Such is the lamentable origin of the white crest set upon *le ministre's* head. The stick is merely a prosthetic to keep the marshmallow from absorbing the red soup juice, which would be of no benefit at all. To claim that a soft bite of marshmallow would prepare the palate for the perfumed soup beneath would be to cradle ourselves with illusions. *Le ministre's* crown serves no more purpose than an historic pedigree; and so we dispose of this inept appetizer, without ceremony, in a single mouthful. Pure and simple vanity, vanity of vanities, better it whispers in the ear of triumphant Caesars a reminder that 'you are nothing'.

Le Diplomate

Le diplomate is a late-nineteenth century invention, emblematic of what is generally termed bourgeois cuisine. Similar to le juge, le diplomate's name also references a profession. The term is also applied to a sauce and a cake that are similarly rich, perhaps even too rich for an uninitiated palette.

Inventor of the codified diplomate, Auguste Estoffier, describes the sauce, according to the repertoire of his most fervent Gringoire, as finely chopped truffles, dipped, to achieve a simple mix of viscous mollusc and noble rottenness. This version of the sauce has a base of smoked fish combined with 'essence of oyster and mushroom'. This is reduced, before butter and cream are added—hardly easy on the digestion.

Le diplomate dessert should not be confused with diplomate pudding. This pudding was defined by the very same Gringoire, using the lapidary forensic skill for which he became famous, as an 'unfriendly wooden pudding', of no great note until a cream, said to be the diplomate cream, was added to its composition. The latter was no more than a simple custard sauce, with a slightly thicker texture than the Bavarian version. It is to this unintentional collusion with powers hostile or rival to France at that time that it would owe its denomination. It is worth noting that diplomate cream is flavoured with liqueur or coffee. Customarily, historic references choose to remain silent on this particularity, though no one quite knows why.

Le diplomate that concerns us here comprises only three ingredients—biscuit, diplomate cream, and fruit. These ingredients are organised in the simplest way: a layer of biscuit hidden under a layer of cream, which is then covered with fruit. This order is usually repeated once or twice, creating a towering challenge to its consumer.

Traditionally the biscuit used in this recipe is a 'spooned' biscuit; so called, in spite of its appearance, because it was moulded this way during four centuries of its grand association with French cuisine. The fact that this biscuit is often dipped into alcohol—kirsch usually—doesn't plead in its favour. It has been clearly established by historians that the consumed separation between the word and the thing it describes, date back to the Napoleonic debacle, when the biscuit that was to provide the soon to be forth-coming diplomate's seat, was reduced in size by Carème. It was then further flattened and lengthened by Talleyrand, so he could dip it comfortably into his Madeira. This would have been inconceivable under the first constitution.

The alcoholic base of the biscuit and the cream is evidently proof of bad taste; unforgivable considering that the fruits are also soaked in alcohol. Bad taste is also courted by the fact that the common diplomate holds court only with candied fruit. Presently, where these commodities have acquired a degree of vulgarity, the mediocrity of their flavours and textures is unfortunately only emphasised by the addition of the very alcohol intended to diminish it.

The ease with which le diplomate is prepared—simply consisting of piling up the measure of ingredients, perhaps explains the lack of culinary interest it commands. Le diplomate has long been banished from good French restaurants and respectable food shops. It is thus probably the only French dessert almost unknown to French people. Yet, the recipe has survived, albeit in a fragmented way, in places destined for housewives seeking quality of life, or worse, surviving only at the far reaches of the colonial empire, evidence of the scandalous neglect into which traditional French patisserie has fallen. To measure this decay would require the perilous collection of information in the most remote places, which from a culinary French point of view, would imply China, Africa or South America, knowing these countries have probably never seen le diplomate in so revolting a form as the Eastern European version. It is hard to imagine volunteers scrambling to undertake such research.

that would produce a pleasant contrast with the other ingredients of the dessert. *Diplomate* cream would perhaps be better received, if a little lighter in consistency. It is well suited to a spray of perfume such that alcohol lends, although it would be preferable to use amber coloured rum from Martinique. With such fine rum, only the fragrance of its body penetrates the cream, without imposing the slightest burden of alcohol to weigh it down.

These small modifications should already be sufficient to return a sense of vitality to *le diplomate*, but the use of fruit here is essential. Apricot jam or even orange zest marmalade should make the dessert delicious. However, it would be a mistake to strangle culinary experimentation simply to excuse the use of exclusive prescriptions. Ideally, one should opt for seasonal fruit, the finest of the moment, and also review the ingredients constantly. This is, of course, to suggest a new approach to the traditional *diplomate*, which has allowed itself to become heavy and wooden, and entirely opposed to the principal of freshness. Raspberries, figs, or mangos would each do great service to *le diplomate*, and even pineapple, in its own way, although that fruit should be lightly caramelised, so that its natural acidity does not affect the *diplomate* cream spread beneath it. Maximum eating pleasure would be assured with the use of quince, softened and candied in Tahiti vanilla.

Finally, as it is assembled, the three layers of *le diplomate* ought really to be repeated but once. One might then pour a thin layer of cream over the assemblage in order to disguise the cumulative structure beneath, and to lend the petit mound a more graceful mien. Some freshly cut fruit, similar to those used for the filling, could then be set on top of the dessert, but elegantly disposed if they are to perform a greater service than mere decoration. The pleasure of consumption depends on these diplomatic refinements of *le diplomate's* deportment. For surely even the most urbane of citizens ought, at least once in a lifetime, give himself over to enjoying the sophisticated experience of engaging with a refined *diplomate*.

There is, however, not a great deal to be derived from this rout. In the final analysis, definitions of *le diplomate's* constitution have never been shown to imply anything other than a combination of three elements: the biscuit, the cake and the fruit; which it must be said is not dissimilar to those ingredients listed in the great majority of French patisseries. The use of *diplomate* cream, which is thickly spread within layers of dense, cloying plasterwork, perfumed as it is, and often with alcohol, hardly makes for an offence to any purist, as long as the doses are well measured in a tactful manner, achieving for this dessert an entirely original flavour.

As for the simplistic form of its construction, one should not succumb to excessive encouragement to stack up the layers beyond the bounds of modest propriety. Perhaps one might consider a biscuit that refuses flour in favour of ground almonds. Such would serve the purpose well, especially if soaked in syrup, or better still, almond milk for a rich, savoury finish

Le Juge

At first glance *le juge* might not seem very impressive: dark in colour, it has a flat, round shape, rather like a hockey puck. Indeed, with its smooth glacée coating, it would, if struck, glide quite comfortably across a frozen surface. In spite of its smooth round exterior, *le juge* is in a class of desserts whose ingestion is a permanent challenge to every attempt at maintaining table etiquette. Although it might not seem easy to determine by which extremity to attack *le juge* — because he has no extremity to speak of— it is easy to surmise that it will more gladly defy social norms of decency and elegant consumption, than fail to honour its reputation of being available to each and every pressing appetite.

Beneath the outer coat of chocolate icing that cloaks *le juge* is concealed a fine layer of gooseberry jam textured with its tiny crunchy seeds. The result is a notable combination of sweetness and acidity. This tart marmalade rests on a layer of chocolate mousse whose bitterness counterbalances headaches brought on by overly rich cocoa extractions in those predisposed to such afflictions, or the loss of pleasure after two bites. This blend of soft and bitter companions is settled on a thick base comprised of a soft chocolate biscuit. In most cases, *le juge* is decorated with a rippled chocolate fan, and a modest sprinkling of fresh redcurrants. However, there are many acceptable variations of decoration applied to *le juge*, each of them evolved in the course of its rich, but little-known history, which has travelled through the centuries under many different guises.

The name of this 'hockey puck' is one and the same with the man of the profession who stalks the corridors of the courthouses. Yet, the naming has nothing to do with a superficial analogy with his sombre, often terrifying appearance—sporting an outfit that to a contemporary critical wit seems tailored for a highwayman. Having said that, the winning reputation of French gastronomy as *Art* was not achieved just by technique and flavour alone. The literary and political implications of many of its creations have also made a significant contribution to its success. This phenomenon is particular to France, where culinary tradition, whether gourmet *haute cuisine* or family home cooking, often transcends the simple satisfaction of nutritive or even gustative ambitions. These are taken for granted. The process has been elevated to the dimension of a sophisticated game, indifferent to social status, nor conscious of the opposition between the man that creates with his words, and the man who creates with his hands. Such non-essential anecdotes of misunderstanding are best kept for after-dinner conversation. All we should concern ourselves with in regard to *le juge* is to adopt an air of fun in the manner children bring to eating. For this reason, *le juge* can be eaten anytime, anywhere.

Pastries have always played a leading role in the culinary game, and often combine humour with daring provocation. In that sense, the justification for naming *le juge* thus may have a grain of truth. *Le juge* is so-called because it is popular French opinion that judges share with their fellow magistrates, a sobriety, whether moral, physical or sartorial. Consider Daumier, who knew that judges did not refuse little 'treats': bribes that they chose to deem mere gratitude.

'Cold-blooded monsters wrapped in false pride...': this description of the judiciary explains the bitterness that lies beneath *le juge's* glacée icing. Just as seeds get stuck in one's teeth, the pitfalls of negotiating with judges far outweigh the benefits of the justice they are meant to administer.

Yet a dessert is more than a set of disembodied concepts. French pastry tradition proves not only that verbal cleverness isn't the perquisite of laborious theoreticians, in spite of their idolatry, but more to the point, that irony has its place in manual realisation, which gives it shape often far better than words can. This joy, born of action, flourishes in the dessert under the guise of humour, a transmitted, shared humour

experienced in the midst of an authentic collective history, although it may never be written, or even glimpsed by art historians, omitting their object because they ignore its existence.

Le juge is a case study in this alternative art history. It is part of a tradition that goes back to the middle of the fourteenth century and originates in Bar-le-Duc, in Lorraine: that is where a gourmet apothecary invented a redcurrant jelly which was seeded by a goose feather. The city archives would rapidly report extravagant acquisitions of this precious substance for quite unconventional uses. The same document records the first instance of the practice of rewarding a judge for displaying magnanimity in handing down sentences with jam from Bar-le-Duc. The practice gained even more importance in 1518, when the wooden case used to contain the jam was replaced by

delicate jars made of precious crystal, produced by monks at the abbey of Lisle en Barois. From then on, both the nobility and the middle class rivalled each other in upholding this custom, under the benevolent gaze of the judges, always eager to do justice, not least to their appetites.

This comical, almost childish form of corruption further spread to the common people, and with time reached the excessive proportions attested to in accounts of the city right up to the eighteenth century, when the Revolution put an end to this malpractice. Production had reached 50,000 pots in 1780 and, as was common knowledge throughout France, during centuries the Bar-Le-Duc jam was offered all over France to all the mighty or influential people of the kingdom passing through this most welcoming and agreeable city of Lorraine, for protection or influence.

The first known version of le juge was a redcurrant roll. This kind of rolled cake is an old recipe from Eastern Europe, usually made using puffed pastry spread with various fillings depending on the region. This was rolled into a log-shape, which was then cut into fine round slices. Variations on this roll can be found from Alsace to Hungary, where poppy seeds and walnuts are preferred to jam. In Eastern France, redcurrant jellies dominate, for reasons bound to remain mysterious, if one fails to take into account both the century-old tradition of graft in Bar-le-Duc, as well as a major linguistic phenomenon which appeared in Europe during the fifteenth century: the emergence, in the wake of the Rom's arrival, of a slang specific to the so-called 'dangerous' classes. The trial of the Coquillards that took place in Dijon in 1455 has provided us with a precious lexicon of double-meanings used by these villains, all too-familiar with justice, and this has completed the data provided by the jargon in Villon's ballads. Thus it is that we learn from the glossary that was put together by the judges from Dijon, that the Coquillards call 'the justice of any place the *marine* or the *roue*' (wheel). Consuming redcurrant jelly rolls, as preceded by the farcical slicing of the

roll into 'wheels', in the popular layers of society which were not devoid of humour, was a festive simulacrum of the cannibal ritual, intended to purge society of the judges' revolting corruption.

Of course, by definition, the power of slang is that the majority of people don't understand it. Thus it was that the tradition of naming *le juge* the redcurrant jelly roll in the eastern part of France remained quite esoteric, despite the cake's popularity, and almost disappeared as time went by, as the roll changed appearances, as new pastry trends came along, such as the progressive introduction of chocolate, in the form of icing or cream. Why *le juge* was to reappear with such panache on the French gastronomic scene in the 1870's must therefore be explained at length. France had just lost Alsace as well as a part of Lorraine, birthplace of *le juge*, the future of the Republic, which was dear to *le juge*-eaters, seemed far from well-assured, when an apparently new dessert began its incredible ascension. The very first Christmas *bûche*, or Yule log, was a confectionary produced by Antoine Chabarlot, on Christmas Eve in 1874. It was made of sponge cake, butter and chocolate cream, and was shaped as a roll. The scholars of the profession in their unconvincing quest for believable origins evoke a Provençal custom of burning a log on Christmas Eve, or covering a log with cream. We only have to know that in the 'dangerous social classes' the judge was called the 'saboteur', assisted by gendarmes known as 'Christmas trees'. The Yule log is but a metamorphosis of the original roll known as *le juge*. He has always been eaten on Christmas Eve throughout Eastern Europe: yet the association relies upon a verbal pun: of the Yule log being a means to deliver a cheerful poke at the judge with a Christmas tree, whereby justice is served. Words can deceive and pleasure is not only oral...

The first *juges* were sold in Paris, by daring pastry chefs from Alsace. These took the form of gooseberry rolls, served lying flat and coated with chocolate icing, giving them an appearance quite close to the form of a reclining judge. The name blended in easily, given this

pompous end of century fad, with its *diplomates*, *marquises*, *religieuses*, *financiers*, *colonels* and other nourishing notables. *Le juge* remained in fashion until World War I, aided by the steady production of gooseberry jam, which by 1909 had achieved an output of 600,000 jars. The progress of the democratic spirit under the Third Republic, as well as the Dreyfus affair, and the persecution of Jewish Alsatians ordered by the judiciary, provided rich fodder for the French love of caricature. However, the thrill of victory was not favourable to *le juge,* steeped as it was in sarcasm. The way judges acted during the Occupation is certainly not a subject of pride for the French administration, especially in the higher spheres of power. The goose-feather seeded jelly having disappeared, there arose the need for a replacement fruit. The solution came from a pastry confectioner in Rom, who disgusted by the gutlessness of his magistrate clientele, found the adequate fruit: in the absence of the goose-feather seeded white or redcurrant jelly, he used the gooseberry.

Yet, our modern *juge* was born a bit later. This event took place in Paris, at a time during which the lack of chocolate entailed the use of all kinds of mediocre substitutes. He modified the dessert's structure by adding a thick and very mellow Sacher sponge cake, made from raw almond paste and cocoa powder. By proceeding this way, he could reserve the real chocolate for the icing on the top, without altering the traditional aspect of *le juge*, black from head to toe. The 'almond' was not the most honourable, but the recipe was a treat and the connoisseurs appreciated the artful appropriation of the invention of the Viennese pastry confectioner, homonymous with the famous Sacher-Masoch, whose laughable perversions echoed the depravations of the eponymous puppets of their favourite sweet. A taciturn Lorraine pastry confectioner it was, who tired of hearing his finicky clients reproach him with the disappearance of the goose-feather seeded jelly, added one last touch to *le juge's* reform by adding an original decoration: a little feather planted right in its *heart*, as he called it politely.

So that those who were not content could seed the gooseberry jam themselves before eating the dessert. This new version of the sweet met with resounding success and spread all over the country, for, beyond its supposed function, it meant a return to the sources of this historical pastry. Its keen irony was immediately deciphered as a limpid allusion to the nocturnal collusion of the collaborating judges and Nazi occupying forces, who shared a taste for Parisian cabarets presenting pert young ladies dancing, wearing almost nothing but a few feathers, most often planted on their rear ends. Most confessed that the judges, by their outrageous submission to the occupants, had shown that they deserved this insignia: they deserved to have a feather planted in their arses to complete the picture. This dessert, which was emblematic of dark times, did not thrive during the period immediately after the war. Beyond the psychological barrier, there were also many material obstacles: rationing as well as the absence of the counter-balancing fighting force of indignation. Yet, *le juge* managed a stupendous comeback during our millennium, which remains unexplained in the actual state of research—although it would constitute an admirable topic of investigation—with the founding of a new company in 2000, thus perpetuating the lineage of *le juge*.

Zhou Xiaohu [b.1960]

Self-Defence 2007
live action animation, 10mins 50'

After graduating from Sichuan Academy in 1989, Zhou Xiaohu earned his living as a graphic designer. Although trained as an oil painter, his job gave him a grounding in computer-assisted design systems, which led him to discover previously unimagined 'machine-made' possibilities for creative expression. Technological processes learned during this time suggested potential new visual sensations that, for Zhou Xiaohu, were excitingly evocative of this era of rapid modernisation in China. The use of computer technology in creating fine art still had yet to find acceptance — even in the late 1990s in contemporary art circles — but Zhou Xiaohu was far-sighted in realising that, far from negating the value of an individual's skills, technology was simply a contemporary tool at the disposal of the artist: "No matter how much we can achieve with computers, and in spite of the perfect images they allows us to attain, I have always been conscious of injecting a hand-made touch in my work that locates it in the sphere of fine art. Art can never be made by machine alone." This attitude helped him to become a pioneer in video animation in China, and prevented him from being seduced simply by the allure of technical effects for their own sake.

Zhou Xiaohu began using computers as an artistic tool in 1997. The initial formats were CD-roms and then the internet — both viewed as an easily transportable means of disseminating information and facilitating interaction with an audience as well as a general public, which led to such works as *Maze* 1998, and *B's Diary* 2000. Around this time, he also acquired an analogue video camera, and began experimenting with self-directed film sequences, which he then incorporated into installation works, using the actual video monitors as formal components of the arrangement. In *No Malice Intended* 1999, two monitors each represent a male protagonist, where the two are engaged in a discussion about their experiences with women. The 'woman', meanwhile, is represented on another monitor, but without a voice, filmed almost as if in secret in the private sanctuary of her own bedroom and bathroom.

The videowork *Closely Guarded Secret* 1998, is the closest Zhou Xiaohu has come to indulging in effects, although the process of deftly fading one still portrait shot of a series of famous people — icons, political leaders and celebrities (Marilyn Munroe, Churchill, Mao, Elizabeth Taylor, Andy Warhol, Cindy Crawford and Zhang Ziyi to name but a few) — ultimately says more about the similarities of humanity regardless of ethnicity or race, and the random nature of genius, beauty and power. The following

work, *Swimming in a Vase* 1999, is not, technically, an animation at all. Instead, it comprises pre-recorded video footage of a person swimming in a pool, played back on a television screen and re-filmed through the distorting filter of a blue-tinted glass vase. He creates a split-screen effect by mirroring the image across a horizontal axis; a symmetry which enhances the poetics of underwater motion, and serves to emphasise the underlying simplicity by which the dreamlike quality is achieved.

The element of creating layers of images between moving pictures and real objects upon which this work pivots is important, because it has become a signature element of Zhou Xiaohu's style. It was used again in *The Journey of Men and Lust* 1999, which is also the first time he deployed the basic stop-frame function of his analogue camera. By this means, Zhou Xiaohu learned how to animate objects by manipulating them by hand, frame by patient frame. In this first attempt, he breathes life into various articles of male and female clothing, which crawl along the ground like disfigured four-legged creatures and, from time to time, rise up and dance like souls possessed. All this unfolds against familiar urban settings and surreal apocalyptic photographic stills that complete the montages. Following this, he began to make use of digital video and computer game software which made it possible to combine filmed footage of the real world and people with a fictional, digitally rendered reality — seamlessly created by the artist.

Zhou Xiaohu's first digitally constructed work in this manner was *Beautiful Cloud* 2001, and like many first attempts it has its flaws. The breakthrough came a year later with *The Gooey Gentleman*, which demonstrates a level of technical accomplishment that allowed Zhou Xiaohu to focus on the artistic aspects of the piece This wonderful fantasy features the artist's own body as the stage upon which a hand-drawn story unfolds. Playing with the theme of fatal attraction between the sexes, Zhou Xiaohu tells a tale of sexual chemistry via an animated drawing that is alternately inscribed across his chest and that of a female counterpart. We never see the male character's face, but we do catch glimpses of his mouth, which smiles, and frowns, as his hand draws a nubile young woman, clothes her, and devises a boudoir complete with a romantic bouquet of flowers. She teases with coquettish tricks and feminine wiles that never cease to test the depths of her lover's affection. Zhou Xiaohu makes clever use of the anatomical features of both sexes as a playful allusion to the sexual allure that fuels their mutual attraction and encourages the flirtatious nature of the lovers'

The Gooey Gentleman 2001
live action animation

sport. In presenting a Barbie-like ideal of womankind, Zhou Xiaohu makes
no apology for the natural urges and fantasies of his sex. To the
deliberately stilted soundtrack of a famous Shanghainese love song, he
humorously illustrates the timeless antics of lovers engaged in the mating
game. Deceptively simple, this immensely charming work remains one of
Zhou Xiaohu's most accomplished pieces.

Zhou Xiaohu would employ this technique again for *Conspiracy!* 2004, and to
equally good effect. In the meantime, his energies were absorbed in a
physically monumental work, *Utopian Machine* 2002, that began with stop-
frame animation techniques but took them in quite another direction. This
time, he created an enormous cast of clay figures, which were then
individually manipulated millimetre by millimetre, to enact a parody of a
national television news broadcast — the Chinese equivalent of the *News
at Ten*. The inspiration came in 2000 with an invitation to participate
in the Long March project — a contemporary recreation of the 1936
Long March undertaken by Mao and his supporters, which takes the
form of a cultural investigation into the forces of ideology at work in
the provinces nearly seventy years on. The parody begins with the
programme's signature tune, which is followed by the world news.
We see Chinese delegations on missions abroad, whilst foreign heads
of state arrive at Beijing airport. The local news begins with an
update of a redevelopment project in Shanghai on the site of an
historic landmark, followed by stories about the success of the
government's fight against corruption and crime, and of natural
disasters in the provinces. This is rounded off by a cultural section: a
report on the 'musical' *Che Guevara* in Beijing, whilst in Zhunyi,
China's new Long Marchers are joined by international cultural
workers in a round of talks on the state of art and literature today (a
reference to the original *Talks on Art and Literature*, at a forum in Yan'an
in 1942, where Mao fixed the parameters for creative expression in
New China). Finally, the programme is interrupted with a breaking
story on the 9/11 terrorist attack in New York.

Utopian Machine took Zhou Xiaohu and a team of collaborators many
months to devise and film, but the intensity of energy and effort required
work to good effect, making this a powerful and symbolic comment on the
socio-political framework of present-day China. It has also made *Utopian
Machine* enormously popular with international audiences. The ideas and
approach used have since been variously reworked along similar lines

Utopian Machine 2002
clay figure animation

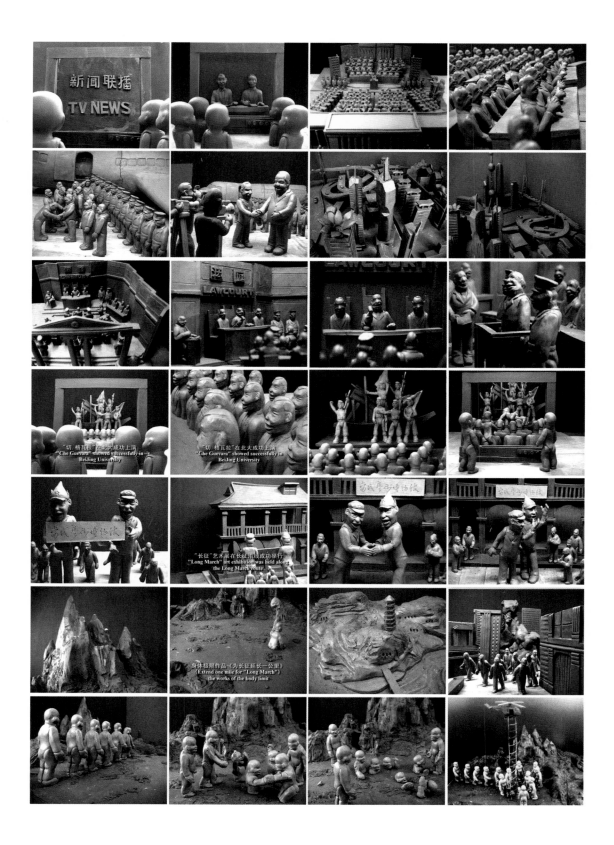

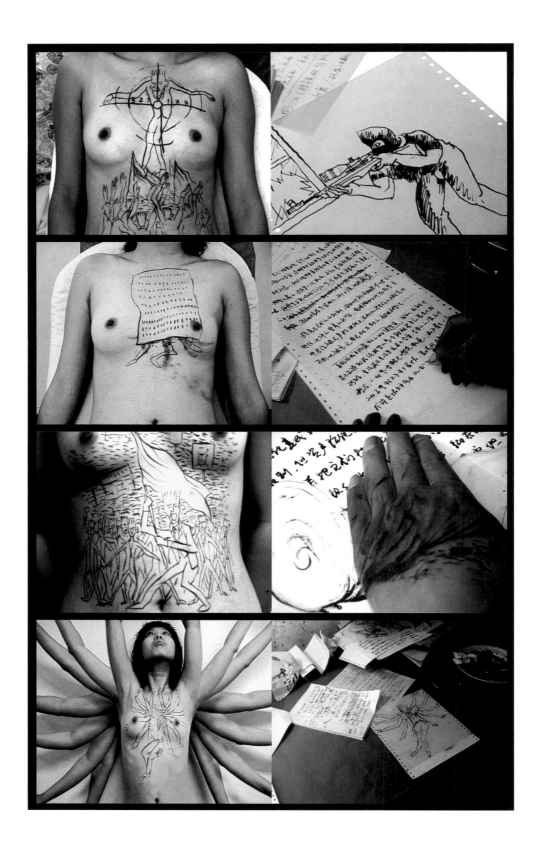

beginning with *Obsession — Century Celebration* in 2003, a sculptural installation and animation, and in works such as *Summit Meeting* 2003, and *Crowd Around* 2003-5, which juxtaposed a series of short animations with the sets and props used to create them in one giant installation.

For *The Real Thing*, however, we decided to select two works, first *The Gooey Gentleman*, but then it was a close call between *Conspiracy* and *Self-Defence*, both of which reflect, in different ways, personal experiences that, whilst articulated in a specifically Chinese context, have a universal reach. *Conspiracy*, in particular, references the post-9/11 climate in which notions of terrorism and the influence of the media exert an insidious impact upon individual lives everywhere. The action unfolds across two screens in a medley of hand-drawn animation and film of real figures. The sequence of activities on each screen is perfectly synchronised to achieve the illusion of an interactive interplay between the two, and cleverly underscores the relationship between cause and effect; the effect of an action and the issue of the instigator's awareness of its impact and responsibility taken for the outcome. As always, the serious nature of the subject matter is infused with a keen humour and delight in visual play and punning. The use of a male and a female character to represent opposite perspectives builds on the conflict visualised in *The Gooey Gentleman* and the method of combining human anatomy and real and animated props used to achieve it. Weighty, abstract issues are thus articulated in terms of a common experience that is both familiar and easily understood. As Zhou Xiaohu explains: "Consumerism and entertainment have overtaken the political nature of the body, so by adopting familiar forms of entertainment and images of hedonism, my goal is to transform these figures into perfect examples of body politics."

Conspiracy! 2004
live action animation installation

Self-Defence 2007

Similar to *Conspiracy*, *Self-Defence* also references a leading topic of our times, and one that has direct implications for at least fifty per cent of the population—the female half.. Although Zhou Xiaohu's new work is not addressed exclusively to womankind, they are highly sensitive to the issue that *Self-Defence* seeks to expose. A woman does not have to have been sexually harassed herself to empathise with those who have. From literature to mainstream films, from women's magazines to the daily news, contemporary society is presented with multiple references to sexual harassment between the extremes of provocative, seductive plotlines brought to the big screen, and headlines railing against actual attacks that are frighteningly real. Contemporary society is tagged with any number of warnings for the female sex about crossing the bounds of acceptable behaviour. What is acceptable changes from generation to generation, recognized by most women's magazines for the advice these provide centres less on a need for women to curtail their activities, and more on being prepared for every eventuality, as every good Girl Guide ought to be. These are a rich source of instructions and tips as to how women can protect themselves from would-be aggressors, and stave off unwanted advances: in short, how they should manage their charms without inviting trouble that they cannot handle. Or better still, how they could learn to handle any situation by acquiring the skills of self-defence. Every woman knows, however, that she doesn't have to be out there 'inviting trouble' to find herself in a tricky situation: in real life, no one is ever as alert and prepared for action as one of Charlie's angels.

In his inimitable fashion, in *Self-Defence*, Zhou Xiaohu presents the value of self-protection, in a humorous, and plausible narrative plucked straight from contemporary reality. This ambitious live action animation is a vehicle for his latest protégé, who appears to have taken a few leaves out of *Miss Congeniality*'s book, for she is quite the modern self-defence expert. She is the star of Zhou Xiaohu's tale of an ordinary city girl, who being much set-upon in the course of her day, is compelled to unleash a feisty alter ego in the mode of virtual super-chic Lara Croft. 'She' is a puppet-like mannequin who is goaded into life, and action, when she is molested on a train en route to work. This is the first of an outrageous stream of assaults upon on person—a male superior who flaunts lewd intentions as she sits at her desk; a co-worker who forces himself upon her even as she fixes her make-up in the bathroom; a prowler at a bus stop. Each of these advances,

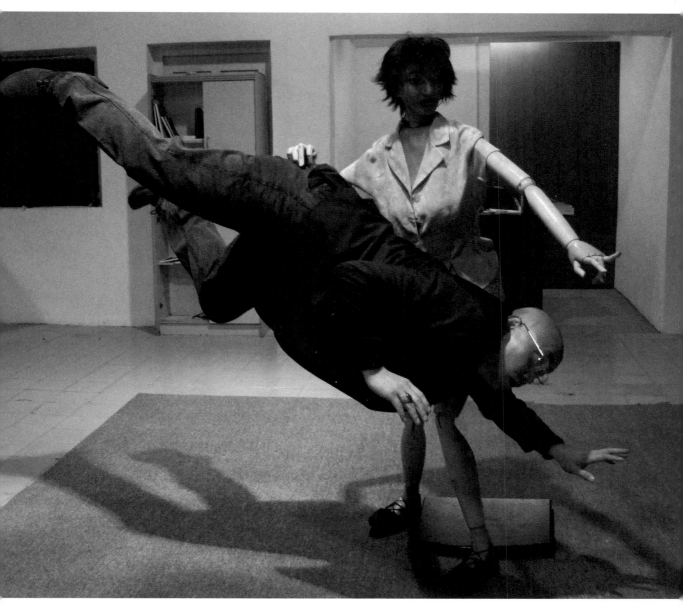

Self-Defence 2007
live action animation, 10mins 50′

results in the efficient trouncing of the male offender. One has to admire the way she handles herself, her quick reflexes, and her fearless focus in the face of adversity. Whilst Zhou Xiaohu invokes high violence to makes his audience laugh, and discourage the male portion from trying to push their luck, his star presents women with a veritable manual of self-defence.

Zhuang Hui [b.1963]

Factory Floor 2003
installation
1600 x 2300 x 350cm

In terms of his art, Zhuang Hui has always been motivated by humanist as well as aesthetic concerns. A review of past works to date demonstrates how in his practice, art and society are closely interwoven. This is not uncommon for an artist of his generation, and in particular, for one who has had little formal training: in common with many of his peers — particularly those who came from the provinces and who had no entitlement to the benefits of city life — Zhuang Hui's interest in art was nurtured in drawing classes on the factory floor of 'The East is Red Tractor Factory', where he was employed from the age of sixteen. These classes were provided as a little light leisure for those workers who were artistically inclined, but were nonetheless linked to crafts and skills that could usefully be put to the service of extolling the workers' lives in the immutable parade of Socialist Realism. Logically then, when Zhuang Hui first began experimenting with contemporary forms of art, his primary audience was China's vast manufacturing workforce, which he felt to be deserving of some *real* intellectual stimulation beyond the endless, and boorish, stream of propaganda with its unified mindset and message. As an eager enthusiast for new modes of thinking and the expression of ideas that did not rely wholly on painted realism, Zhuang Hui believed that cavernous industrial spaces could themselves become a dynamic backdrop to his work. Here, perhaps, was a real opportunity to rise to the challenge Mao had set for artists of 'serving the people'. Thus, most of his early works were directed at the workers, with a few works specifically intended to involve the workers. Ironically, Zhuang Hui soon discovered that this sector of society, which had been denied much of an education, but had been fully

Serve the People 1993
performance work

informed of the dangers of spiritual pollution and modern — western — bourgeois thinking, was at times more than a little reluctant to respond to these novel interventions with too great a display of curiosity or fervour. Whilst this might have been disappointing to a truly devoted Maoist, Zhuang Hui was not blind to the pressures exerted upon the workers, or the necessity felt by most to side with the common, rather than independent, viewpoint. That did not mean, however, he had to give up.

Between 1990 and 1993, Zhuang Hui criss-crossed the country to realise a series of conceptual and site-specific projects under the name of *To Serve the People*. His attempts to get the workers involved would later emerge as a strategy for producing art. This strategy was implemented in the massive collaboration with various State organs and social groups required to produce a series of twelve group portraits, as well as a second photographic series titled *1+30*. The *Group Portraits* were conceived in 1995, and would be almost two years in the making. Each

Chashan County (detail) 2001
intallation

involved a protracted process of negotiation in order to get approval for gathering together what were enormous groups of people in one place at one time. Zhuang Hui displayed remarkable diplomatic skills, and considerable charm, in persuading the powers in charge to let him photograph the entire staff of a public hospital, for example, or the complete faculty and cadets of a police academy. The *1+30* series is divided into four sets of thirty images, each set representing a specific social group — workers, peasants, artists, and children — whilst the '1' referred to Zhuang Hui. This references the social reality of China during Mao's reign, when all were categorised as '*gong, nong, bing*' (workers, peasants, soldiers), and again required much persuasion to bring thirty individual representatives of each 'group' to stand next to Zhuang Hui in the photographs. Here, by attempting to focus on individuals, Zhuang Hui is interested in the collective dynamics of Chinese society. So, instead of forcing us to consider the individual, the process through which he realises his works and the final format of their presentation, points to the commonalities and sense of collectivism that bind the ordinary people in China in the course of doing an honest day's work.

*Group Portrait Series:
Officers and Cadets of the
Fourth Artillery of 51410
Army Division, Handan,
Hebei Province, July 23* 1997
production still

From performance, photography, installation and more recently video and painting, Zhuang Hui's body of work spans a diverse range of materials and approach. The pace of work has slowed significantly in recent years as he concentrates his energies on a smaller number of monumental pieces, of which *Factory Floor* is perhaps the most ambitious. *Factory Floor* sits between an initial excursion into the contemporary human condition in 2001, *Chashan County*, and *Tunnel Building* 2004, which recreated the sparse living conditions afforded labourers and workers in the single-sex dormitories that were the bedrock of socialist housing.

Chashan County is a visual rendering of a real-life incident reported in a southern China newspaper, in which a girl was found mutilated — attacked whilst walking home at dusk, her eyeballs removed. The article was one of a series that appeared from 2000-2001 related to the gruesome 'profession' of organ stealing.

1+30 Workers (detail) 1995-6
set of 30 black and white photographs
each 61x 50.8cm

The idea of such an assault left a profound impression upon Zhuang Hui. That it was reported at all was significant, for such areas of real life were largely withheld by the authorities in the interests of public security. The idea of organ robbers in rural Guangdong has a distinctly absurd ring to it: unemployed, poverty-stricken labourers 'stealing' organs from living donors sounds like a physical impossibility. In terms of creating an artwork, the story was extremely difficult to approach, for its horror as much as for its sense of theatricality. Zhuang Hui presents us with a surrealist Technicolor scene, in which we see the figure of a girl in a paradisiacal landscape, a lush expanse of flourishing, verdant flora, realised from every variety of silk and imitation plant-life available in China. In the centre of all this, the girl stumbles forwards, slightly confused, dazed perhaps, as though fresh from a tumble in the bushes with an unseen lover, gently dabbing her eye as if a particle of dust is causing a momentary irritation. Amazingly, the girl appears just a breath away from being real — her hands and face, the only skin visible, were created by a team at China's leading prosthetic factory — but the fine trickle of blood rolling down her face from her eye socket shatters any romantic illusion, and suggests the full horror of what has actually happened.

1+30 Children (detail) 1995-6
set of 30 black and white
photographs
each 61x 50.8cm

Factory Floor 2003

Similar to the event that inspired *Chashan County*, the story behind *Factory Floor* is also based upon a real incident. This took place in the steel plant belonging to 'The East is Red Tractor Factory', and to which Zhuang Hui had once been assigned to do exactly the same job as the accident victim he immortalises in the work. The incident happened in the steel plant one lunchtime, just as the workers were drifting off to wash before collecting their lunchboxes. In a rush, perhaps, to finish the job before lunch, a forklift driver loads a final steel sheet onto the pile. As the driver parks the vehicle, he hears the sound of steel grating on steel, a dull thud and a muffled cry, as the top sheet slips to the floor severing the legs from the torso of a young worker who was patiently waiting for him to finish.

In his powerful full-scale installation, Zhuang Hui recreates the silent factory floor, deserted by the workers who have gone to the aid of the victim. On the table are the half-eaten lunchboxes, the protective glove dropped unnoticed to the floor, and the gaping emptiness projected by the machines.

Zhuang Hui was assigned to the factory in Luoyang, in 1979, after finishing middle school. Moving to the factory he describes as the biggest event of his formative years: "I always wanted to find some way to use the memories of this world in my art. My sense of the workers and their situation was deeply tied to the collective era in which I grew up, so that's how I regarded them: as heroes if you like." Although Mao had described the workers as the inheritors of the Chinese new world, by the 1980s, as the impact of the economic reform policies began to produce results, unemployment emerged as an unexpected corollary of economic development. Nationwide, as living standards in the urban centres began to rise, those of the workers fell into steady decline.

By 2000, Zhuang Hui was decided about using the factory as the starting point for a work, but had yet to arrive at a clear idea of what form this might take: "I took a trip back, to reconnect with the people, to remind myself of the sights, sounds and working conditions, and open to what might strike me. The sheer force of the factory environment (it employs over ten thousand people, spread over a vast compound of processing plants and productions lines) was overwhelming. I decided, however, that I could recreate a part of it, using a real interior, with all its machines parts, to speak about the new reality of the social climate today for the people it affects most."

Factory Floor 2003
detail of a blade sharpner

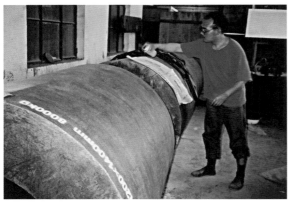

Factory Floor 2003
production process

Amongst the many divisions of the factory is one devoted to building models
of machine parts to make the moulds needed to produce them. The model
factory alone employs a thousand people, and it was these workers that
Zhuang Hui asked to create the individual components of *Factory Floor*. "I
decided to use polystyrene for the work. To use steel or iron would merely
replicate what already existed, and lack any real creativity. Polystyrene
presented an enormous challenge: to carve, to sculpt, and to paint required
all kinds of experimentation and clever handiwork. I loved the idea of the final
parts not being that which on the surface they appeared to be."

The first piece completed was the lathe, which allowed the workers to resolve
a number of technical issues to realise the one-to-one scale Zhuang Hui
envisaged. The single largest component is the base of the tooling
mechanism — 370cm long — that necessitated absolute precision in cutting
the polystyrene blocks to ensure structural resilience. Each piece is protected
with a skin of sealant to shield the polystyrene from the corrosive effects of

the industrial paint with which it was then sprayed as a base coat. Finally, each piece is finished by hand with acrylic pigments to replicate the impression of solidity and weight that conceals the levity of its physical substance.

Factory Floor is one of a handful of grand-scale works of contemporary art to have been produced in China in the new millennium. Its first showing in Beijing banished any lingering doubts that the decorous overtones of *Chashan County* might have raised, and of Zhuang Hui's ability to address serious social issues in works of this kind. The realism of the work is astonishing: artist friends called to ask where his work was in the exhibition space, believing the 'old machinery', nestled between the other art works, belonged to the former life of the reformed factory space in which the exhibition was being held. Zhuang Hui enjoys the fact that the work is not obvious, that people are confounded by the piece — "How the hell did you persuade people to move machines from a factory to the exhibition space...?" is a sentiment that was matched by an official at the tractor factory who became enraged, seeing what he believed to be major machine parts standing in a store room, thinking that the workers were plotting to sell them off and pocket the proceeds. Before anyone could put him straight, he kicked one piece so hard he put his foot through it.

Factory Floor references reality in China today on many levels. Its power lies in its directness, its refusal to pretend to be something that it is not, claiming no intellectualised theory for comprehension, nor alluding to abstract philosophical debates beyond the realm of common experience. The reality of this factory floor remains a troubling one for the broad mass of the Chinese labour force, forced to labour with little in the way of safeguards or safety net. China makes no provision for soapbox socialists, and whilst Zhuang Hui eschews the role of socio-political activist, the incorrigible sensibilities that motivate his work give it a tangible edge over a great majority of works produced by artists in the thrall of market forces that are *per force* realigning aesthetic strategies with mendacious commercial agendas. In the context of China in the early 2000s, both the content and form of Zhuang Hui's works represent a tangible measure of individual artistic innovation that few younger artists have yet managed to surpass. The problem may also be that the younger generation lack any firsthand experience of the ideological doctrines and political dogma that underpin the New China era, which is such a central point of reference for artists like Zhuang Hui, and which are slowly unravelling in the face of modernity.

LIST OF EXHIBITED WORKS

Ai Weiwei and Fake Studio
Working Progress (Fountain of Light) 2007
Mixed media light installation
Commissioned by Tate Liverpool / Supported by
Urs Meile Galerie, Lucerne and Beijing, and the
Northwest Regional Development Agency / Courtesy
of the artist

Cao Fei
Whose Utopia? 2006
Video
Commissioned by Sieman's Art Project: What are
they doing here? / Courtesy of the artist

Geng Jianyi
An Unapologetic Act of Sabotage 2007
Video installation
Commissioned by Tate Liverpool / Courtesy of the artist

Gu Dexin
2007, 3, 30 2007
Mixed media, light and sound installation
Commissioned by Tate Liverpool / Supported by
Caspar Schuebbe / Courtesy of Caspar Schuebbe /
Courtesy of the artist

He An
Thirty Minutes 2007
Video installation
Commissioned by Tate Liverpool / Supported by
private collector / Courtesy of the artist

Li Yongbin
Face V 1999-2001
Video installation
Courtesy of the artist

Qiu Xiaofei
Art Class 2006
Painting and object installation
Commissioned by Tate Liverpool /
Courtesy of the artist

Qiu Zhijie
Railway from Lhasa to Kathmandu 2007
Video and mixed media installation
Commissioned by Tate Liverpool / Supported by the Long
March Foundation, Beijing / Courtesy of the artist

Wang Gongxin
Our Sky is Falling! 2007
Video
Commissioned by Tate Liverpool / Courtesy of the artist

Wang Peng
Passing Through New York 1997
Video
Courtesy of the artist

Passing Through Beijing 2006
Video
Commissioned by Tate Liverpool / Courtesy of the artist

Gate 2001
Video
Courtesy of the artist

Wang Wei
Temporary Space 2003-7
Lightbox installation and video
A Long March Project
Courtesy of the artist and the Long March Foundation,
Beijing

Xu Zhen
8848 – 1.86 2005
Video and mixed media installation
A Long March Project
Courtesy of ShangHart Gallery, Shanghai

Disco Venus 2007
Mechanical sculpture
Courtesy of the artist

Yang Fudong
East of Que Village 2007
Film installation
Commissioned by Tate Liverpool / Supported by
Marian Goodman Gallery, New York, and ShangHart
Gallery, Shanghai / Courtesy of the artist

Yangjiang Group (Zheng Guogu, Chen Zaiyan,
Sun Qinglin)
If I knew the danger ahead, I'd have stayed well clear:
Firework Project 2007
Firework performance
Commissioned by Tate Liverpool / Supported by
Frank Cohen and Nicolai Frahm

Yang Shaobin
800 Metres No.17 2006
Oil on canvas
80 x 100cm
A Long March Project
Courtesy of White Space, Beijing and Alexander Ochs
Gallery, Berlin and Beijing

800 Metres No. 16 2006
Oil on canvas
80 x 100cm
A Long March Project
Courtesy of White Space, Beijing and Alexander Ochs
Gallery, Berlin and Beijing

800 Metres No. 2 2006
Oil on canvas
210 x 350cm
A Long March Project
Courtesy Leister Collection and Alexander Ochs Galleries,
Berlin | Beijing

800 Metres No. 3 2006
210 x 350cm
Oil on canvas
A Long March Project
Courtesy of Long March Foundation, Beijing

800 Metres No. 8 2006
260 x 450 cm
Oil on canvas
A Long March Project
Courtesy of Long March Foundation, Beijing

Zhou Tiehai
Le Ministre, Le Diplomat, Le Juge 2007
Patisserie desserts
Commissioned by Tate Liverpool / Courtesy of the artist

Zhou Xiaohu
The Gooey Gentleman 2001
Live action animation
Courtesy of the artist

Self-Defence 2007
Live action animation
Commissioned by Tate Liverpool / Supported by
Intelligent Alternative, Beijing / Courtesy of the artist

Zhuang Hui
Factory Floor 2003
Installation
Courtesy of the artist